MADISON MUSEUM OF CONTEMPORARY ART

CHICAGO IMAGISTS

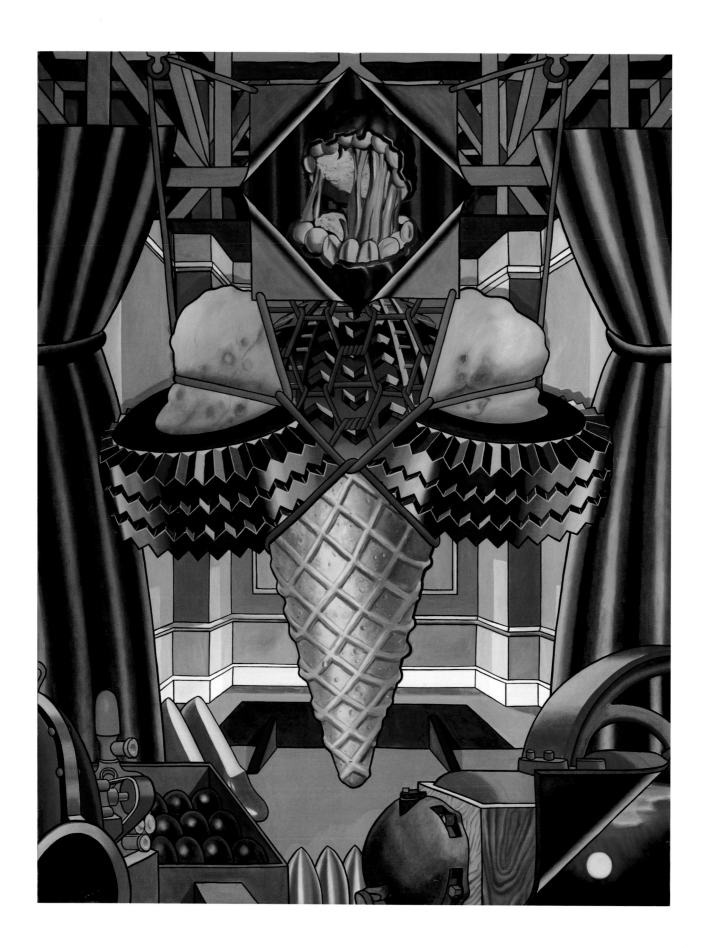

ART GREEN *Regulatory Body* 1969

MADISON MUSEUM OF CONTEMPORARY ART

CHICAGO IMAGISTS

ESSAYS BY RICHARD H. AXSOM

STEPHEN FLEISCHMAN

JANE SIMON

LYNNE WARREN

CÉCILE WHITING

This volume is dedicated to Bill McClain, whose years of passionate collecting made this project possible.

CONTENTS

ACKNOWLEDGMENTS

RICHARD H. AXSOM, STEPHEN FLEISCHMAN, AND JANE SIMON

Bill McClain is a long-time friend of the Madison Museum of Contemporary Art (MMoCA) and a former member of the Board of Trustees. For decades, McClain has generously provided the museum with his insight, leadership, and service. Two years ago, he decided to make available to MMoCA the entirety of his breathtaking collection. Augmenting our existing holdings, this generous gift ensured the appreciation of seminal works by Chicago Imagists for generations to come. We cannot emphasize enough the care that Bill took not only in choosing great examples of work by these artists, but also the attention he took in making sure the works were housed in an appropriate environment. He assembled a tremendous collection of supporting material, including ephemera. All of his efforts will engender scholarship for generations to come.

MMoCA is also grateful to the Raymond K. Yoshida Living Trust and Kohler Foundation, Inc., which has contributed another generous gift to our growing holdings of Chicago Imagists. We would like to especially recognize the efforts of the Yoshida estate's coexecutors, Shayle Miller and Jennifer Goto Sabas. We would also like to extend thanks to Terri Yoho of the Kohler Foundation, Inc. for her preservation and management of the estate's gift.

Many of the Chicago Imagists agreed to meet with us to discuss their work, their experiences, and this important period in American history. We would like to thank Sarah Canright, Art Green, Philip Hanson, Gladys Nilsson, Jim Nutt, Suellen Rocca, Barbara Rossi, and Karl Wirsum for their openness. Indeed, many of the artists set up estates to enable scholars to have access to their work. We would like to thank the estates of Roger Brown, Ed Paschke, and Christina Ramberg for their kind assistance. Lisa Stone, curator of the Roger Brown Study Collection, was particularly helpful.

A key group of curators, critics, dealers, and enthusiasts also helped advance the project. A number of them agreed to interviews, including Dennis Adrian, Russell Bowman, Ruth Horwich, Judith Russi Kirshner, Karen Lennox, Bill McClain, and Franz Schulze.

The exhibition and the publication were made possible by generous funding from the National Endowment for the Arts; The DeAtley Family Foundation; Ellen Rosner and Paul Reckwerdt; Perkins Coie LLP; Daniel and Natalie Erdman; J.H. Findorff & Son Inc.; MillerCoors; McGladrey; The Terry Family Foundation; the Madison Arts Commission, with additional funds from the Wisconsin Arts Board; the Dane County Cultural Affairs Commission; a grant from the Wisconsin Arts Board with funds from the State of Wisconsin and the National Endowment for the Arts; and MMoCA Volunteers.

Lynne Warren, curator at the Museum of Contemporary Art, Chicago, has contributed two thoughtful essays to this publication, and she has been a great resource for our research. Cécile Whiting, professor at the University of California, Irvine, has used her broad knowledge of the 1960s to write an illuminating essay about the female Chicago Imagists. Lorraine Ferguson contributed a classic and appropriate design for the publication. Paula Cooper used her expertise for careful and precise editing of all the texts.

Special thanks go to the MMoCA Board of Trustees for their ongoing support of the museum and all its projects. It is always a pleasure to collaborate with our fellow staff members. Leah Kolb, curatorial associate, has applied her tremendous research and organizational skills and her eye for detail to numerous aspects of this publication and exhibition. Development associate Meghan Bruzzi, curator of education Sheri Castelnuovo, public information associate Carol Chapin, preparators Doug Fath and Devon Hugdahl, director of development Jennifer Holmes, director of public information Katie Kazan, head registrar Marilyn Sohi, assistant registrar Stephanie Zech, and director of technical services Mark Verstegen have all contributed their hard work and knowledge in the undertaking of this project.

INTRODUCTION

STEPHEN FLEISCHMAN

In 1966, a group of young artists showed their work together at the Hyde Park Art Center on the South Side of Chicago. The show began as a project of Jim Nutt and Gladys Nilsson, who had shown single works several times at the center and were looking for a new way to see and display their work. Artist Don Baum was the director of the Hyde Park Art Center, and he urged Nilsson and Nutt to include Karl Wirsum. Other participants in this first show were James Falconer, Art Green, and Suellen Rocca. When planning for the exhibition, they decided that the title should be different from other group shows in New York; they wanted to avoid numbers and seriousness. As some individuals discussed Harry Bouras, who ran a popular classical radio show that focused on cultural topics, Wirsum asked, "Harry who?" which quickly changed into "hairy." All of the artists liked the wit and humor of this new moniker, the Hairy Who.

This group sparked a series of exhibitions and became influential to painting in the 1960s. Six more exhibitions—in New York City, Washington, D.C., and San Francisco—would follow. *Nonplussed Some* brought together the work of Sarah Canright, Ed Flood, and Ed Paschke. In 1968, the work of Roger Brown, Eleanor Dube, Philip Hanson, and Christina Ramberg was included in the exhibition *The False Image*—also at the Hyde Park Art Center. By the early 1970s, this loose-knit group of Chicago artists would be known as the Chicago Imagists. Although the term was coined by critic and art historian Franz Schulze to describe a multi-generational group of artists, including a group known as the Monster Roster, it has come to denote this group of Hairy Who, Nonplussed Some, and False Image artists. Since that time, exhibitions and publications have discussed the ability of these artists to create lyrical, witty, dynamic works of art featuring limber bodies, references to popular culture, and wry comments about

our world. As a group, the Imagists were influenced by outsider art, nontraditional art, comic books, pulp fiction, and advertisements.

This publication and the accompanying exhibition stem from a recent gift to the Madison Museum of Contemporary Art of a collection carefully amassed by Bill McClain. Featuring stunning early and late examples of the work of Roger Brown, Sarah Canright, Ed Flood, Art Green, Gladys Nilsson, Jim Nutt, Suellen Rocca, Barbara Rossi, and Karl Wirsum, this collection combined with MMoCA's existing holdings has created a tremendous institutional collection of the Chicago Imagists. The estate of the late Ray Yoshida also augmented the museum's collection, creating depth in paintings by Ray Yoshida and Karl Wirsum as well as adding works by James Falconer and Suellen Rocca. Yoshida was one of the many teachers who guided and influenced these young painters. Looking closely at the paintings, sculptures, and works on paper from these artists, MMoCA's curatorial staff and guest authors were inspired to develop a number of art historical approaches to the work. My essay "Fanning the Flames in the Windy City" examines the early attention paid to the Imagists—from memories of early collectors to the recollections of the artists, curators, critics, and gallerists—and defines what it meant to steward these seminal works. Richard H. Axsom's essay, "L.A. Snap/Chicago Crackle/New York Pop" makes the case that there was a strong corollary among the Pop art scenes in New York, Los Angeles, and Chicago. From sources to inspirations and techniques, Axsom argues that historians should rewrite the chapter on Pop art to include the Chicago Imagists. The late 1960s and the early 1970s are synonymous with social, political, and cultural change in the United States and abroad. Looking into the turbulence of that era, Jane Simon's essay examines reflections of that time in the work of Roger Brown, Art Green, Philip Hanson, Gladys Nilsson, Jim Nutt, and Karl Wirsum. Over one-third of the Imagists were women, which is strikingly different from other movements in American art in the twentieth century. Noted feminist scholar Cécile Whiting uses her knowledge of the 1960s and feminist strains within the history of art to parse through the six female imagists and see how their works rethink feminity through examinations of painting, clothing, and the body. Lynne Warren, curator at the Museum of Contemporary Art, Chicago, contributes two essays to this volume. The second essay, "Jest Digestion: [Truly Awful] Puns, [Genitalia] Jokes, and [Caustic] Wit in Chicago," looks at how the Hairy Who and the other groups use puns and other forms of humor in their work. Warren, a scholar who has known these artists and their scene for decades, has also written a prologue about the evolution of the term "Imagist" from when it was first used to its meaning and implication today.

The aim of this publication is to look and look again at the work of these American artists. With a fresh perspective from various academic/scholarly angles, we hope to broaden the appreciation of this work and the Madison Museum of Contemporary Art's growing collection.

CHRONOLOGY

LEAH KOLB

Hairy Who
Hyde Park Art Center, Chicago, IL (February 25–April 9, 1966)

The Hairy Who
Hyde Park Art Center, Chicago, IL (February 24–March 24, 1967)

Nonplussed Some
Hyde Park Art Center, Chicago, IL (February 16–March 22, 1968)

Now! Hairy Who Makes You Smell Good
Hyde Park Art Center, Chicago, IL (April 5–May 11, 1968)

Hairy Who
San Francisco Art Institute, San Francisco, CA (May 3–29, 1968)

The False Image
Hyde Park Art Center, Chicago, IL (November 17–December 21, 1968)

Part 2, Chicago: Drawings by the Hairy Who
School of the Visual Arts Gallery, New York, NY (February 14–March 14, 1969)

Nonplussed Some Some More
Hyde Park Art Center, Chicago, IL (February 21–March 29, 1969)

Don Baum Says: "Chicago Needs Famous Artists"
Museum of Contemporary Art, Chicago, IL (March 8–April 13, 1969)

Hairy Who
Corcoran Gallery of Art, Dupont Center, Washington, D.C. (April 15–May 17, 1969)

Spirit of the Comics
Institute of Contemporary Art, University of Pennsylvania, PA (October 1–November 9, 1969)

False Image II
Hyde Park Art Center, Chicago, IL (November 21–December 20, 1969)

Marriage Chicago Style
Hyde Park Art Center, Chicago, IL (February 13–March 14, 1970)

Famous Artists from Chicago
Sacramento State College Art Gallery, Sacramento, CA (March 10–24, 1970)

Surplus Slop from the Windy City
San Francisco Art Institute, San Francisco, CA (April 16–May 16, 1970)

Chicago Antigua
Hyde Park Art Center, Chicago, IL (March 19–April 17, 1971)

Chicago Imagist Art
Museum of Contemporary Art, Chicago, IL (May 13–June 25, 1972)
New York Cultural Center, New York, NY (July 21–August 27, 1972)

Young Chicago Artists
Kalamazoo Institute of Arts, Kalamazoo, MI (October 8–29, 1972)

What They're Up to in Chicago
Circulated by the National Gallery of Canada, Extension Services
Rodman Hall Arts Centre, St. Catharines, Ontario (December 1–31, 1972)
Owens Art Gallery, Mount Allison University, Sackville, New Brunswick (January 15–February 15, 1973)
Musée d'art contemporain, Montréal, Québec (March 1–31, 1973)
Beaverbrook Art Gallery, Fredericton, New Brunswick (April 15–May 15, 1973)
University of Guelph, Guelph, Ontario (June 1–30, 1973)
Dalhousie Art Gallery, Halifax, Nova Scotia (July 15–August 15, 1973)
Burnaby Art Gallery, Burnaby, British Columbia (September 1–30, 1973)
London Public Library and Art Museum, London, Ontario (October 15–November 15, 1973)

XII Bienal de São Paulo
(October 5–December 2, 1973)
Museo de Arte Moderno, Bogotá, Colombia (January 15–February 21, 1974)
Museo Nacional de Bellas Artes, Santiago, Chile (March 25–April 29, 1974)
Museo Nacional de Bellas Artes, Buenos Aires, Argentina (May 27–July 1, 1974)
Museo de Arte Moderno, Mexico City, Mexico (July 29–September 9, 1974)

Made in Chicago
National Collection of Fine Arts, Smithsonian Institution, Washington, D.C.
 (October 31–December 29, 1974)
Museum of Contemporary Art, Chicago, IL (January 11–March 2, 1975)

Made in Chicago: Some Resources
Museum of Contemporary Art, Chicago, IL (January 11–March 2, 1975)

Koffler Foundation Collection
Traveling exhibition circulated by the Illinois Arts Council, 1976

West Coast '76: The Chicago Connection
E. B. Crocker Art Gallery, Sacramento, CA (November 6, 1976–January 2, 1977)
Newport Harbor Art Museum, Newport, CA (January 29–March 13, 1977)
Phoenix Art Museum, Phoenix, AZ (June 10–July 17, 1977)
Brooks Memorial Art Gallery, Memphis, TN (July 29–September 11, 1977)
Memorial Art Gallery, University of Rochester, NY (September 30–November 13, 1977)

Chicago: The City and Its Artists, 1945–1978
University of Michigan Museum of Art, Ann Arbor, MI (March 17–April 23, 1978)

Art from Chicago: The Koffler Foundation Collection
Smithsonian Institution, National Collection of Fine Arts, Washington, D.C.
 (May 25–August 12, 1979)
Traveling exhibition circulated by the Western Association of Art Museums,
 San Francisco, CA

Some Recent Art from Chicago
Ackland Art Museum, University of North Carolina, Chapel Hill, NC
 (February 2–March 9, 1980)

Who Chicago? An Exhibition of Contemporary Imagists
Organized by Ceolfrith Gallery, Sunderland Arts Centre
Camden Arts Centre, London, UK (December 10, 1980–January 25, 1981
Ceolfrith Gallery, Sunderland Arts Centre, Sunderland, UK (February 16–March 14, 1981)
Third Eye Centre, Glasgow, UK (March 21–April 30, 1981)

Scottish National Gallery of Modern Art, Edinburgh, UK (May–June, 1981)

Ulster Museum, Belfast, UK (July–August, 1981)

Selections from the Dennis Adrian Collection

Museum of Contemporary Art, Chicago, IL (January 30–March 14, 1982)

Chicago Imagists

Kansas City Art Institute, Kansas City, MO (September 18–October 10, 1982)

Saginaw Museum of Art, Saginaw, MI (October 24–November 21, 1982)

Surfaces: Two Decades of Painting in Chicago

Terra Museum of American Art, Chicago, IL (September 12–November 15, 1987)

Drawings of the Chicago Imagists

The Renaissance Society, University of Chicago, Chicago, IL (October 4–November 14, 1987)

The Chicago Imagist Print: Ten Artists' Works, 1958–1987

The David and Alfred Smart Gallery, University of Chicago, Chicago, IL (October 6–December 6, 1987)

Chicago Imagism: A 25 Year Survey

Davenport Museum of Art, Davenport, IA (December 3, 1994–February 12, 1995)

Art in Chicago, 1945– 1995

Museum of Contemporary Art, Chicago, IL (November 16, 1996–March 23, 1997)

Jumpin' Backflash: Original Imagist Artwork, 1966–1969

Northern Indiana Arts Association, Munster, IN (September 7–October 30, 1999)

Chicago Cultural Center, Chicago, IL (January 22–April 2, 2000)

Chicago Loop: Imagist Art, 1949–1979

Whitney Museum of American Art, Fairfield, CT (September 15–December 6, 2000)

Art in Chicago: Resisting Regionalism, Transforming Modernism

Pennsylvania Academy of the Fine Arts, Philadelphia, PA (February 4–April 2, 2006)

Hairy Who (and some others)

Madison Museum of Contemporary Art, Madison, WI (October 14, 2007–January 6, 2008)

Figures in Chicago Imagism

Krannert Art Museum, University of Illinois, Urbana-Champaign, IL (August 26, 2010–January 9, 2011)

Chicago Imagists at the Madison Museum of Contemporary Art

Madison Museum of Contemporary Art, Madison, WI (September 11, 2011–January 15, 2012)

CHICAGO IMAGISM

THE DERIVATION
OF A TERM

LYNNE WARREN

The term "Chicago Imagism" has a clear origin, but what is also clear is that the term was not coined to describe that which generally comes to mind when this stylistic description is employed: figurative artists who emerged in Chicago in the mid-1960s, who used vibrant color and depicted the human body grossly distorted, highly stylized, or even schematicized. Needless to say, this has caused confusion in the years since the term came into common use—roughly the early 1970s.

Chicago art historian Franz Schulze invented the term, but it was to describe his peer group, artists who emerged in the years after World War II. In his classic book on Chicago art, *Fantastic Images*, published in 1972, Schulze writes, "The first generation of clear-cut Chicago imagists—nearly all of whom were students at the School of the Art Institute of Chicago (SAIC) in the middle and late 1940s—were unqualifiedly op-

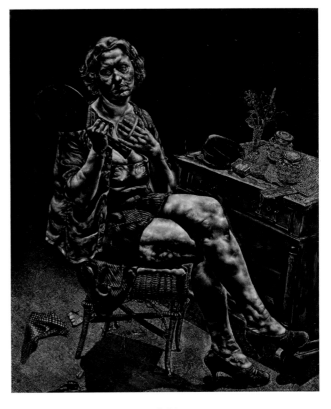

posed to regionalism, to [Ivan] Albright, and in fact to just about anything else in the history of American art."[1] And the term "imagism" originated, as Schulze explains, in the fact that these artists saw utterly no sense in painting a picture for the picture's sake, as they associated this with "decorative" artists. In Chicago, Schulze writes, "the image—the face, the figure, often regarded as icon—was considered more psychologically basic, more the source of expressive meaning, than any abstract configuration of paint strokes could possibly be."[2]

Schulze noted that the New York avant-garde had largely rejected "imagistic art"; it was made "obsolete, so to speak" by the inventions of Jackson Pollock and Mark Rothko. In New York, the practice of art was seen as existing "independently of other histories—political, spiritual, or biographical," the image being seen largely as "an anti-historical phenomenon to be assessed in the context of art history." For Chicago-trained and based artists, the image was "conceived and judged as a psychological or metaphysical entity, not merely an item of art subject matter." He goes on to point out that these artists were deeply interested in psychological material, magic, and "abnormal" states of mind such as irrationality and neurosis. In short,

Ivan Albright
Into the World There Came a Soul Called Ida, 1929–1930
Oil on canvas
56 ¼ x 47 inches
Gift of Ivan Albright, The Art Institute of Chicago

Schulze did not offer a nutshell definition of Imagism, but rather a cornucopia of tendencies, many of which, like "conceived and judged as a psychological or metaphysical entity," are undeniably subtle. Other "isms," such as Abstract Expressionism or Impressionism, yield their meaning with a bit of musing on the terms themselves. As a term, Imagism is a cipher.

Another fact about the term that causes confusion is that the first mature works produced by the generation Schulze identified as Imagist were from 1948–49. The immediate postwar scene was an obscure and ancient history in 1970s Chicago when Chicago Imagism was first being employed to describe the generation then currently emerging. Nothing had to be put aside in order to adopt the term. Furthermore, Schulze had initially dubbed the postwar generation the "Monster Roster," a term he

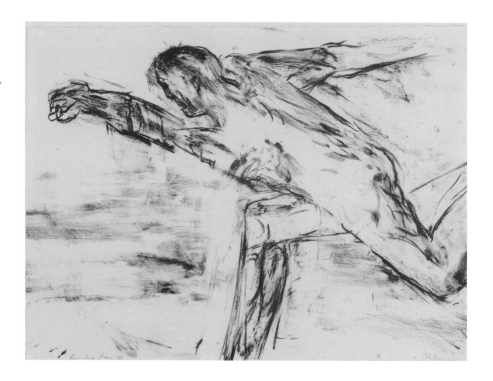

first used in a "Letter from Chicago" published in the February 1959 issue of *ARTnews* to acknowledge the artists' predilection for grotesquely rendered figurative imagery. Another commonality was that most of the so-called Monster Roster artists attended SAIC (many on the GI Bill), exposing them to specific teachers and similar experiences, especially those afforded by the Art Institute of Chicago's exhibitions and collections. Those artists now internationally known include Leon Golub, June Leaf, Nancy Spero, and H. C. Westermann. Those known best in the Midwest or to aficionados of the Chicago School include Robert Barnes, Don Baum, Cosmo Campoli, Ellen Lanyon, Irving Petlin, Seymour Rosofsky, and Evelyn Statsinger.

Beyond the tendencies that caused Schulze to wax poetical with the term Monster Roster, the characteristics that bound them were a tendency toward surrealist content, painterly method, and subject matter that was personally expressive. Yet, to emphasize the uniqueness of these artists, Schulze took pains to differentiate the Surrealism of Chicago from that of Paris or New York, and point out that the Expressionism of Chicago's painters and sculptors was not that of the German Expressionists of the 1920s. He only briefly mentions the Expressionism that would have been most recent at the time of the writing of his book, that is Abstract Expressionism. Given that the majority of Chicago's artists were figurative, the practice had little relevance in an analysis of the nature of Chicago art.[3] He does point out that "this is one of the few respects in which [Chicago's artists] can be likened to the New York painters who were developing abstract expressionism at roughly the same time: both groups were reacting against what they believed to be a tradition of American parochialism, and were seeking a radical new expressive language in models taken from outside American art."[4]

But perhaps the most important point for Schulze in defining his Imagist art was this:

> Insofar as there is a tradition of logic, clarity, and reason in the modern plastic arts, Chicago has contributed impressively to it and gained a noteworthy reputation in the process. Yet that reputation is utterly contradicted by the temper of the painting and sculpture produced in this city . . . "Chicago-type" art is not only not rational, it is anti-rational to the point of perversity.[5]

Yet at the same time, he writes, for the Chicago artists, art is seen as "an activity of some essential and serious existential import," perhaps to dissuade readers from thinking that if Chicago art is "anti-rational to the point of perversity" it might not be very serious.

It is important to remember that the Monster Roster would have been "pre-youth culture"; the immediate postwar generation may have launched the sexual and youth revolution, but those ten years their junior—the next half generation who would be in their seventies today—lived the youth culture lifestyle fueled by pot, free love, rock music, and opposition to the Vietnam War and the "establishment" in general. In terms of Chicago Imagism it is interesting to think of the Monster Roster as those who built the house, but the noisy, far more colorful tenants—the Hairy Who, Nonplussed Some, False Image, Chicago Antigua, etc.—who moved into the house got the lion's share of the attention. The "house," in a real sense, was the Hyde Park Art Center, during the years Don Baum, a Monster Roster–generation artist, served as exhibitions director at this important community art center on Chicago's South Side.

Irving Petlin
Rower of the Season ... New Stone Ring, 1975
Oil on canvas
63 x 47 ½ inches
Collection Museum of Contemporary Art, Chicago,
Gift of Alexia Quadrani in memory of Federico Quadrani

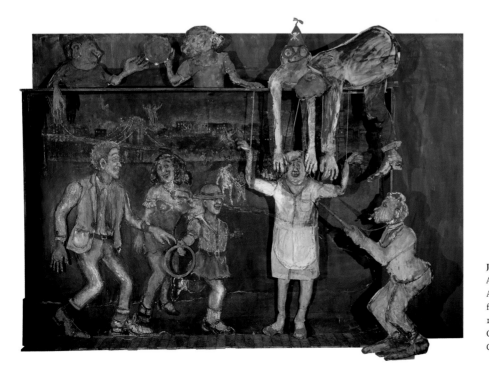

June Leaf
Ascension of Pig Lady, 1968
Acrylic on canvas with hand-sewn and stuffed figures, wood, and tin
123 ⅜ x 174 ¾ x 8 ⅛ inches
Collection Museum of Contemporary Art, Chicago,
Gift of Herbert and Virginia Lust

Famous now for discovering the young talent who are what people think of when they hear the term Imagist, in actuality Baum freely mixed the generations. He placed student alongside teacher in numerous HPAC exhibitions before the first *Hairy Who* show was mounted in 1966, including those who would become the Hairy Who, notably Gladys Nilsson, Jim Nutt, and Karl Wirsum.[6]

Despite its lack of clarity, it is not difficult to understand why the term Imagism would have been seized upon to describe those artists who emerged, accompanied by considerable excitement, in the mid-1960s. Many of the characteristics that Schulze identified in the Monster Roster can also be seen in these artists. And he included Nutt, Nilsson, Paschke, Brown, and others in *Fantastic Images*, making it all the more understandable that the book's readers would have extended the term to the younger figures. Schulze himself pointed out the similarities: They were influenced by ethnographic art, Surrealism, and they were contrarians, not at all concerned that they were not producing art in the "accepted" mode of the day. For the Imagists that would have been Pop art, with which they are often, and carelessly, aligned by those outside Chicago.[7]

Leading art historian Robert Storr, who had the good fortune to be educated at SAIC where he encountered Chicago's artists firsthand, wrote recently in an essay on Ed Flood that "Chicago artists in the late 1960s were of an especially contrarian bent and had a penchant for joining forces just to prove how much of a movement they were not."[8] This observation goes a long way to clearing up other confusions about the Imag-

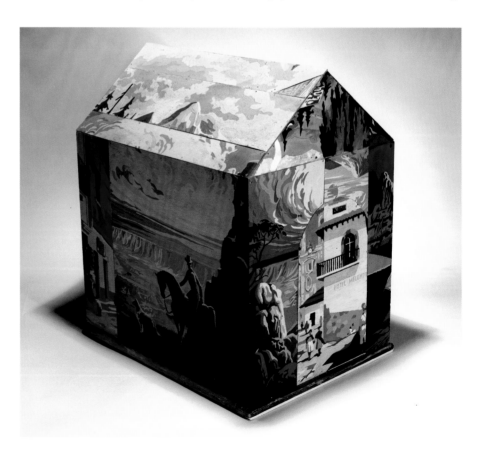

Don Baum
The Apparition, 1988
Canvas board and wood
19 ½ x 14 x 18 inches
Purchase, through National
Endowment for the Arts grant with a matching gift from the Rudolph and Louise Langer Fund,
Madison Museum of Contemporary Art

ists, especially for those outside Chicago, namely, how to interpret the fact they emerged in groups, and how the different groups relate.

In Chicago the tendency to come together in groups is different than the tendency as seen elsewhere. (Dating back to the nineteenth century artists often did not have any other choice but to band together and take matters into their own hands, lacking an infrastructure of commercial galleries, institutions, and an effective art press.[9]) Loose, self-named groups such as Exhibition Momentum are an example. These groups generally resulted from the bonds of friendship and respect with the goal of furthering each individual's interests and not from a desire to subsume oneself in order to market a group identity. In short, to use popular cultural references that were contemporaneous with the emergence of the Imagists, it is the difference between the Beatles and the Monkees. When self-selected, there is real vitality and an undeniable authenticity. When a third party is involved, either through the packaging of artists into groups or by coming up with "isms," the manifestation in the world is very different.

This is not to say the Monkees phenomenon and by analogy, the various monikers that describe Chicago art, whether Imagism or the Monster Roster or the Chicago School, are not useful in understanding the arenas in which they exist. But Imagism defines something very different from what Hairy Who defines and they are not interchangeable. The "ism" in this case comes from the outside and is an attempt by those not engaged in the artistic process to understand what it was they were seeing and feeling. The artists who emerged through the Hyde Park Art Center grouped themselves for their own purposes, not for the purposes of the group. Jim Nutt has been especially clear on this, reiterating as recently as December 2010 that the *Hairy Who* shows grew out of a group of individuals who as they matured as artists, felt representation with one or two works in large group shows no longer served their interests.[10] An exhibition of five or six individuals would allow each to show five to ten works, an appropriate challenge as one matured as an exhibiting artist.

The group identity was completely secondary, and the joking manner in which the moniker Hairy Who was derived demonstrates this. Numerous first-person testimonies confirm various titles were proposed during various get-togethers, and that Karl Wirsum, who at that point was not close with any others of the group (Jim Nutt, Gladys Nilsson, Jim Falconer, Art Green, and Suellen Rocca) did not understand their references to "Harry" and finally asked, "Harry who?" Harry was Harry Bouras, an artist of the preceding Monster Roster generation. He had an influential radio program broadcast by the classical station WFMT on which he reviewed artists and exhibitions. Given the penchant for puns and wordplay of these individuals, Wirsum's question morphed into Hairy Who.[11]

Yet the notion that these quirky Chicago artists had packaged themselves was almost immediate. One non-Chicago author, writing in 1969, went so far as to opine that the Hairy Who and other groups formed precisely to attain a group identity and effect change in a collective manner—an assumption an outsider might make in light of the Chicago backdrop of the era: radicalized politics and youth revolt as typified by the events around the 1968 Democratic Convention.[12]

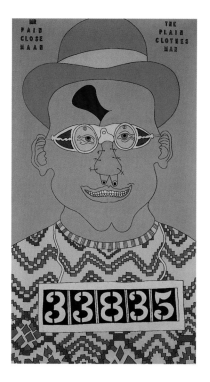

Karl Wirsum
Mr. Pain Close Maan, 1965
Oil on canvas
38 ½ x 21 ½ inches
Collection of Artist

In an interview published in the *Ganzfeld 3* in 2003, Nutt describes the "aftermath" of the Hairy Who this way:

> There have been many that have tried to make the [Hairy Who] group
> into something that it isn't, i.e., a tight-knit philosophical group, or that
> we saw ourselves as similar to rock music groups, or that we "positioned"
> our work in opposition to work being done in New York at the time,
> or that we shared ideas with Bay Area funk . . . We have been lumped with
> lots of diverse stuff and it with us, work that has no business being
> linked. Basically we were individual artists who saw an opportunity to
> make an impact and have fun with what we produced by exhibiting
> together.[13]

By the early 1980s the term Chicago Imagism had come into widespread use in Chicago.[14] In the 1990s, as the art world expanded and the Internet came into being, it spread to national and international usage.[15] Today it is a common term, the Bill McClain Collection of Chicago Imagism being yet one instance of its widespread usage. If it can be argued that Chicago Imagism has become a useful term for describing certain stylistic predilections as exemplified by certain Chicago-based artists who emerged in the 1960s, then the works by these artists of the 1970s, '80s, and into the present seem even more appropriately described as Imagism.[16] While it is indisputable that the Imagists chafed under this moniker and certainly did not pander to it, other factors were in play to codify the artists as interrelated. Imagist collectors, like Bill McClain, are not uncommon. Generally those who acquired, say, Roger Brown, especially in the 1970s and 1980s, were also likely to acquire Paschke, Nutt, Nilsson, and others deemed Imagist, as well as various folk artists, such as Joseph Yoakum, erroneously ascribed as having been influential upon the development of these individuals.

From the 1980s to the present, a number of museums, especially in the Midwest, have shown interest in exhibiting and collecting Imagist artists, further codifying the term. These public collections include the Smart Museum in Chicago, the Kresge in East Lansing, Michigan, the Figge Museum in Davenport, Iowa, the Akron Art Museum in Ohio, and the Krannert in downstate Illinois.[17] Museums outside the Midwest with important collections include the Smithsonian Museum of American Art, Washington, D.C., which sprang from their showing the Hairy Who early on as well as a generous gift by Chicago collectors Sam and Blanche Koffler, and the Pennsylvania Academy in Philadelphia. As public collections expand and scholarship increases, the term Chicago Imagism builds more and more valuable currency.

As well, it is important to note that none of the surviving Imagists who have continued working and showing have radically changed their styles, which allows the term to continue to fit them, so to speak. There have been evolutions, but not radical change to, say, an abstract style or a medium never before used, such as photography or video. Yet, despite being constantly lumped together, innumerable exhibitions, and art historical analyses, Roger Brown's works are unmistakable, as are Ed Paschke's,

as are Jim Nutt's, as are Gladys Nilsson's. Subject matter, color, graphic style, painterly qualities, and so on are distinctive in each, as is apparent in the present exhibition that consists of early and later examples, often in some depth, of the key figures in Imagism.

Brown is unmistakable for his uncompromising political voice, which emerged with force in the 1980s. He frequently lampooned art world figures and tendencies, and did paintings of President John F. Kennedy's assassination as well as that of Italian prime minister Aldo Moro; none of the other Imagists came close to dealing with such subject matter. His use of the silhouetted form, both human and natural, makes his work distinctive within the grouping of Chicago Imagism. The dazzling seven-color woodcut *Family Tree Mourning Print* of 1983 [p.94] demonstrates both his brilliant use of the silhouette and his skill as a printmaker.[18] Approximately ten years out from his debut in the HPAC's *False Image* exhibition of 1968, *Skyscraper with Pyramid* of 1977 [p.80] represents another Imagist tendency at which Brown particularly excelled, that of the painted object. Here, Brown's furtive figures populate the glowing yellow windows of a boxy skyscraper.

Gladys Nilsson, one of the original Hairy Who, demonstrates the maturation of her loopy watercolor technique in works such as *Beautify* (1994) and *Ern* (1999). Yet it is also interesting to view her 2001 work *Some Other Tree* alongside Brown's *Family Tree Mourning Print* and note their several formal similarities. The use of hierarchically scaled figures is one shared visual trope, though Nilsson's mastery of this compositional device is unrivaled among the Imagists. In his early career, Jim Nutt also frequently depicted a mixture of large- and small-scale figures within the same picture plane; Madison's collection is rich in these earlier works, including *Zzzit* (1970) [p.66], a masterpiece of revolting imagery intriguingly presented. In the 1980s, Nutt evolved into a format he continues today, that of imaginary women in a traditional portrait pose, such as the luminous and contemplative *Cheek* (1990–91).

Ed Paschke, as different as his painting style and the scale of his works are from Nutt's, also focused on heads, many being actual, if unattributed, portraits. Yet Paschke, unlike most of the Imagists, tended to rely on photographic sources, often projecting images onto his canvases and tracing them. It is Paschke, often cited as Chicago's best-known Imagist, around whom much confusion seems to reign. Many assume he was one of the Hairy Who artists, when in fact he was inspired by seeing the first *Hairy Who* exhibition to organize his own cleverly titled group, the Nonplussed Some.

Christina Ramberg likewise focuses on heads and fragmented bodies: The early lithograph *Head* (ca. 1969–70) [p.63] shows a luxuriant sweep of hair from the back, while other works including *Tight Hipped* (1974) [p.75] and *Vertical Amnesia* (1981) [p.84] show the artist's palette lightening and her imagery opening up while retaining her characteristic forms of abstracted clothing and bound bodies. Ramberg participated in the *False Image* exhibition in 1968, which notably included Roger Brown and Phil Hanson, yet, like most of her artistic colleagues, she never considered herself affiliated with any particular stylistic grouping.

Karl Wirsum, who like Ramberg shows a predilection for schematizing the

body—aggressively on display in the painting *Fire Lady or Monk's Keybroad* of 1969 [p.57]—also creates, like Roger Brown, engaging and often cleverly conceived objects. *Measle Mouse Quarantined from His Fans* (1980) [p.83] and *Brown Derby Bouncer* (1983) [p.158] are two examples from the McClain collection. And Wirsum's punning, alliterative titles demonstrate another tendency that spanned the group, especially in the early years: wordplay and fanciful or evocative titles.

In the final analysis, Chicago Imagism has proven to be a useful term, even if it was misconstrued by those subsequent to the term's originator. Individual artists so described inevitably chafe under its confines, wishing their achievements to be seen first and foremost on their own terms. This is natural and understandable. Yet as a way into the fascinating worlds of the individual artists, the effort it might take to understand the term Chicago Imagism can be quite valuable. The description of a 1987 exhibition, *Drawings of the Chicago Imagists*, mounted by the Renaissance Society at the University of Chicago says it well: "Imagism became known as 'The Chicago Style' and it was this group of artists that put Chicago on the map for national and international art audiences."[19] And one final word: The Wikipedia entry on Chicago Imagism, though brief, is generally accurate.

[1] Franz Schulze, *Fantastic Images* (Chicago: Follett Publishing Company, 1972), 9. It is also important to note that Imagism has long been in use as a literary term, referring to a style of poetry championed by Ezra Pound and others in London in the early years of the twentieth century. Imagist was described by Pound in his manifesto "A Retrospect" as the "direct treatment of the 'thing,' whether subjective or objective." Imagism also has been used as an art historical term, particularly by noted art historian H. H. Arnason in his catalogue essay accompanying his 1961 Solomon R. Guggenheim Museum exhibition entitled *American Abstract Expressionists and Imagists*. It is not entirely clear from Arnason's essay the distinctions between Abstract Expressionists and Imagists, but the net he cast in curating the show was wide and included figures now largely thought of as Color Field painters (Morris Louis, Kenneth Noland) as well as mavericks such as Alfred Jensen. Incidentally, this exhibition is now best known as being the backdrop against which the famous incident of Willem de Kooning punching Clement Greenberg at the Cedar Tavern transpired.

[2] Ibid., 12.

[3] Although Schulze gives a nod to Chicago abstract artists of the generation in question, mentioning Roland Ginzel and Richard Hunt, and including the significant abstract painter Miyoko Ito, who attended SAIC during the war.

[4] Schulze, op cit., 9.

[5] Ibid., 5.

[6] One especially important teacher was Ray Yoshida, who although older than the artists dubbed Imagist, has come to be thought of as an integral member of the group. In fact, the press release for Yoshida's recent exhibition at SAIC's Sullivan gallery, cites a "pre-Imagist" period that dates from 1953, *www.saic.edu/news/releases/index.html#current/SLC_31937*.

[7] Dennis Adrian, in an essay on Karl Wirsum, makes a cogent point that he "does not 'aestheticize' the images of popular culture or ironically present them out of their ordinary functional contexts as symbols of contemporary civilization" in the manner of the New York Pop artists. This certainly holds true for all the Chicago Imagists. *Karl Wirsum: A Retrospective Exhibition*, exh. cat. (Urbana, IL: Krannert Art Museum, University of Illinois at Urbana-Champaign, 1991), 34.

[8] Robert Storr, "Tropical Isles for a Cold Climate," in *Ed Flood: Constructions, Boxes & Works on Paper 1967–1973*, exh. cat. (Chicago: Corbett vs. Dempsey, 2010), 7.

[9] See Lynne Warren, *Alternative Spaces: A History in Chicago*, exh. cat. (Chicago: Museum of Contemporary Art, 1984).

[10] Richard Hull, "Art —Gladys Nilsson + Jim Nutt," *Bomb* 114 (Winter 2010): 57.

11 Dan Nadel, "Hairy Who's History of the Hairy Who," *Ganzfeld* 3 (2003): 121–2. For another interview in which Nutt describes the origin of the group and term, see Phil Linhares, "Jim Nutt: A Conversation with Phil Linhares," *Currant* (April/May 1975): 23–27.

12 Joan C. Siegfried, "Art from Comics," *The Spirit of the Comics*, exh. cat. (Philadelphia: Institute of Contemporary Art, University of Pennsylvania), unpag.

13 Nadel, "Hairy Who's History of the Hairy Who," 127.

14 It also must be noted that some have identified a second generation of Imagists, artists who came on the scene in the late 1970s or 1980s, including but not limited to, Phyllis Bramson, Richard Hull, David Russick, Hollis Sigler, and Mary Lou Zelazny.

15 Although nationally based figures often use the term very differently than those more familiar with Chicago. An example is Cynthia Roznoy writing in the catalogue essay for an exhibition in 2000: "Franz Schulze coined the term 'Imagism' to described this [postwar, internally focused] work, and it now has become a blanket label for figurative art produced in Chicago after 1945." Ivan Albright was included in this exhibition, the very artist Schulze used as an example of the type of art his generation vehemently rejected. Cynthia Roznoy, *Chicago Loop: Imagist Art 1949–1979*, exh. cat. (New York: Whitney Museum of American Art, 2000), unpag.

16 Unfortunately several of the most prominent of those who have become known as Imagists are deceased: Roger Brown (1941–1997); Ed Flood (1945–1985); Ed Paschke (1939–2004); and Christina Ramberg (1946–1995).

17 A recent traveling exhibition mounted by Krannert from their permanent collection, *Figures in Chicago Imagism*, sought to "broaden the scope of Chicago Imagism by including not only artists commonly exhibited as such, but also those who were influential in the creation of the school," *www.kam.uiuuc.edu/pr/imagism/index.html*.

18 Most of the Imagists are accomplished print-makers. See Dennis Adrian, *The Chicago Imagist Print* exh. cat., (Chicago: University of Chicago, David and Alfred Smart Museum, 1987).

19 This show included Roger Brown, Art Green, Philip Hanson, Gladys Nilsson, Jim Nutt, Ed Paschke, Christina Ramberg, Suellen Rocca, Barbara Rossi, and Karl Wirsum. *www.renaissancesociety.org/site/Exhibitions/Intro.Drawings-of-the-Chicago-Imagists.106.html*.

FANNING THE FLAMES IN THE WINDY CITY

STEPHEN FLEISCHMAN

Chicago is a city of geographic contradictions: a town with a navy tradition that lies nearly one thousand miles from the ocean. It is a dense, urban environment that rises from the agrarian plains of the Midwest. Differing sensibilities also can be detected in the artistic directions that captivated Chicago soon after World War ll. On one front, there was Ludwig Mies van der Rohe, who had moved to Chicago and served as the head of the architecture school at the Illinois Institute of Technology (formerly Chicago's Armour Institute of Technology). There he developed a master plan for the campus and built many of its structures, including his renowned S. R. Crown Hall. From this post, he continued to spearhead the development of a new architecture that was lean, simple, and rational. His highly visible Lake Shore Drive apartments of 1949 and 1951 and other major projects still dot the Chicago landscape. Laszlo Moholy-Nagy also was a midcentury force for pragmatic design in Chicago. He had emigrated from Europe in 1937 to become the director of the New Bauhaus in Chicago. Although this American experiment was short-lived, his impact on making Chicago a center for the thoughtful design of utilitarian products was long lasting.

In contrast, Chicago simultaneously was nurturing a very different, less rational artistic tradition. There was considerable interest by early collectors in European Modernism. Although the Art Institute of Chicago eschewed early involvement in twentieth-century collecting, they were encouraged by the activities of the Arts Club of Chicago and individuals such as Joseph Winterbotham, who provided the museum with a dedicated fund to acquire contemporary works.¹ Over time, this led to the museum's acquisition of important canvases by Giorgio de Chirico, Salvador Dalí, René Magritte, among many others. Chicago's passion for Surrealism also is exemplified by the collecting practices of Ed and Lindy Bergman, who by the late 1950s had established what was to become a preeminent collection of Surrealist works. Eventually, the Art Institute of Chicago became the beneficiary of these early dedicated collectors and patrons.

Perhaps because of its sprawling geography, artists in Chicago lived, worked, and exchanged ideas in a different fashion than artists in New York. There was a well-established tradition of New York artists living, working, and socializing in close proximity to one another. Many of the members of the so-called Ashcan School at the turn of the twentieth century kept studios in Washington Square. The Abstract Expressionists of midcentury fame gathered nightly at the Cedar Street Tavern, and in the late 1960s SoHo underwent serious redevelopment. This neighborhood's old manufacturing buildings were valued by artists for their vast spaces, natural light, and inexpensive rents. In more recent years, Brooklyn has become the draw for a new generation of young artists, once again lured by cheap rents and a lively artistic scene. In discussing

Chicago, the art critic and collector Dennis Adrian phrased it this way: "There was no district where artists lived. There were spaces available all over the city and that's where they lived. It wasn't geographically compressed the way New York is. The need for classification, assortment and rounding up the wagons to be in your group just didn't make any sense in Chicago."[2]

Despite the physical and cultural sprawl of Chicago, two organizations emerged as energetic centers of the local art scene in the 1960s. The School of the Art Institute of Chicago (SAIC) and the Hyde Park Art Center were both central to the development of Chicago Imagism. SAIC traces its roots back to 1866 and throughout the twentieth century its students benefited from the encyclopedic collections housed next door at the Art Institute of Chicago. The young Imagist students regularly took the opportunity to access works by Max Beckmann, Francis Bacon, and Jean Dubuffet, among many others. There were a number of influential instructors at the well-established SAIC, but none were more important to the student artists who comprised the Imagists-to-be than Whitney Halstead and Ray Yoshida.[3] Halstead, an artist in his own right, was an assistant in the Field Museum's anthropology department and also taught art history classes at SAIC. He introduced his students, including Roger Brown, Philip Hanson, Gladys Nilsson, Jim Nutt, and Karl Wirsum, to the considerable sway of what then was described as "primitive art."[4] Halstead had wide-ranging interests in non-Western art, which encompassed African art, Native American pottery, and kachinas,[5] as well as work by self-taught individuals such as the locally based artist, Joseph Yoakum.[6]

Ray Yoshida began his legendary teaching career at SAIC in 1959 and served on the faculty for forty-five years. In addition to his own artistic endeavors, Yoshida was an avid collector of things that often were outside the boundaries of traditional art objects. He compulsively gathered vintage toys, lawn ornaments, and other materials that resonated with him. These objects found their way into his work and also were of considerable interest to his young students. Barbara Rossi stated, "Both Ray and Whitney Halstead encouraged me to investigate my own attractions to visual phenomena, as well as develop my own interpretations of works of art. Collecting was part of this research process."[7] Yoshida's influence as a painting instructor was unparalleled, but the ideas of his students also permeated his work. This complex dialogue was a hallmark of the relationships he forged with his students. Recounting Yoshida's influence Jim Nutt wrote, "He had a special knack for getting students to think about the possibilities of their work, encouraging them to experiment from within, and, as such, take chances. But in both his teaching as well as his practice, Ray was not doctrinaire. Rather he allowed all sorts of things to enter his mind and, as a result, he was constantly having discoveries—some of which he pursued and others he let go of."[8] Yoshida's artistic sensibilities were in harmony with the Chicago Imagists, as evidenced by their shared exhibition histories in later decades. As former curator and museum director Russell Bowman wrote in regard to Yoshida, "His painting style developed in similar directions and at roughly the same time as that of his students, making him simultaneously an important influence and a full-fledged member of the Imagist movement."[9]

Ray Yoshida
Courtesy of the Raymond K. Yoshida Living Trust and Kohler Foundation, Inc.

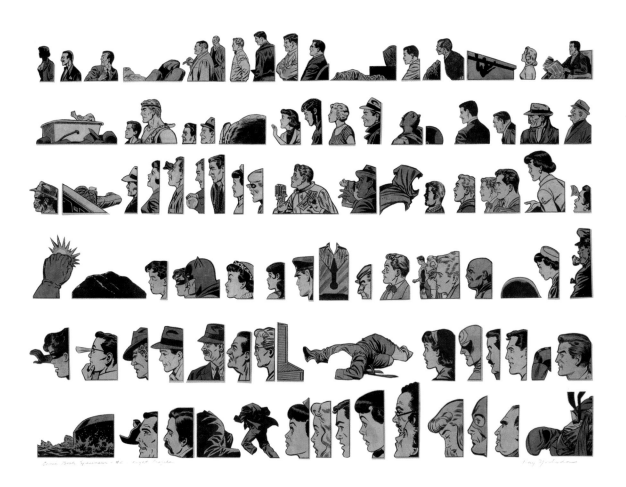

Ray Yoshida
Comic Book Specimen #2, Right Profile, 1968
Collage on paper
19 x 24 inches
The Bill McClain Collection of Chicago Imagism,
Madison Museum of Contemporary Art

Don Baum at the opening for *Made in Chicago: Some Resources*, 1975 at the Museum of Contemporary Art, Chicago
Collection Museum of Contemporary Art, Chicago

The first meeting to form the Hyde Park Art Center was held in June 1939. First dubbed the Fifth Ward Art Guild, the name was changed to Hyde Park Art Center in February 1940. Although this early alternative space occupied a number of different facilities, all of the Imagist exhibitions in the 1960s and 1970s took place at the 5236 S. Blackstone Avenue location. The Hyde Park Art Center offered classes and a lively exhibition program featuring local artists, which was overseen by an exhibition chairman. Don Baum served in this capacity from 1956 to 1973. Baum was an admired artist in his own right, whose assemblages of cast-off materials attracted considerable attention. He was also a strong promoter of young artists, and he often would show their work side by side with more established figures. His willingness to take chances was instrumental in the development of the Chicago Imagists. The artist Roger Brown wrote, "From 1966 to 1970, the Art Center was about the only place around where unseen artists could exhibit."[10] All three of the *Hairy Who* exhibitions at the Art Center, the two *Nonplussed Some* shows, the two *False Image* exhibitions, as well as *Marriage Chicago Style* and *Chicago Antigua* took place under Don Baum's watch.

Don Baum was a driving force for innovation at the Hyde Park Art Center. He was an astute observer of young talent, open to new ideas, and made good use of his many connections in the Chicago art scene. In speaking about the artists' orchestration of their first *Hairy Who* exhibition at the Hyde Park Art Center, Jim Nutt recalls, "Gladys [Nilsson] and I took the proposal to Don who by that time had become a good friend as well as our employer (we taught a children's class on Saturday at the Hyde Park Art Center) and he liked it. He suggested we add Karl Wirsum to the group we were in, which all of us were happy to do, though none of us knew him personally at all."[11] In the ensuing years, Baum continued to advocate for these artists. Two exhibitions curated by Baum for the Museum of Contemporary Art, Chicago, which was established on East Ontario Street in 1967, included work by the Imagists: *Don Baum Says: "Chicago Needs Famous Artists"* (1969) and *Made in Chicago* (1975),[12] which was accompanied by a corollary exhibition that examined the artists' source material such as comic books, toys, and folk art.

Working alongside Don Baum at the Hyde Park Art Center was Ruth Horwich. She and her husband, Leonard, had moved from Philadelphia to be closer to his family in Hyde Park. Ruth and Leonard settled into a welcoming brick home on South Woodlawn Avenue. Ruth was asked by Eleanor Peterson to become involved in the Hyde Park Art Center, and she almost immediately became its cochairman together with her good friend Lillian Braude. Together they served in this capacity from 1962 until 1974.

Despite the dispersion of artists across Chicago, the Hyde Park Art Center exhibition openings quickly became the gathering place for the cultural community. "Suddenly in the mid 60s the Center became fashionable and it was 'in' to be seen at the Friday night parties. By the second *Hairy Who* in 1967 there were wall-to-wall people who came from all parts of the city."[13] The *Hairy Who* and, later, the other exhibitions of Imagist work were announced with lively posters created by the artists. The exhibitions often were accompanied by artist-made comic books and other ephemera such as decals, which in part took the place of exhibition catalogs. In addition to the lively

installations of artwork, the exhibition openings offered remarkable people watching with individuals sporting vivid costumes. And attendees always could rely on the infamous Hyde Park Art Center punch. This liquid refreshment was comprised of a fifth of Wolfschmidt Vodka, a quart of club soda, and six ounces of Rose's Lime Juice.

After parties at the Horwich home were a regular part of the Hyde Park Art Center scene. A small group of artists, critics, curators, and close friends would assemble on Woodlawn Avenue for conversation, food, and libations. Naturally, guests had the opportunity to view the impressive Horwich collection and to meet many of the artists responsible for creating these works. Often, a few of the artists would sleep over at the Horwich home and go to an open-air flea market the next morning, to expand further their collections of inspirational objects. As Ruth Horwich recalls, "We would go have breakfast . . . we wanted to get there early to see what was going on, what we could find to buy."[14]

In addition to Ruth and Leonard Horwich, there were a number of early collectors who helped provide important support for these emerging artists by regularly purchasing works from the Hyde Park Art Center exhibitions. Ed and Lindy Bergman quickly were drawn to the Imagist sensibility and collected it from the beginning, as did Dennis Adrian, Peter Dallos and Jim Faulkner, and John Jones, among others. Within a brief time, this initial group of committed collectors expanded to include other serious individuals such as Gilda and Hank Buchbinder and Peter and Eileen Broido. During the 1970s, several noteworthy collections of Chicago Imagism were developed. Larry and Evelyn Aronson and Bill McClain passionately pursued Imagist works. This latter group of individuals each assembled focused, in-depth collections of objects by the Imagists as opposed to collectors such as Lew and Susan Manilow, Ann and Walter Nathan, and Stephen Prokopoff, who acquired Imagist works as one facet of a broader collecting mission. Fortunately, many of these private collectors understood the importance of making the works publicly accessible, loaning them for exhibition, or in the case of Bill McClain, passing on his entire collection, built over three decades, to the Madison Museum of Contemporary Art. In describing his motivation, McClain stated, "I knew that I was the temporary caretaker of these works, and that ultimately they would go to a permanent home where they could be viewed by the entire public."[15]

Although early purchases of Imagist works transpired directly from the Hyde Park Art Center exhibitions, these young artists were in need of professional gallery representation throughout the year. The Chicago gallery scene was quite modest in scale during the 1960s and early 1970s. There were two galleries of particular interest to the young Imagists: Richard Feigen's space and the gallery operated by Allan Frumkin. This latter gallery represented many earlier generation Chicago artists, for whom the Imagists had substantial respect, including Robert Barnes, Leon Golub, June Leaf, Peter Saul, and H. C. Westermann. Ultimately, it would be the Phyllis Kind Gallery that took up the banner of the Chicago Imagists. Born Phyllis Cobin in New York, she started selling old master prints beginning in Chicago in 1967. A decision to show the work of the Chicago painter Miyoko Ito—and later other contemporary artists—caught

the attention of the Chicago Imagist artists. On a return trip from California, where they had been living for several years, Gladys Nilsson and Jim Nutt visited Kind's gallery and asked her in a direct fashion whether or not she was interested in having their work.[16] The other Imagist artists followed Nilsson and Nutt's lead and soon Kind represented Roger Brown, Ed Flood, Art Green, Philip Hanson, Christina Ramberg, Barbara Rossi, and Karl Wirsum.[17] In the fall of 1971, Karen Lennox began to work for Kind and would manage the Chicago gallery until 1981. This was significant because Kind decided to open a second gallery in New York in 1975 and spent increasingly longer periods away from Chicago. The New York gallery focused on some of her Chicago roster as well as a broader grouping of artists from across the United States, with an emphasis on outsider stylistic tendencies. It was unusual for a gallery in Manhattan to have such a preponderance of Chicago artists and it certainly can be questioned whether or not this helped or deterred the Imagists' assimilation into New York. In speaking about this dilemma Lennox stated, "These artists should never have been lumped together with one Chicago gallery . . . It doesn't spread the word, and that is the tragedy."[18] Both Nilsson and Nutt had solo exhibitions at the Whitney Museum of American Art in the early seventies, but most of the Imagists had limited exposure in New York, and these opportunities had resulted in mixed critical reviews.

The first critic to write significantly about the new developments transpiring at the Hyde Park Art Center in the mid-1960s was Franz Schulze. He was an art critic for the *Chicago Daily News*, and a professor of art at Lake Forest College. Schulze's November 1966 article published in *Art in America* brought significant exposure to the young artists participating in the first *Hairy Who* exhibition. Entitled "Chicago Popcycle," the headline stated, "It's mad, it's monstrous, it's how a group of Midwestern individualists rejected the Paris, New York or West Coast mold to form a school that is distinctly its own."[19] Some Chicago critics, such as Alan Artner, were less enamored with the Chicago Imagists and expressed their reservations.[20] In New York, the work of the Chicago Imagists often was met with chilly reviews. In 1982, John Russell wrote for the *New York Times* about the Pace Gallery's exhibition, *From Chicago*. He stated, "Anatomical allusions abound. Jokes come straight from the garbage heap. Nothing is said once that can be said a dozen times." Russell closes the article with a direct summation: "Maybe this is just a way of saying that the paintings I like best in the show are the ones that owe least to the 'Hairy Who.'"[21]

Although the early Hyde Park Art Center exhibitions were not accompanied by catalogs, later publications did contain scholarly essays. A key example was the 1980 book *Who Chicago?* produced to accompany an exhibition organized by the Ceolfrith Gallery, Sunderland Arts Centre in Great Britain. It included an essay by Dennis Adrian, who wrote frequently about the Chicago Imagists. Russell Bowman's essay helped bring perspective to the Chicago scene. Entitled "Chicago Imagism: The Movement and the Style," it provided a strong argument for why this group of artists constituted a movement. Bowman went on to organize important museum presentations, including *Jim Nutt*, a traveling exhibition that premiered at the Milwaukee Art Museum in 1994.

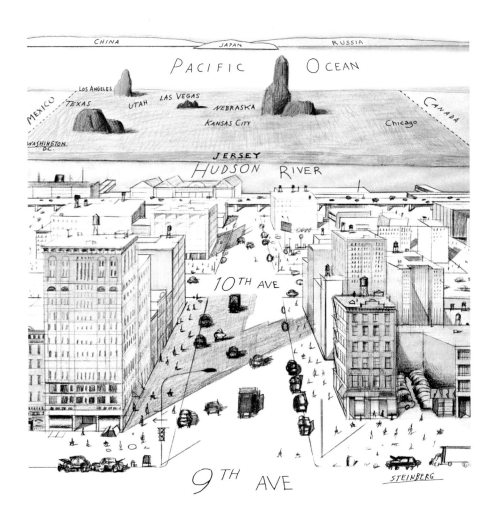

In addition to Don Baum and Russell Bowman, many other individuals helped advance the Chicago Imagists by organizing museum exhibitions that included their work. In 1961, A. James Speyer became the curator of Twentieth-Century Painting and Sculpture at the Art Institute of Chicago. In this capacity, he included many works by the Imagist artists in the regularly scheduled *American Exhibition* and *Artists of Chicago and Vicinity* shows. In particular, the *American Exhibition* presentations proved to be important to the Imagists, as they placed the work of Chicago artists in a national context.

31

Not all of the curators who championed these artists lived in the Chicago area. The legendary curator Walter Hopps had become a fan of the Imagists and even attended festivities at the home of Ruth and Leonard Horwich. Hopps helped to ensure that the 1973–75 exhibition *Made in Chicago* traveled to the *XII Bienal de São Paulo* and to the Smithsonian's National Collection of Fine Arts in Washington, D.C., where he then served as curator of twentieth-century American art. In 1974, Thomas Armstrong, the newly appointed director of the Whitney Museum of American Art, and himself an Imagist collector, worked with then Whitney curator Marcia Tucker to bring Nutt's first major solo exhibition to New York.[22] Tony Knipe of Great Britain organized the exhibition *Who Chicago?* Other museum directors and curators such as James Demetrion and Robert Storr were responsible for bringing Imagist works into important American museum collections.

Despite all of these efforts, the Chicago Imagist phenomenon has remained largely sequestered in the Midwest. As other art-making centers in the United States, such as Los Angeles and Miami, have burgeoned with new museums and galleries, the art scene in Chicago always seems slightly removed from the national dialogue. Perhaps the notion of overlooked American geography was captured best by Saul Steinberg's now-infamous 1976 cover for the *New Yorker*, "View of the World from 9th Avenue." Chicago appears as a small blip on the map: clearly not a suitable fate for a city that has produced so many talented artists, including the Imagists who emerged on the scene beginning in 1966. Thank goodness for the visual arts organizations and a band of insightful curators, critics, art dealers, and collectors who blew on the embers of Chicago Imagism and kept the home fires burning.

1 Joseph Winterbotham and his family held prominent positions in the Arts Club for generations. \His daughter, Rue Winterbotham Carpenter, was elected club president in 1918, strengthening the organization by continuing to bring modernist art to Chicago. Rue Winterbotham Shaw—Rue Winterbotham Carpenter's niece—was elected president of the Arts Club in the 1940s, a position she held for thirty-nine years.

2 Author conversation with Dennis Adrian, January 7, 2011.

3 Kathleen Blackshear, an SAIC professor who retired in 1961, was an important influence on Ray Yoshida, Karl Wirsum, and Gladys Nilsson. Blackshear was a student of Helen Gardner, one of the first art historians to include non-Western art in an art history survey text. Blackshear's connection with Gardner, and her personal interest in African and Asian cultures, informed her teaching. Dan Nadel, "Hairy Who's History of the Hairy Who," *Ganzfeld* 3 (2003): 123, 127.

4 Used to describe the traditional or indigenous arts of Africa, Oceania, and North America, the term "primitive art" is avoided in contemporary art historical discussions due to its colonial and racist implications.

5 Kachina dolls are Native American Indian carvings representing particular spirits.

6 Jean Dubuffet's 1951 "Anticultural Postitions" lecture at the Arts Club of Chicago was also very influential with Chicago artists and art historians. Dubuffet discussed topics related to *Art Brut*.

7 Kate Zeller, ed., *Ray Yoshida*, exh. cat. (Chicago: School of the Art Institute of Chicago, 2010), 48.

8 Ibid., 45.

9 Russell Bowman, "Chicago Imagism: The Movement and the Style," in *Who Chicago? An Exhibition of Contemporary Imagists*, exh. cat. (Sunderland, UK: Ceolfrith Gallery, Sunderland Arts Centre, 1980), 22.

10 Roger Brown, "Rantings and Recollections," in *Who Chicago? An Exhibition of Contemporary Imagists*, 30.

11 Nadel, "Hairy Who's History of the Hairy Who," 121.

12 This exhibition first was organized for the *XII Bienal de São Paulo* (1973), circulating throughout Mexico and South America the following year. Debuting in the United States at Smithsonian's National Collection of Fine Arts at the end of 1974, *Made in Chicago* then traveled to the Museum of Contemporary Art, Chicago.

13 Goldene Shaw, ed., *History of the Hyde Part Art Center: 1939–1976* (Chicago: Hyde Park Art Center, 1976), 13.

14 Author conversation with Ruth Horwich, January 29, 2011.

15 Author conversation with Bill McClain, November 2, 2010.

16 Author conversation with Jim Nutt and Gladys Nilsson, November 12, 2010.

17 Ed Paschke and Suellen Rocca joined the Phyllis Kind Gallery later.

18 Author conversation with Karen Lennox, November 12, 2010.

19 Franz Schulze, "Chicago Popcycle," *Art in America* 54, no. 6 (November 1966): 102–4. Franz Schulze later coined the phrase "Chicago Imagists" to refer to a broad, multigenerational group of artists. Much to Schulze's chagrin, this term has been used by many, including this author, to refer to a more specific grouping of artists who showed from 1966 to 1971 at the Hyde Park Art Center.

20 Alan Artner, "Art: An Imagist's Showing While the Battle Goes On," *Chicago Tribune*, March 24, 1974.

21 John Russell, "'The Hairy Who' and Other Messages from Chicago," *New York Times*, January 31, 1982.

22 *Jim Nutt: An Exhibition Organized by the Museum of Contemporary Art, Chicago* traveled from Chicago to the Walker Art Center and then to the Whitney Museum of American Art in 1974.

L.A. SNAP / CHICAGO CRACKLE / NEW YORK POP

RICHARD H. AXSOM

**Something astonishing in the way of art, music, or literature must one day
come out of the great wind-bruised city of Chicago.**

John Russell, New York Times *art critic*

Faint praise, indeed, for a city that boasts Saul Bellow, Harry Callahan, Robert Frost, Leon Golub, Ludwig Mies van der Rohe, Carl Sandburg, Studs Terkel, and Frank Lloyd Wright. This litany also could include the Chicago Imagists, who, in 1969, could look back over a remarkable three years of increasing recognition. They originally had begun showing in 1966 at the Hyde Park Art Center, situated on the campus of the University of Chicago. The core members, including Roger Brown, Sarah Canright, Ed Flood, Art Green, Philip Hanson, Gladys Nilsson, Jim Nutt, Ed Paschke, Christina Ramberg, Suellen Rocca, Barbara Rossi, and Karl Wirsum, variously had banded together to present their work in a series of exhibitions titled *Hairy Who, Nonplussed Some, False Image,* and *Marriage Chicago Style.*

Most of the artists were native to Chicago, in their later twenties, and students who either had or were to earn their BFAs and MFAs at the School of the Art Institute of Chicago (SAIC). They were drawn—like Pop artists in New York, Los Angeles, London, and Paris who were all a generation older—to the everyday urban world and popular culture. But Chicago Imagism, unlike Pop variants elsewhere, was an art of personal fantasy characterized by assertive line, offbeat color, and consummate craftsmanship. The Imagists trafficked in exuberant and irreverent satire that spoke to the social foibles, violence, and absurdities of contemporary life—with the tumultuous late 1960s as backdrop.

The Imagists had been showcased earlier in 1969 at the new Museum of Contemporary Art in Chicago and at the Corcoran Gallery of Art in Washington, D.C. Several from the group also appeared in *The Spirit of the Comics,* an exhibition with other artists organized by the Institute of Contemporary Art, University of Pennsylvania, and in another group show at the Whitney Museum of American Art in New York. At this point, recognition was coming more from out of town than from Chicago itself; not much of a critical art press existed in the city in 1969. Franz Schulze, an art reporter for *Panorama* magazine of the now-defunct *Chicago Daily News,* was an early supporter of what he saw as a second generation of "Imagists"—a name he originally conferred on all postwar Chicago artists with a surrealist and fantasy bent, but later co-opted to refer to the Hyde Park Art Center group.[1]

Despite their acknowledgment and a notable exhibition history during the late 1960s and the 1970s outside of Chicago, the Imagists most usually were sidelined as a local phenomenon and not brought into the mainstream of American art history. Was there no room for a vibrant new art indigenous to Chicago and indicative of broader currents in contemporary art? Why? These questions inform the intention here to situate Chicago Imagism in a larger story and claim for it a more critical position that lifts it out of any insular perspective that regards it only as regional. Chicago Im-

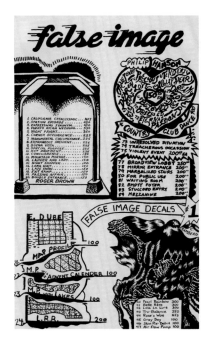

Roger Brown, Eleanor Dube, Philip Hanson, Christina Ramberg
False Image (price list), 1969
Offset lithograph on white wove paper
14 x 8 ½ inches
Gift of the Roger Brown Study
Collection of the School of the Art Institute of Chicago
Courtesy of Corbett vs. Dempsey Gallery

agism should be brought into the fold of Pop art. Pop art cannot be defined by the New York Pop model alone; Pop has many voices, which can be heard in New York, Los Angeles, Great Britain, Europe, and, as argued here, Chicago. The differences among all of these variants revolve around issues of style; however, their commonality is a shared embrace of mass media and a drive to mediate between high and low culture.

But any important recognition of a new kind of Pop art coming out of the Midwest in the late 1960s was overshadowed by a blockbuster exhibition that opened in mid-October at the Metropolitan Museum of Art: *New York Painting and Sculpture: 1940–1970*.[2] As one of four major exhibitions to fete the Met's centennial anniversary, it was organized by Henry Geldzahler, well-known art critic, art historian, and first curator of contemporary arts in a newly formed department. Celebrating a New York–centric triumph of American postwar painting and sculpture, it exalted the achievements of Abstract Expressionism, post-painterly abstraction, Pop art, and Minimalist sculpture. Great prominence was given to such luminaries as Franz Kline and Andy Warhol. Although the exhibition received good press in some quarters, conservative art critic Hilton Kramer at the *New York Times* was chagrined. In three reviews, he charged Geldzahler with personal choices that were "terribly overextended, ill-chosen, and modishly inspired."[3] "The exhibition was not an account of American art as a whole. It was bound to affect the way a great many people will think about the art of the period for many years."[4] And it did, confirming the hegemony of the New York School. The exhibition, despite its detractors, ratified a canon of postwar art that is still recited.

The 1960s, however, did produce—more so than any other decade in the twentieth century—the highest number of American artists who can claim historical significance. This congestion of brilliance included John Baldessari, Jasper Johns, Ellsworth Kelly, Roy Lichtenstein, Brice Marden, Claes Oldenburg, Robert Rauschenberg, Ed Ruscha, George Segal, Richard Serra, Robert Smithson, Frank Stella, and Warhol. Not that anyone got this wrong; it was simply that the complexion of contemporary American art was far more varied, if accomplishments west of the Hudson River were taken into account.

By the later 1960s, Chicago could lay claim to a postwar avant-garde of two generations that mirrored the scene in New York and Europe. The city's Monster Roster, a group of artists including Leon Golub, June Leaf, Nancy Spero, and H. C. Westermann, worked in a manner that linked them to a figurative expressionism prevalent in Europe (Karel Appel, Francis Bacon, Jean Dubuffet) and to Bay Area Figuration in Northern California (Elmer Bischoff, Richard Diebenkorn, David Park). Although there was no significant manifestation of a post-painterly or formalist abstraction during the sixties in Chicago, there was the appearance of the Imagists, whose paintings, sculptures, works on paper, and ephemera were allied in spirit to Pop art.

An infrastructure for the support of modern art also crystallized in Chicago during the postwar years. The Art Institute of Chicago increased its coverage of contemporary art, continuing to highlight all the achievements of important modernist artists such as Francis Bacon, Max Beckmann, Max Ernst, Jean Dubuffet, and René Magritte. The Arts Club of Chicago, under the enlightened direction of Rue Winter-

botham Shaw, presented, among others, Balthus and Rauschenberg in exhibition. New galleries devoted to modern art also were established, notably Allan Frumkin Gallery (1952), with its emphasis on Surrealism and German Expressionist prints; Richard L. Feigen & Co. (1957), also specializing in Surrealism and German Expressionism; Richard Gray Gallery (1963), featuring New York School painting and sculpture; and Phyllis Kind Gallery (1967), the earliest commercial champion of Chicago Imagism. These galleries fostered a local enthusiasm for modern and contemporary art, particularly a taste for fantasy art, which enlightened general audiences, collectors, and art students. In addition to the Art Institute, the Museum of Contemporary Art, Chicago (MCA), opened in 1967. It was among the first institutions in the United States devoted solely to contemporary art. One of the first two exhibitions at the MCA was *Claes Oldenburg: Projects for Monuments*, featuring the New York sculptor whose early drawings and soft sculpture paralleled the funky sensibility of the Imagists. Oldenburg's later Large Scale projects of the 1970s and on were more congruent with the bright colors and hard-edged forms of New York Pop. But as will be argued later, the Pre-Pop work of such artists as Claes Oldenburg and Jim Dine provided an important bridge to the Imagist work of the later 1960s.

At first blush, though, Imagism did not seem to accord with standard issue New York Pop despite a shared sensibility that drew all of these artists to popular culture. New York's critical reactions to Imagist work were infrequent, indifferent, or mixed. However, when John Canaday reviewed a smaller version of *Chicago Imagist Art*, organized in 1972 by the MCA, and presented at the New York Cultural Center on Columbus Circle, he was not uncharitable, mocking the supposed bruises to the sensitivities of his fellow Manhattanites by titling his piece "No Need to Man the Barricades."[5] Canaday prized the exhibition's raucousness (better seen in its fuller version in Chicago, as the critic had), and he knowingly perceived the crossbreeding of Pop art and Surrealism. Canaday's comment suggests an art critic who could think outside the island. He appreciated Chicago's attraction to the fantastic in art, exemplifying what Schulze described as a tradition of eccentric individualism, favoring the personal and the dream.[6] Canaday saw this as a "viable alternative position to that of single-axsied [sic] New York–West Coast." Ten years later, John Russell, however, still could not conceal his irritations. In his review of *From Chicago* at the Pace Gallery in New York, which presented the work of Hairy Who artists, he certainly had barricades in mind: "Wherever new art is coarse and tacky in substance, all-embracing in its range of demotic allusion and frankly hostile to accepted high art, there are likely to be affinities of one kind or another with the 'Hairy Who.'"[7]

Because of New York's clout, Pop art had been anointed by 1963 the gold standard of the new—more so than post-painterly abstraction, which quickly assumed its place in a tradition over a half century old. Like the power base historically known as the East Coast establishment (with its symbiotic intermingling of media, Wall Street finance, Ivy League schools, and legal and business structures), the New York art establishment was also a coterie of aligned interests—art criticism, art magazines, art galleries, auction houses, and museums that since World War II has formed a critical

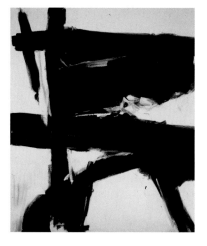

Franz Kline
Contrada, 1960
Oil on canvas
91 ¾ x 79 inches
Grant J. Pick Purchase Fund, The Art Institute of Chicago
© 2008 The Franz Kline Estate / Artists Rights Society (ARS), New York

Martial Raysse
Untitled from *Das Grosze Buch*, 1963, published 1964
Screenprint with feather additions, from an
illustrated book
16 ⅛ x 14 ⅜ inches
Publisher and printer: HofhausPresse, Dusseldorf
Edition: 100
Linda Barth Goldstein Fund, The Museum
of Modern Art, New York
© ARS, NY

mass hard to contest. In its complacency, ironic but not uncommon in cosmopolitan centers, New York proceeded as though nothing of real import could happen west of itself. In the 1960s, there was a specific constellation of older and new regulars that brilliantly promoted the New York brand of color abstraction and Pop art—heavyweights including the art magazines *Art in America*, *Arts Magazine*, *Artforum*, and *ARTnews* and their able editors and smart contributors, counting, among others, John Coplans and Clement Greenberg with his entourage of formalist critics Michael Fried and Rosalind Krauss from Harvard University. Before World War II, there were few galleries devoted to modern art; now there was a slew aggressively selling contemporary American art—Betty Parsons Gallery (1946), Sidney Janis Gallery (1948), Martha Jackson Gallery (1952), Stable Gallery (1953), Leo Castelli Gallery (1957), Green Gallery (1960), and Allan Stone Gallery (1960). Joining the Museum of Modern Art in showcasing new American art were the Whitney Museum of American Art (housed in a new landmark Marcel Breuer building that opened in 1966) and the Guggenheim Museum (with Frank Lloyd Wright as architect, opened in 1959). By the 1960s, Christie's and Sotheby's, long-established auction houses in New York, were directing their energies toward postwar American and European art, a new burgeoning market.

Even though New York Pop was swamping all competition, Pop art's elevation of popular culture had its beginnings in London in the mid-1950s in the hands of such artists as Richard Hamilton and Eduardo Paolozzi. A second wave appeared in the early 1960s, including David Hockney. All of the artists in question took a keen interest in the stuff of everyday commodities and commercial advertising. Despite the use of the term "Pop Art" at this time by the Independent Group in London, especially as linked to the milestone *This is Tomorrow* exhibition (1956) and its appearance in the writings of British art critic Lawrence Alloway, it was appropriated in the early 1960s by American writers to apply to developments in New York. Related developments abroad carried other names, for example Nouveau Réalisme (France), Polymaterialism (Italy), and El Equipo Crònica (Spain). Early names for a so-called Pop art in the United States were New Realism and Neo-Dada, its artists Factualists, Sign Painters, and New Vulgarians. In the New York art press during the early 1960s, Pop art as the official term established its permanence in the art history lexicon with "A Symposium on Pop Art" that was held at the Museum of Modern Art on December 13, 1962. Organized by Peter Selz, curator of painting and sculpture exhibitions, the panel consisted of invited participants from the New York art world.[8]

What sealed the deal for the primacy of Pop art in New York was an exhibition at the Sidney Janis Gallery in the fall of 1962 titled the *New Realists*, borrowing in name from the French Nouveau Réalistes. Epic in scope, it represented fifty-four artists, including Jim Dine, Robert Indiana, Roy Lichtenstein, Richard Lindner, Claes Oldenburg, George Segal, Wayne Thiebaud, Tom Wesselmann, Andy Warhol, and contingents from England, France, Italy, and Sweden. With its emphasis on American artists, the exhibition clearly meant to demonstrate who was leader of the pack.

New York Pop set the pace with its borrowings and stylistic transformations of motifs from popular culture—ordinary objects and signs of consumerism drawn

from newspaper illustrations, movies, television, advertising, comic strips, and tabloid magazines. With saturated color flats, simplified form, design techniques drawing on the commercial layouts of Madison Avenue, and working on a large scale, the New York Pop artists created secular icons for a consumer society. Here were ironic signs—both celebratory and critical—of an American identity to be reckoned with. Adlai Stevenson, the American Democratic Party's nomination for president in 1952 and 1956, lamented in 1960: "With the supermarket as our temple and the singing commercial as our litany, are we likely to fire the world with an irresistible vision of America's exalted purpose and inspiring way of life?"[9] For better or worse, the answer was an emphatic yes.

Was Pop only a New York phenomenon in the United States, the city our sole ambassador for an international Pop art? To answer this question, variables of subject matter, style, and place are at stake. There was, without doubt, activity in Los Angeles that suggested Pop was alive and well in the City of Angels. Cécile Whiting in her examination of artists and Pop art in Los Angeles during the 1960s argues for surprising and illuminating relationships. She sees the city providing artists linked to Pop art with subject and mood—in its landscape, freeways, motorcycle culture, suburban comforts, signage, and mass marketing of desire in the glamorization of objects and Hollywood movie stars. Everything, in the land of the unreal, held the promise of a close-up.[10]

Ahead of the national curve in presenting Pop artists, the Pasadena Art Museum opened the first Pop art museum exhibition in September 1962, predating the historic Sidney Janis Gallery's *New Realists* show by a month. Curated by Walter Hopps, *New Painting of Common Objects* included Dine, Lichtenstein, Ruscha, Thiebaud, and Warhol. Earlier in July, Irving Blum, director of the Ferus Gallery in Los Angeles, had given Warhol his first solo exhibition and first gallery show with the presentation of *32 Campbell's Soup Cans*. In the following year, although to the north in the Bay Area, the Oakland Museum presented *Pop Art USA*, curated by Los Angeles critic and art writer, John Coplans. Seeing the Pop impulse as more ecumenical, Coplans sought to reveal the nationwide character of Pop art by including artists from the East and West Coasts.

Ferus Gallery and Dwan Gallery were among a new set of art galleries in support of contemporary art that recently had begun to appear in Los Angeles. In addition to the opening in 1965 of the Los Angeles County Museum of Art, reincarnated in a new building and now devoted exclusively to fine art, a new arts infrastructure in Los Angeles could brandish, by the mid-1960s, a respectable roster of art critics—John Coplans, Philip Leider, and Peter Plagens, among others—and host the headquarters of *Artforum* before it gravitated its operations to New York in 1967. The city's new generation of artists linked to Pop art—and the implicit rejection of lingering Abstract Expressionist styles—included native sons (Billy Al Bengston, Ed Kienholz, Ed Ruscha, Kenneth Price, Mel Ramos, and Wayne Thiebaud, albeit the latter two with roots in Sacramento) and artists in short- and long-term residencies (Claes Oldenburg, 1963–64; David Hockney, 1963–2005). Additionally, artists who were primarily based in New York intermittently came and went, particularly those artists who made printed editions at the newly opened print publishing workshop Gemini G.E.L. By 1970, Lichtenstein, Oldenburg, Price, Rauschenberg, Ruscha, and Thiebaud had made their first editions

Andy Warhol
Campbell's Soup Can, 1964
Oil on canvas
36 x 24 inches
Gift of Robert H. Halff through the Modern and Contemporary Art Council, Los Angeles County Museum of Art
© Andy Warhol Estate/Artists Rights Society (ARS), New York
Campbell Trademarks used with permission of Campbell Soup Company

Edward Ruscha
Large Trademark with Eight Spotlights, 1962
Oil on canvas
66 ¾ × 133 ¼ inches
Purchase, with funds from the Mrs. Percy Uris
Purchase Fund, Whitney Museum of American Art,
New York
© Ed Ruscha

there; in the next decade, Hockney, Kienholz, and Rosenquist were added to the list. It was somewhat hard to know where New York left off and Los Angeles began.

Without wishing to establish an aesthetic category of L.A. Pop (witness the inverted title of her book), Whiting stresses the role of the city in the florescence of Pop art. She does not see a discernable style, although stylistic commonalities have been argued elsewhere.[11] A vernacular dialect, however, may suggest itself in the work of Hockney, Ruscha, and Thiebaud with more subdued palettes admissible of pastels and darker colors, a greater pictorialism, and a more suggestive, even cinematic narrative. There is more stylistic coherence than may first meet the eye. L.A. Pop is as real as New York Pop.

So Los Angeles, so Chicago? When Lucy R. Lippard wrote her classic *Pop Art* in 1966, an early and still insightful examination of the movement, she invited two writers to relate Pop art to developments outside New York, namely in Great Britain and California.[12] The Imagists just had begun to show their work at the Hyde Park Art Center, so there was no mention of activities in Chicago. Nancy Marmer, an arts editor in Los Angeles, wrote in her chapter "Pop Art in California" of a disparate range of expression in Los Angeles and Sacramento that paralleled varying aspects of New York Pop yet with its own distinctive, indigenous inflections in subject matter, style (less "brassiness"), and less interest in mechanical reproduction and the "found object."[13] Casting about unsuccessfully for specific influences on California Pop—local antecedents, a national reaction in the arts against the expressionist modes of the postwar period, or the example first and foremost of New York—she states:

> Whatever and whenever the ultimate sources, it is beyond question that
> in the work of such artists as Billy Al Bengston, Edward Ruscha, Joe Goode,
> Wayne Thiebaud, and Mel Ramos Pop Art did take root easily, early,
> and that it has flourished smartly, if diversely, in a milieu in which it could
> well have been invented.[14]

Marmer does see a California Pop, diverse in expression, different from New York Pop. But is there a commonality that ties Left Coast Pop to Right Coast Pop, one that might net a Midwest Pop in the Chicago Imagists? Marmer sees a "return to life" underscoring a general shift in the visual and literary arts beginning in the late 1950s and taking hold in the critical press by 1962. And yet, she is right to observe that this aesthetic is a native American mode that has run cyclically through our national art history: early nineteenth-century genre and Romantic landscape painting, Ashcan School,

the American Scene painters and Social Realists, and Pop art. A major shift in artistic sensibility did occur here and abroad in the late 1950s—in an embrace of the ordinary. But Marmer sees a fundamental common denominator that goes beyond a concentration on common objects to situate itself in a "sanction of advertising, illustration, and commercial art conventions as well as techniques for the presentation of these . . . in the context of 'high art.'"[15] To what extent do these currents pull in the Chicago Imagists? They had their major group shows at the Hyde Park Art Center when Pop art was fully established and already being challenged by new directions in the later 1960s—Minimalism, Process art, Earthworks, and Photorealism. Was Imagism poised more toward a pluralistic contemporary art scene of the 1970s, or can it be brought into the fold of American Pop to good effect?[16]

Like so-referenced Pop artists elsewhere in the United States and Europe, the Imagists held popular culture as the foundation of their art. They were not, however, drawn to consumer goods and mass marketing as much as life on the street, not life as witnessed from a speeding car on a Los Angeles freeway or from a yellow cab honking its way through Times Square. The Imagists were taken with the gritty, rough-and-tumble "Black City" descriptive of Chicago in the late nineteenth century that was contrasted to the "White City" of Daniel Burnham's Columbian World Exposition of 1893, with its culmination in the rational International Style architecture that Mies van der Rohe visited upon the city after World War II.

The Imagists' Chicago was dilapidated painted-brick and neon signage, old buildings, storefronts, neighborhoods, Maxwell Street Market, corner gas stations and grocers, the ethnic and racial mix of peoples relaxing and playing on the north and south beachfronts—haunts, in other words, off-limits to the genteel folk of the Gold Coast and Lincoln Park. Into this mix of inspiration drawn from popular culture, the Imagists also drew upon imagery from placards, posters, pinball machines, broad-

(from left)
Roy Lichtenstein
Blam, 1962
Oil on canvas
68 x 80 inches
Gift of Richard Brown Baker, B.A. 1935,
Yale University Art Gallery
© Estate of Roy Lichtenstein

Roy Lichtenstein
Drowning Girl, 1963
Oil and synthetic polymer paint on canvas
67 ⅝ x 66 ¾ inches
Philip Johnson Fund and gift of Mr. and Mrs.
Bagley Wright, The Museum of Modern Art,
New York
© Estate of Roy Lichtenstein

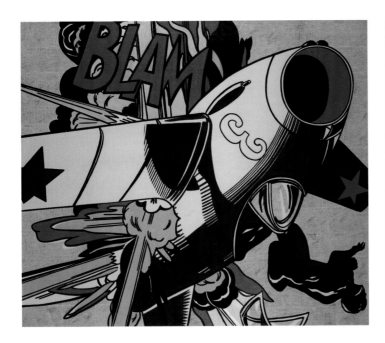

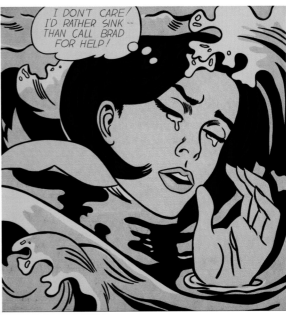

Richard H. Axsom

sides, vintage postcards of Chicago, decals, tattoos, and cast-off toys. These objects and visuals are not those of Madison Avenue; they are not slick objects of desire to seduce the pocketbook.[17]

Another source of imagery were the comics of an older stripe: Elzie Segar's *Popeye* (1929); Chester Gould's *Dick Tracy* (1931), originating in the *Chicago Tribune*; Marjorie Buell's *Little Lulu* (1935); and Max Gaines's EC Comics (1944). A comparison between Lichtenstein's approach to comic strips as an appropriated source and that of the Imagist Jim Nutt is telling. With few exceptions, the image is isolated as a single frame. But in *Drowning Girl* (1964) and *Blam* (1964), Lichtenstein quoted directly from a specific comic strip source, with speech balloons and text intact, if abbreviated. Although a single cell, a before-and-after narrative or story line still is suggested in both paintings. Lichtenstein simplified form to a high degree of abstraction, intensified color, emphasizing the primaries, and realized the image on a large scale. The Imagists, on the other hand, were attracted more to the visual character of the comics, not to an actual cartoon cell. Big, bold paintings with no evidence of hand drawing held no interest.

In Nutt's *Toot 'n Toe* (1969), for example, which is characteristic of the Imagists' non-nostalgic, often sexualized approach to comic book imagery, the male figure is aggressively caricatured and body parts vulgarized with oozing fluids [p. 55]. Avoiding speech balloons, Nutt incorporates conventionalized action lines to suggest his subject's ascension through turquoise ether, littered with fragments of ladies' shoes and female bodies drawn from girlie comic strips and advertisements. If Lichtenstein assigned titles to his comic strip paintings, he usually took the first sentence in the speech balloon. Imagist titles, like *Toot 'n Toe*, are plays on language that can add scabrous wit. Text does play an important role in the Imagists' cartooned images, but it can be freely inscribed throughout a composition, very seldom contained in speech balloons of varying kinds. If Lichtenstein's paintings clearly connect to older comic book style, the Imagists convey the look of underground comix, a tradition emerging in the 1960s. Yet, in speaking about the influence of R. Crumb, the founder of underground comix, Nutt states, "I wanted something that was more evocative and suggestive than literal. I wanted more use of formal elements (i.e., dot, line, plane, color, etc.) toward an expressive end rather than an emphasis on the descriptive and narrative."[18] With the exception of Lichtenstein's comic book paintings of aerial combat, one clear distinction between the New York Pop artist and the Imagists is the Chicagoans' insistence on dynamic forms in motion, in some instances nearly convulsive.

The Chicago Imagists took from their very specific urban environment a world of things to create a highly fantastical art—in distinction from the feel of L.A. and New York Pop. With none of the anonymous qualities that can describe more familiar aspects of Pop art, as epitomized in a Warhol Campbell's Soup can, Chicago Imagism takes pleasure in the autographic gesture of the artist's pen, pencil, or brush, and in private links between artists and subject. In speaking to the importance of certain images, drawn from popular culture, Suellen Rocca observes for herself and colleagues that "they were all part of our personal histories either in the past or present. I will say

that I wasn't in any way making a comment. Somebody could say, 'Well maybe she was commenting on the commercialism of our culture.' It wasn't that at all, it was more about personal history, and about how all of these things were a part of it" [p.52].[19]

With no interest in mechanical reproduction of media images to create dead-pan commentaries on American life, the Imagists, in idiosyncratic variations unique to each, created a rambunctious art of vibrant oddball color and free line, with links to surrealist automatic writing and its connotations of the unconscious, dream, and personal gesture. Although bold forms are simplified in contour, detail can run rampant. Nothing minimalist here—all is maximalist with a relentless horror vacui. Subjects can be centered and frontal, lending the image an iconic presence that enhances its direct, even confrontational impact as in Art Green's old building and ice cream paintings with their baroque embellishments [p.2].

Imagist palette held none of the seductive colors of commercial advertising associated with New York Pop, nor pastel summer colors identifying a be-palmed Hockney suburban lawn. Bright, yes, often flat, but Imagist color revels in nonspectral, achromatic, secondary colors, pastels as well as punchy color: blaze red, pumpkin orange, gold yellow, acidic yellow, pea green, khaki green, teal green, ice blue, indigo, pink, turquoise, the purples (magenta, fuchsia, lavender), and full use of the gray scale from white to gray to black. The range of color is idiosyncratic to each of the Imagists. Gladys Nilsson's pale blues, pinks, and lavenders in *Landed Bad-Girls with Horns* (1969) [p.64] play against Roger Brown's forceful blacks, yellows, and ice blues in *Sudden Avalanche* (1972) [p.70]. There can be an amusement park stridency, a psychedelic cast to color that sets Chicago apart from Los Angeles and New York—a younger palette for a younger generation.

Graphic strength is a hallmark of the Imagists. The fluid drawing of the Imagists, free yet deliberate, animates images with an energy and motion that evades L.A. and New York Pop. It primarily is enlisted for caricatures of the human figure, with attendant satirical overtones, although it can become nearly abstract in a painting such as Barbara Rossi's *Eye Deal* (1974) [p.74]. Chicago Imagism, however, is essentially figurative, its male and female types presented in portraiture, alone, or in exchange—in suggestive and enigmatic narratives. Figures are caught in calamities, brawls, circus antics, scatological awkwardness, mysterious places, and gendered confrontations. Danger can lurk around the corner. Men and women alike are subjected to bodily deformations, transformed into grotesqueries, and must often fend for themselves, which they do with great brio. Sometimes the figure is absent a scene, yet the Imagist argument is still in place. Philip Hanson's *Mezzanine* (1969) takes us into a theater lobby recalling in its vacancy of objects and people an open piazza by the Italian Surrealist Giorgio de Chirico. Who knows if the stairs will take you to some darkened place above where you will sit, perhaps not alone, bathed in the sound and flickering light from the movie below [p.58].

Despite hints of threats and collapse in Imagist works, humor—nearly vaude-villian—leavens most dramas. The Imagists, like Lichtenstein, Oldenburg, and Ruscha, incorporated the printed word directly into their works of art, also concocting titles

whose groaning puns and silly double entendres identify their paintings, drawings, prints, and sculptures as quickly as any other element. This is art that in many cases guffaws with fits of laughter—much as the Imagists themselves did when gathering in meetings.[20]

One of the most trenchant ironies of Imagism is that the near chaos, irreverence, over-the-top antics, and sometimes gross impoliteness always is given form with the greatest craftsmanship. Imagist works of art have no intention of aping the machine-made, hands-off appearance of Pop art in New York or Los Angeles. Imagists worked in a broad range of media: painting, sculpture, and works on paper, including drawing, collage, etching, lithography, screenprinting, woodcut, Xerox, watercolor, and ephemera (posters, announcements, decals, and comic book catalogues). The artists took an experimental approach to media. The use of unorthodox materials and formats—acrylic on Plexiglas and Masonite, handcrafted frames that extended the painted image, enameled found objects, paper mâché, painted-wood constructions, quilted-fabric sculpture—landed them on the far side of the more conventional choices of Pop artists elsewhere. What truly separated them from the pack was their dedication to the handcrafted object. The Imagists produced works of art that always and ostensibly are handmade—adding a signature dimension of the personal.

Like Pop in all it guises, Chicago Imagism is a mediation between high and low culture. In commenting on the Imagists as a group, Art Green observed, "I think we share an interest in looking at various levels of artifice in both high art and in the lower depths of popular culture."[21] Their well of sources and influences was deep. The permanent collection, exhibition program, and faculty of the School of the Art Institute of Chicago played a significant role. Of all their instructors, Ray Yoshida factors in most importantly for his art and teachings, especially his love of collectibles and junk

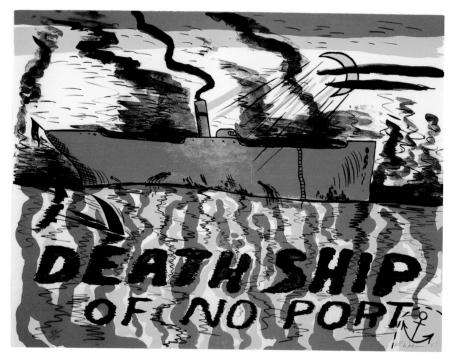

in the shops of Maxwell Street and his incorporation of actual comic strip fragments into his collages. Instructors in art history also directed the students to the Field Museum to study its celebrated collections of East Asian, ancient Egyptian, West African, Oceanic, and Native American art. As BFA and MFA students at SAIC, the young Imagists had a rich exposure to an encyclopedic range of art in the Art Institute, with their interests fixing on artists in the expressionist tradition from the Northern Renaissance to the twentieth century and, especially, on the rich trove of surrealist material that came into the permanent collection in the postwar years. With commercial deal-

ers such as Allan Frumkin and Richard Feigen fostering and catering to local collectors' taste for Surrealism and German Expressionism, the young Imagists could satisfy their interest in the fantastical and psychological. For more contemporary work, the Imagists earlier in the 1960s could see in the art galleries, the Arts Club of Chicago, and in exhibitions at the Art Institute works by Robert Rauschenberg, H. C. Westermann, the Swedish Pop artist Öyvind Fahlström, and Peter Saul. Westermann was of particular importance for Nutt and Wirsum in his cartoonlike drawing, violent and sexualized subjects, and his use of language as epitomized by the lithograph *Death Ship of No Port (Red Death Ship)*, (1967).

If Chicago Imagism finds common ground with L.A. and New York Pop in popular culture, it also has ties in style and expressive content to what is called Pre-Pop and Hand-Painted Pop that preceded a full-blown Pop art by 1962.[22] In this formative period, artists with interests in the commonplace realized their subject matter with spontaneous gesture linked to postwar expressionist styles, both abstract and figurative. This identifies the early work of Johns and Rauschenberg and describes the Mickey Mouse drawings of Lichtenstein and the idiosyncratic drawings of Oldenburg and Dine, all of which were executed in 1958, as well as the "rough" drawings and paintings of David Hockney from the early 1960s. This type of drawing also characterizes the early achievements of Red Grooms, whose works on paper—here the offset lithograph *City of Chicago* (1968)—and later installations have affinities in style and spirit to the Imagists.

The style of this body of work is more raw than the fluid, continuous line of the Imagists, which in contrast could be described perversely as elegant. Yet the personalizing of the everyday conjoins them. Both Grooms and Oldenburg had ties to Chicago. Grooms had studied briefly at SAIC in the early 1950s and Oldenburg was a bona fide native son.[23] Although sharpening his taste for urban culture as a cub reporter for the City News Bureau, Oldenburg decided to become a professional artist through intensive self-education and intermittent enrollment at SAIC. Leaving for New York in 1956, he nonetheless took with him a sense of the city that always has permeated his more freely rendered drawings. His early drawings,

Richard H. Axsom

including the works on paper shown at the Judson Gallery in 1959 and 1960, show a roughness of imagery and a nervous line that alludes to street writing and graffiti. For his first major installation, *The Store* (1961), he displayed and sold sculptures of dry goods and foods made of chicken wire and muslin constructions covered with plaster and painted with loosely brushed applications of enamel. As a part of his self-promotion he created a letterpress poster and a lithographic *Store Poster*, several impressions of which he hand colored with watercolors. In this small-editioned fine art "poster," with its rambling and ballooned comic strip letters, the Imagists could find sympathetic company. Oldenburg, as well as Hockney, denied early on that he was a Pop artist. In

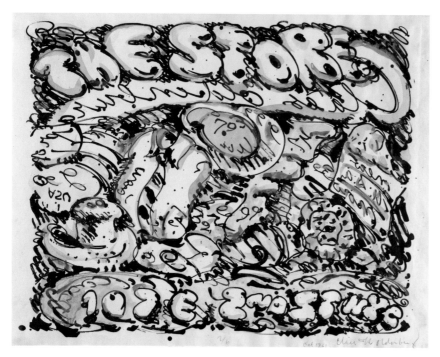

Claes Oldenburg
Store Poster, 1961
Lithograph with watercolor additions
20 x 25 15/16 inches
Publisher: Claes Oldenburg, New York. Printer: the artists at Pratt Graphics Center, New York. Edition: 6. The Associates Fund, The Museum of Modern Art, New York
© 2011 Claes Oldenburg

identifying his art as "objective expressionism," he disassociated himself from his New York Pop colleagues. He sees his drawings and sculptures as too personal to fit a New York definition, an attitude toward the world of ordinary things that allies him with the Imagists. Oldenburg's early Pre-Pop works on paper, happenings, installations, and the painted cloth soft sculptures take relish in the gritty, messy life of the street. This sensibility was shaped in Chicago for further elaboration in New York. Oldenburg is an informative "missing link" between Chicago Imagism and New York Pop.

Chicago Imagism assumes a place in the history of Pop art, although historically it has been left out of any pertinent discussion. It may have been too after the fact. A New York notion of Pop, measured against Lichtenstein, Rosenquist, and Warhol may also help explain why. But there is no single Pop style to be discerned when canvassing developments in New York, Los Angeles, or abroad. Critical language, with few exceptions, has reified a tendency that should admit more variation.[24] And the exchanges between the various centers complicate matters more. The common denominator of Pop art, however, is mass media culture. But like a faceted crystal ball, Pop art catches different lights. If Chicago Imagism can be usefully integrated into the fold of Pop art, it nonetheless holds special distinction in being Janus-faced. It looks back to that which paved its way; it looks forward to what follows in style and attitude. Its legacy, if measured in precedents, is the formulation during the later 1970s of Pattern and Decoration and New Image art (personalized subjects in open-ended, ambiguous narratives); Lowbrow art, also known as Pop Surrealism, in Los Angeles at the same time; and Graffiti art and the East Village scene of the early 1980s in New York.

A toast, then, to Chicago Imagism and to an American Pop with showrooms on the East Coast, West Coast, and Third Coast.

[1] See Franz Schulze, *Fantastic Images: Chicago Art Since 1945* (Chicago: Follett Publishing Co., 1972) and *Chicago Imagist Art*, exh. cat. (Chicago: Museum of Contemporary Art, 1972). In the latter exhibition catalogue, the term Chicago Imagism is used for the first time in an institutional setting. Schulze, however, still adheres to his broader understanding of a tradition that includes both the Monster Roster and the Hyde Park Art Center groups. Schulze's endorsements later waned. *See Who Chicago? An Exhibition of Contemporary Imagists*, exh. cat. (Sunderland, England: Ceolfrith Gallery, Sunderland Arts Centre, 1980).

[2] The exhibition opened on October 18, 1969, and closed on February 1, 1970. See Henry Geldzahler et al., *New York Painting and Sculpture: 1940–1970*, exh. cat. (New York: E. P. Dutton & Co., Inc., 1969).

[3] Hilton Kramer, "Ascendancy of American Art," *New York Times*, October 18, 1969.

[4] Kramer, "A Modish Revision of History," *New York Times*, October 19, 1969.

[5] John Canaday, "No Need to Man the Barricades," *New York Times*, July 23, 1972.

[6] Schulze, *Fantastic Images*, 5–39.

[7] John Russell, "'The Hairy Who' and Other Messages from Chicago," *New York Times*, January 31, 1982.

[8] Participants included Henry Geldzahler, assistant curator of American Painting and Sculpture at the Metropolitan Museum of Art; Stanley Kunitz, critic and editor; Hilton Kramer, art critic of the *Nation*; Leo Steinberg, associate professor of art history at Hunter College; and Dore Ashton, critic and author. *Arts Magazine* published the papers of the panelists, April 1963, 36–45.

[9] Adlai Stevenson (1900–1965), U.S. Democratic politician, *Wall Street Journal*, June 1, 1960.

[10] Cécile Whiting, *Pop L.A.: Art and the City in the 1960s* (Berkeley and Los Angeles: University of California Press, 2006).

[11] In 1989, the Newport Harbor Art Museum presented *L.A. Pop in the Sixties* with an accompanying catalog. Artists included Baldessari, Bengston, Wallace Berman, Vija Celmins, Robert Dowd, Llyn Foulkes, Joe Goode, Phillip Hefferton, and Ed Ruscha.

[12] Lucy R. Lippard, *Pop Art* (New York: Frederick A. Praeger, Inc., 1966).

[13] Nancy Marmer, "Pop Art in California," in *Pop Art*, ed. Lucy R. Lippard (New York: Frederick A. Praeger, Inc., 1966), 139–61.

[14] Ibid., 139–40.

[15] Ibid., 148.

[16] Shortly after the Imagists first began showing their work, Schulze compared artists of the Hairy Who with Pop art, but found no common link. They were "more idiosyncratic, alienated, and low down." *Art International*, May 1967.

[17] This inventory of sources and influences is taken from Russell Bowman, "Chicago Imagism: The Movement and the Style," in *Who Chicago? An Exhibition of Contemporary Imagists*, 21–28. Also see Jim Nutt's and Karl Wirsum's list of sources in high art and popular culture that interested and influenced the Imagists, with Nutt's correction of earlier texts that inaccurately posited the impact of outsider art on the group. For this, see Dan Nadel, "Hairy Who's History of the Hairy Who," *Ganzfeld 3* (2003): 110–46.

[18] Nadel, "Hairy Who's History of the Hairy Who," 120.

[19] Ibid., 38.

[20] Ibid., 128. Gladys Nilsson gives an account of the "laugh fests" that group meetings often became, noting the hilarity of Art Green reading the phone book.

[21] Ibid., 137.

[22] *Hand-Painted Pop: American Art in Transition, 1955–62* (Los Angeles and New York: Museum of Contemporary Art and Rizzoli International Publications, 1992).

[23] Born in Sweden, Oldenburg moved to Chicago in 1936, where his father began a long tenure as Swedish consul general. Attending Yale University, he returned to Chicago in 1950 to pursue a career in journalism

[24] Very few texts have speculated on a larger understanding of American Pop. In 1987, Sidra Stich curated an exhibition for the University Art Museum at the University of California at Berkeley entitled *Made in U.S.A.: An Americanization in Modern Art, '50s & '60s*. In the accompanying catalogue, Stich wrote, "This study shows the beginnings and expansions of the attention to American mass culture in postwar art. It moves well beyond the usual Pop art focus and concentration on the early sixties and on New York to include art of the fifties and late sixties and to recognize the equally significant contributions of California and Chicago artists who were simultaneously creating art derived from and related to American mass culture. *Made in U.S.A.: An Americanization in Modern Art, '50s & '60s* (Berkeley: University of California Press, 1987), 4.

CHICAGO IMAGISTS

THE PLATES

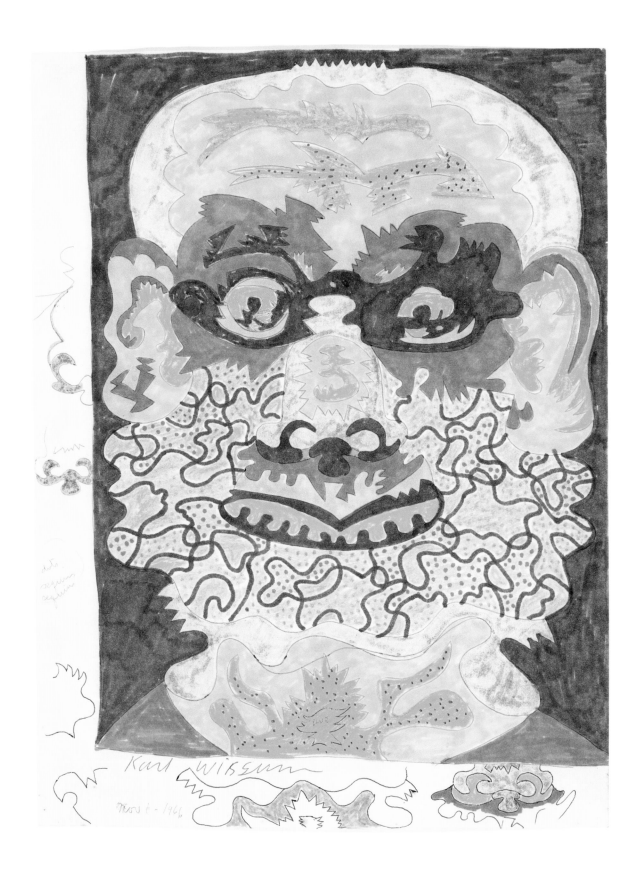

KARL WIRSUM *Untitled (Head of Bearded Man)* 1966

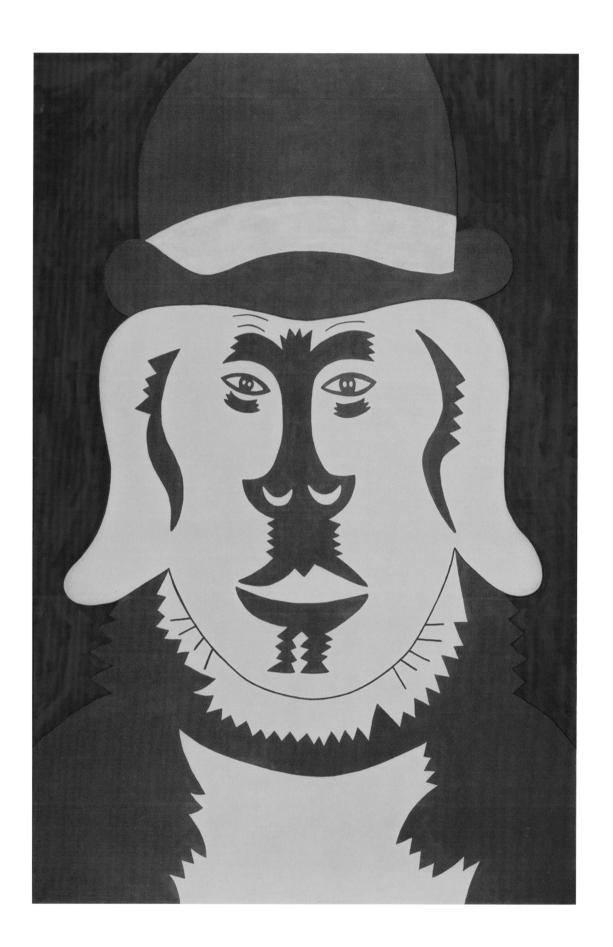

KARL WIRSUM *Moon Dog First Quarter* ca. 1966–67

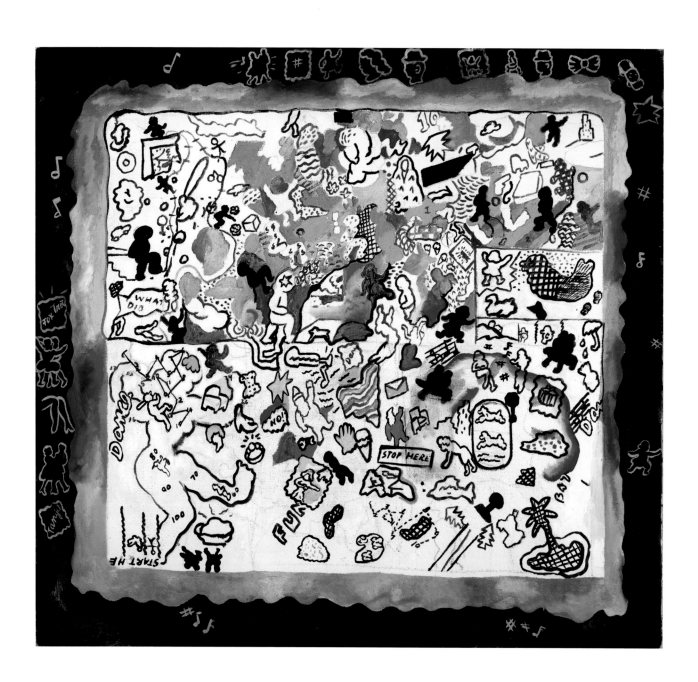

SUELLEN ROCCA *Game* 1966–67

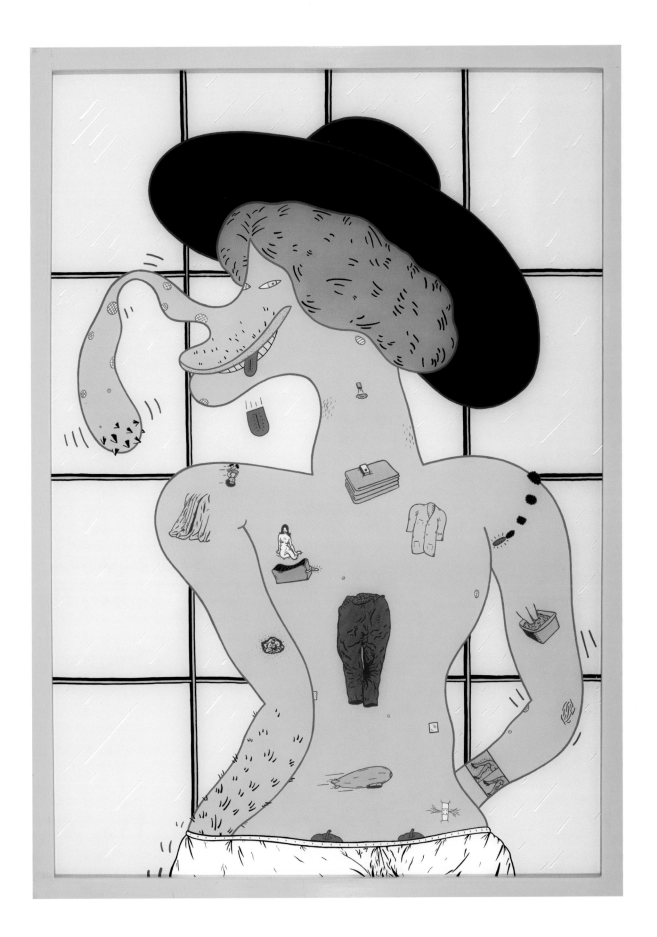

JIM NUTT *Rosie Comon* 1967–68

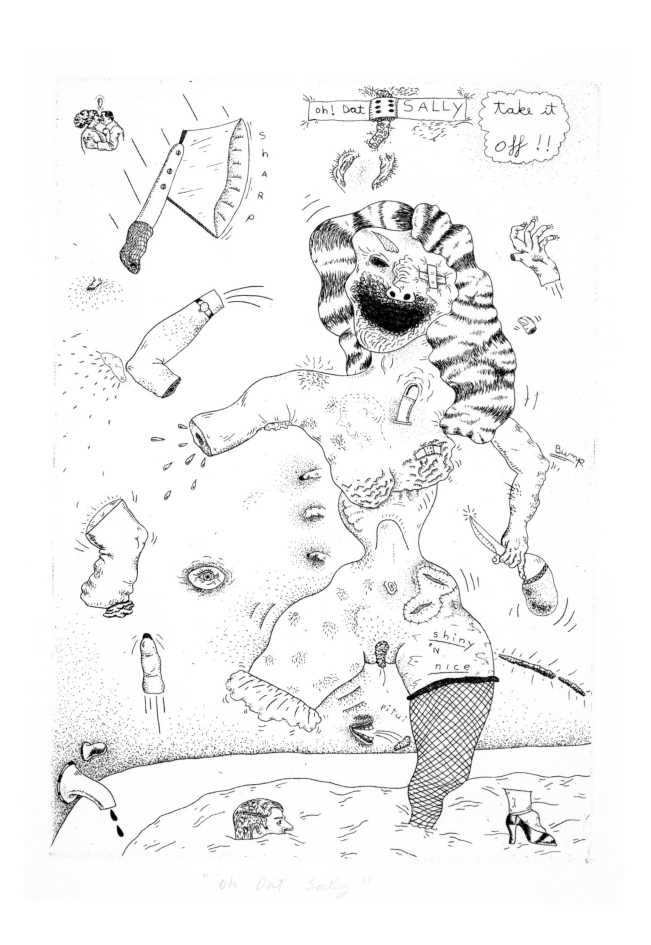

JIM NUTT *Oh Dat Sally* 1967–68

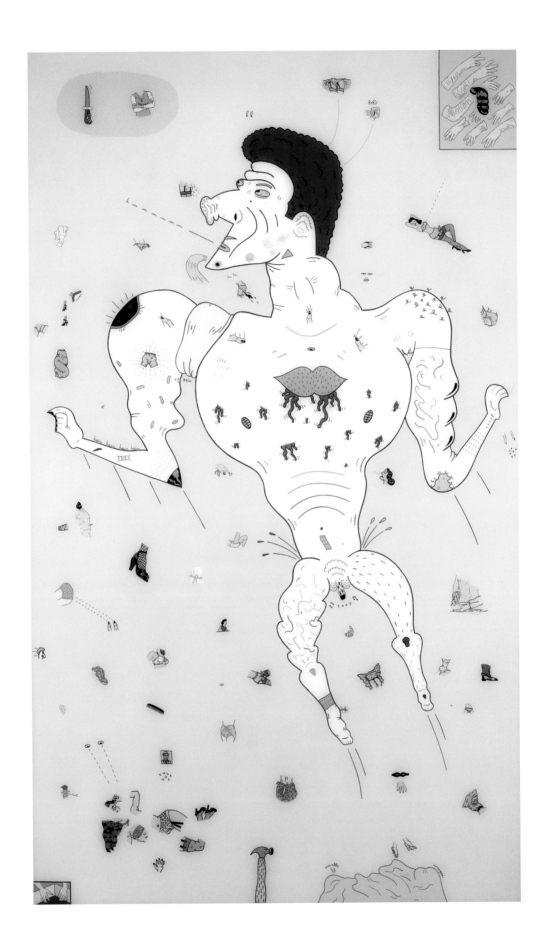

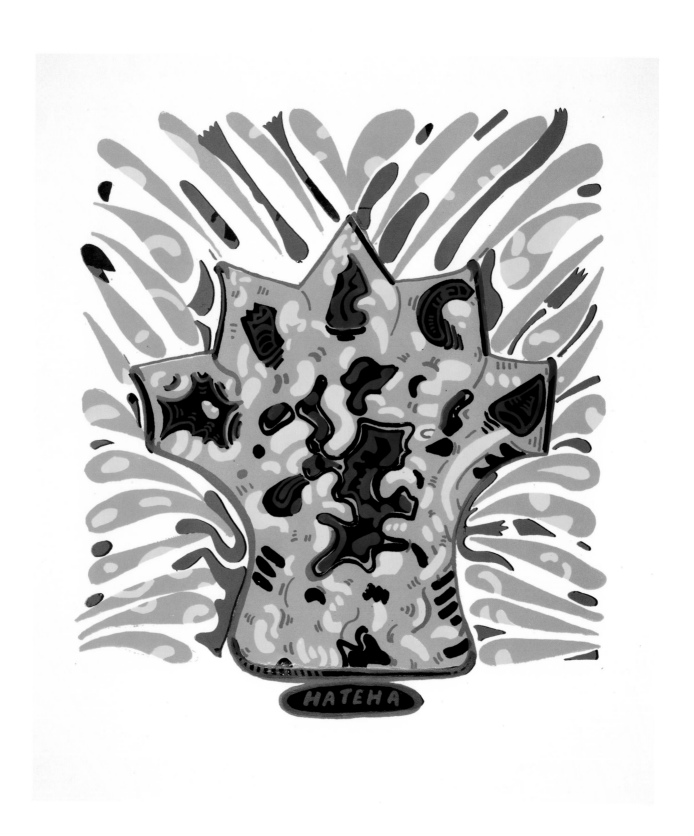

FALCONER *Hateha* 1967–68

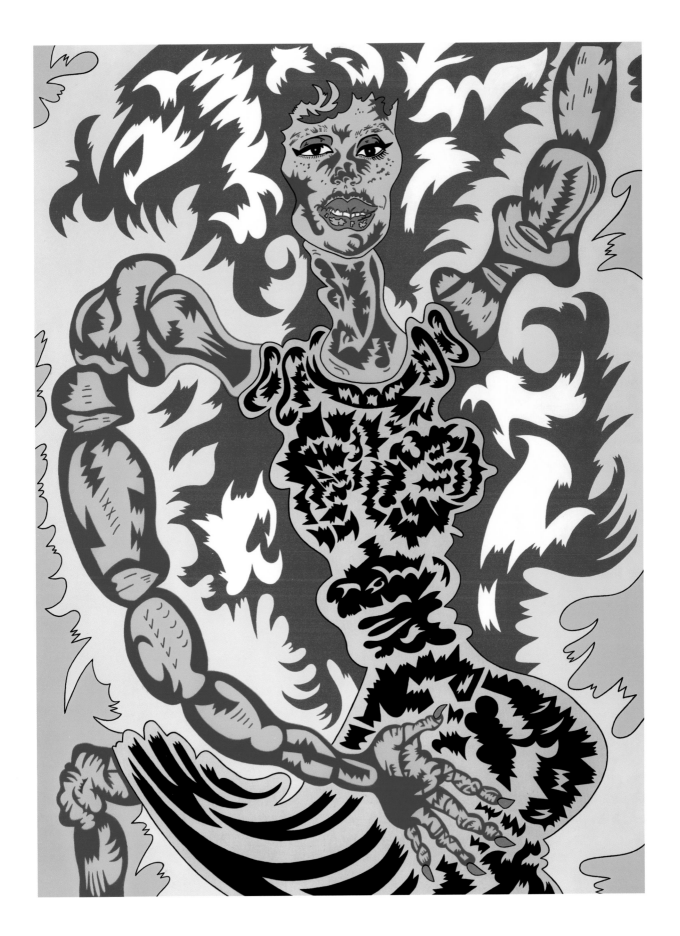

KARL WIRSUM *Fire Lady or Monk's Key Broad* 1969

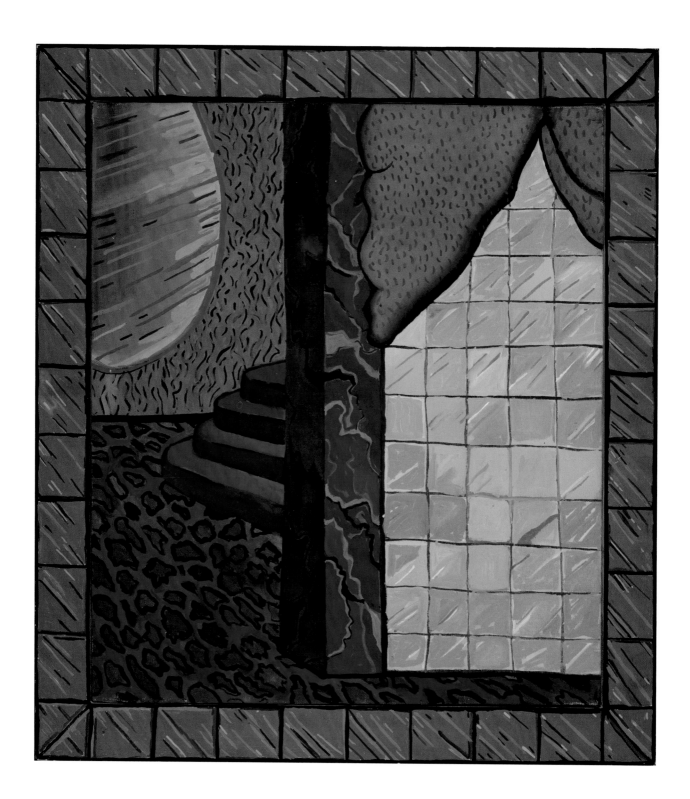

PHILIP HANSON *Mezzanine* 1969

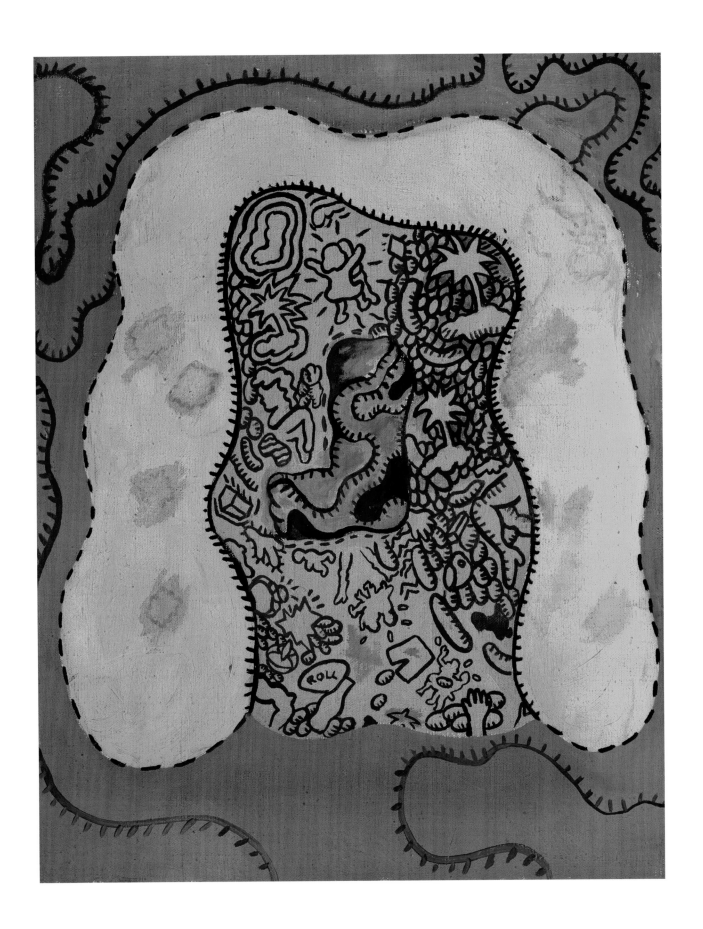

SUELLEN ROCCA *Foot Smells* ca. 1966

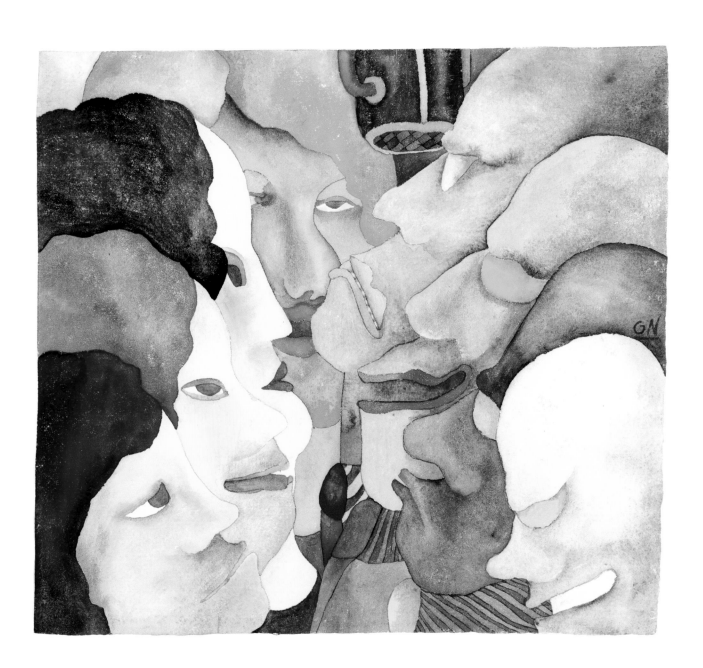

GLADYS NILSSON *Quartets Recording* 1965

SARAH CANRIGHT *Shadow* 1969

SUELLEN ROCCA *Night Light for Little Girl* 1969

C Ramberg

CHRISTINA RAMBERG *Head* 1969–70

GLADYS NILSSON *Landed Bad-Girls with Horns* 1969

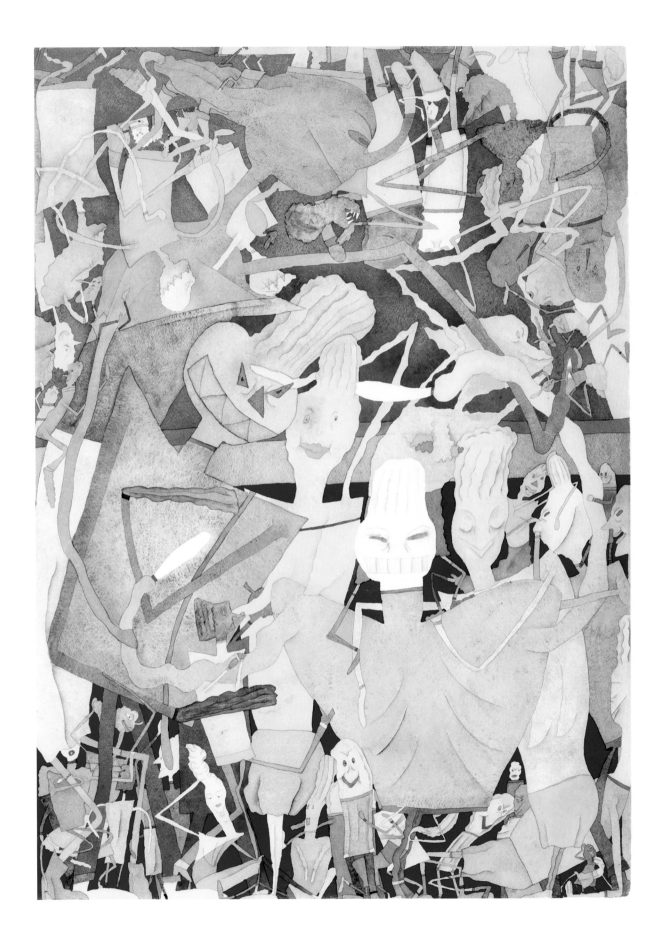

GLADYS NILSSON *Veggie Great* 1970

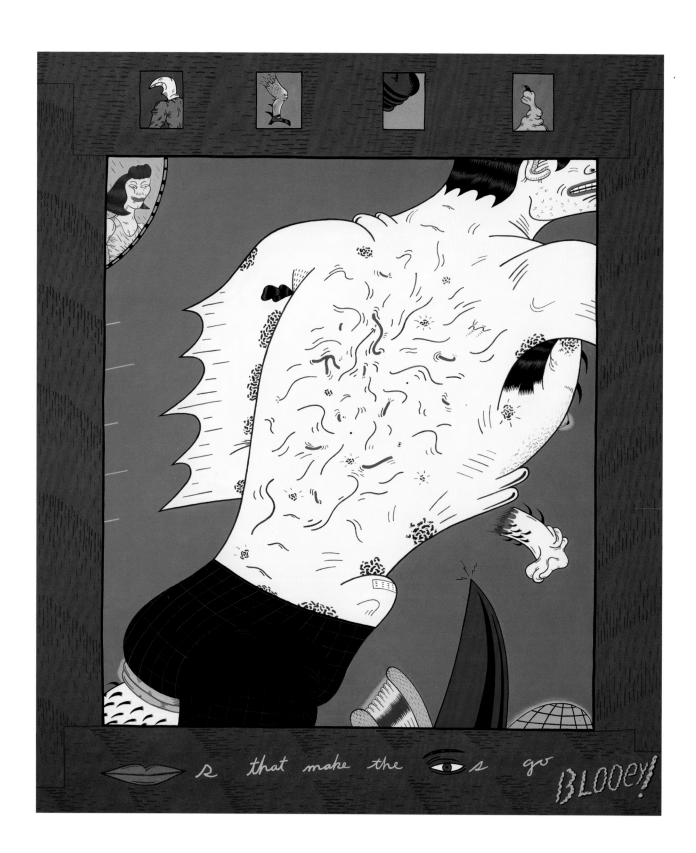

JIM NUTT Zzzit 1970

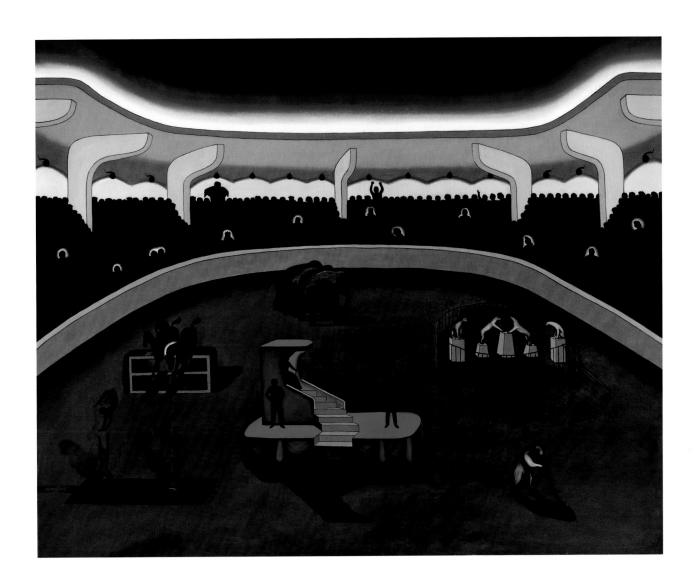

ROGER BROWN *Untitled (Circus)* ca. 1970–71

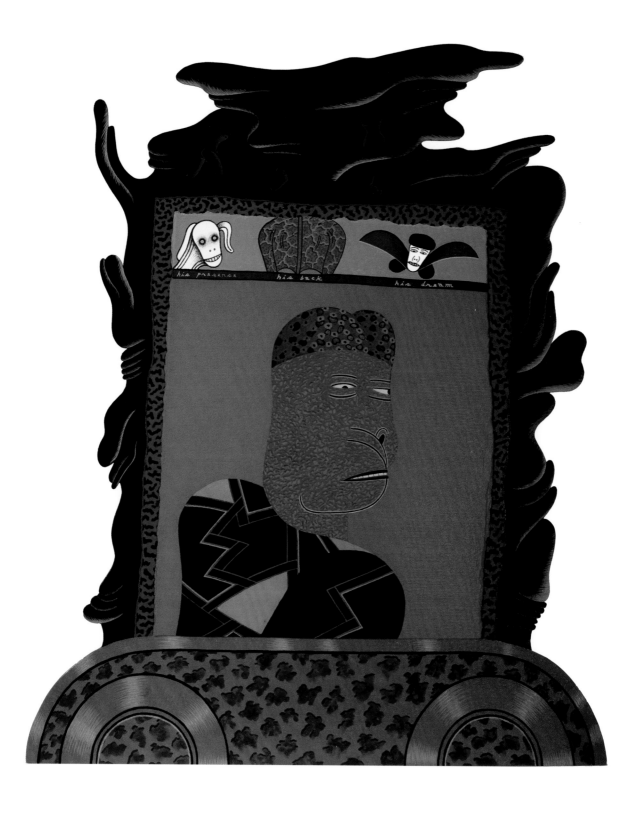

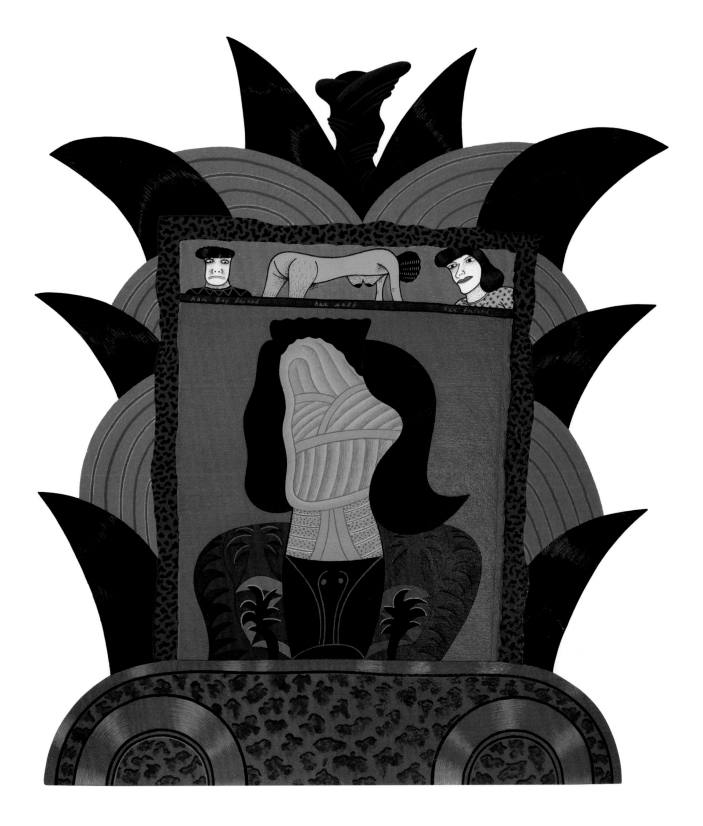

JIM NUTT *He Might Be a Dipdick But They Are a Pair* 1972

ROGER BROWN *Sudden Avalanche* 1972

KARL WIRSUM *Mity Mite Quilted Twin* 1972

ROGER BROWN *Mountain Sites* 1973

ED FLOOD *Aluminum Floater #2* 1974

BARBARA ROSSI *Eye Deal* 1974

CHRISTINA RAMBERG *Tight Hipped* 1974

ROGER BROWN Untitled (Bus) 1975

JIM NUTT *Don't Make a Scene* 1975

CHRISTINA RAMBERG *Untitled* ca. 1975

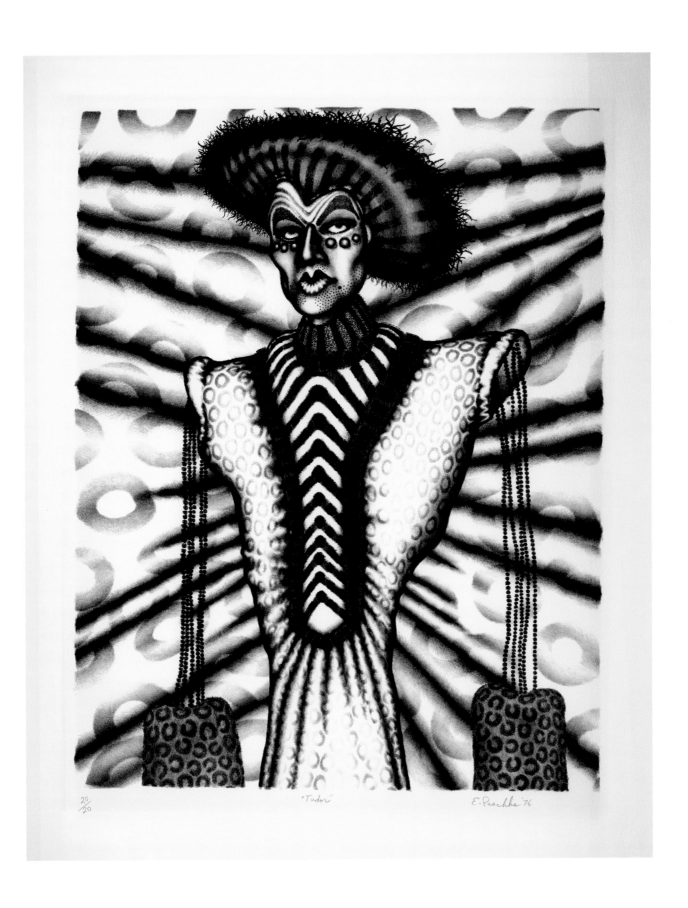

"Tudor"

20/20

E. Paschke '76

ED PASCHKE Tudor 1976

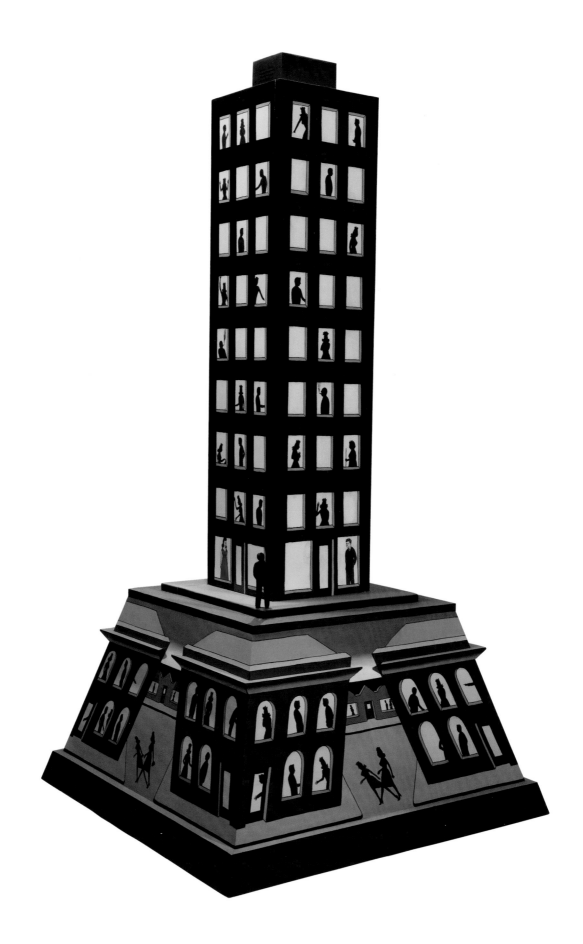

ROGER BROWN *Skyscraper with Pyramid* 1977

ART GREEN *Dead Reckoning* 1980

PHILIP HANSON *Untitled (Woman Disrobing)* 1979

CHRISTINA RAMBERG *Vertical Amnesia* 1980

CHRISTINA RAMBERG *Untitled #13* 1981

ROGER BROWN *Giotto in Chicago* 1981

ALAS, THEY WERE ALL TOO LATE.
THE NEW ART HAD SPEAD LIKE
WILD FIRE. THE TALL GAUNT MONK
THREW UP HIS HANDS IN TOTAL CONFUSION
CONSTANTLY OFFERING CONTRADICTORY
ADVICE, WHILE THE LUTE PLAYER WENT
RIGHT ON PRAISING THE ABSTRACT
CONCEPTUAL STYLE. BEING TOTALLY
NON-VISUAL HE NEVER EVEN NOTICED
THE BYZANTINES WERE ALTERING
THEIR STYLE.

ED PASCHKE *Pachuco* 1982

ED PASCHKE *Prothesian* 1982

CHRISTINA RAMBERG *Untitled #15* 1982

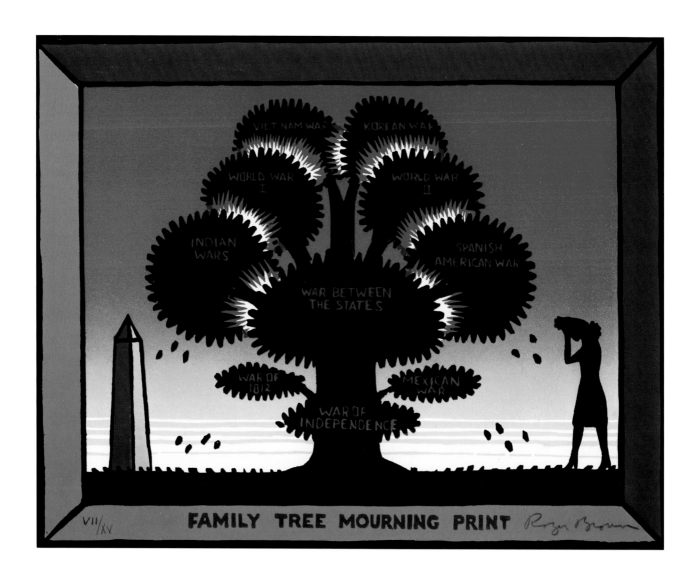

ROGER BROWN *Family Tree Mourning Print* 1983

ROGER BROWN *Welcome to Siberia, the Nuclear Freeze, the Flat Earth Society, No Nukes, and the Dark Ages*
(When the Earth was Flat and the Evening Sun was Red from Looking Down into Hell) 1983

GLADYS NILSSON *Problematical Tripdickery* 1984

KARL WIRSUM *Stork Reality* 1985

JIM NUTT *Wee Jim's Black Eye* 1986

JIM NUTT *Cheek* 1990–91

GLADYS NILSSON Ern 1999

JIM NUTT *Untitled* 2002

THE BRASH, THE SEXY, AND THE POLITICAL

CHICAGO AND THE IMAGISTS

JANE SIMON

One of the central questions confronting art historians is: Is art tied to the social, political, and cultural contexts in which it is made? Does art reflect changes that are already in the air? In the 1970s, art historian T. J. Clark posed this question when analyzing the nineteenth-century paintings of Gustav Courbet. During the fight for civil rights for workers in France, Courbet depicted the plight of such workers with visual clues revealing the endless cycle of repression confronting the proletariat. Clark felt it was his focus as an art historian to point to these important undercurrents in the paintings.

One can ask the same question regarding the group of Chicago painters termed the Chicago Imagists. Loosely organized during the late 1960s and early 1970s, these artists studied at the School of the Art Institute of Chicago and the University of Chicago. They visited the collections of the Art Institute of Chicago and the Field Museum. And, thanks to the insightful eye of curator and artist Don Baum, they showed their work together in a series of exhibitions at the Hyde Park Art Center from 1966 to 1970. Before, during, and after those years, Chicago was the site of a number of important counterculture events and transformations. Populated by three and half million people at that time, Chicago was the second-largest city in the country.[1] Its ethnic neighborhoods—Polish, German, and African American—stretched north, south, and west over relatively flat terrain. Like other American cities, Chicago had its share of problems. Fair housing and wealth discrepancies, racial tension and social unrest plagued the city during the 1960s and 1970s. For example, after the first victories of the civil rights movement in the South, Martin Luther King Jr.'s first focus in the North was Chicago. The Windy City was also the site of a race riot in 1965 as well as one of the most discussed and dramatic demonstrations of the time—the 1968 yippie demonstration against the Democratic National Convention. This essay seeks to unearth how some of these events and broad transformations are reflected in the artwork of the Chicago Imagists. Colorful, brash, dynamic, explicit, seedy, and even troubling at times, the work of these artists sheds light on Chicago during this period of cultural and political revolution. As visual texts, the work of Karl Wirsum, Jim Nutt, Gladys Nilsson, Ed Paschke, Art Green, Philip Hanson, Christina Ramberg, and Roger Brown (just a selection of the Imagists) examines changes in perception toward race, sexuality, and politics. These works of art have come to presage many of the developments we associate with the transformative period of the late 1960s.

At the time, none of the Chicago Imagists saw their work as revolutionary or even radical. Plagued by "second city" sentiments, Chicago created its own artistic movements, but that does not mean these artists saw their work that way. Although they knew they were working in a different mode than some artists in New York, they did not see their work as a cohesive part of the counterculture. Now almost fifty years after the first *Hairy Who* exhibition at the Hyde Park Art Center, we can look with fresh and critical eyes on this group of influential artists.

The 1960s are synonymous with transformation, in part because the beginning of that decade was consumed by protests for civil rights for African Americans. Although Chicago was not responsible for Jim Crow segregation, it was the site of

Walter Bennett
Anti War Demonstrators on the Floor of the Democratic National Convention, 1968
Time & Life Pictures/Getty Images

rampant racial inequality that affected housing, employment, and civic justice. Chicago was also the first Northern city King chose as a focus for his nonviolent activism, and when he arrived in 1966, he was met with violent opposition, at one point taking a stone to the head.[2] Earlier, in 1965, Chicago had been the site of a race riot.[3] By the end of the decade, Chicago police would brutally murder African American activist and National Black Panther Party figure Fred Hampton while he was sleeping in his bed.[4] Against this backdrop of racial tension and even close proximity, painter Karl Wirsum was born and raised on the South Side. According to the artist, he grew up in a white neighborhood, but would often traverse fiercely segregated neighborhoods to buy

Karl Wirsum
Screamin' Jay Hawkins, 1968
Acrylic on canvas
48 x 36 inches
Mr. and Mrs. Frank G. Logan Purchase Prize Fund
The Art Institute of Chicago

records.[5] During this time, Wirsum was interested in the jazz music of the age and bought the records of Thelonious Monk and Jalacy Hawkins, known as Screamin' Jay Hawkins. Both of these legendary music figures emerge in Wirsum's art. One painting, now in the collection of the Art Institute of Chicago, features a comic-like figure with outstretched arms and legs. The figure wears yellow and green wing tips. His orange and red legs are covered with green hair sprouts. His arms and shoulders are divided into two sections, while his midsection shows a spinal column flanked by yellow veinlike shapes. The detailing around each form was inspired by mola blouses created by Native Americans. Wirsum examined examples of such garments at the natural history museum during a trip to Amsterdam in 1968.[6] At the top of the painting, the artist has created red and yellow letters spelling out "Screamin J Hawkins." The small red figure with a white face at the bottom placed between the legs of the figure stands in for the audience.[7] Green, red, yellow dominate the palette of the work. Hawkins was a legendary rhythm and blues singer best known for his hit single, "I Put a Spell on You." But his original live recording of the song was banned by radio stations because his grunting and guttural sounds were deemed too sexual for the time. Alternatively, the emotional and realistic qualities of the song made it a legend for generations to come.

Later in his career, Hawkins was known for the theatricality of his performances, in which he would arrive onstage in a coffin and often use various props such as capes and canes.[8] Wirsum undoubtedly was influenced by the rebellious nature of the Hawkins recording, the theatricality of the performer, and the particular intersection of cultures that he experienced in Chicago. The palette of the work—sporting the Pan-African colors of green, red, and yellow—underscores Wirsum's gesture of outreach.[9]

For a later painting, entitled *Fire Lady or Monk's Key Broad* (1969), now in the collection of the Madison Museum of Contemporary Art, Wirsum was influenced by a *Time* magazine feature on Thelonious Monk published in February 1964 [p. 57].[10] Jazz music at that time had reached the mainstream, but its irregular forms and innovations were still news to reporters and readers. Years later, the image of the genius Monk, sitting down with his loyal wife, Nellie, next to him would inspire Wirsum. Monk was

the epitome of the artist—wonderful and charming, but completely consumed by his work. Nellie, whom he married in 1947, stood by his side. She supported him financially before his career took off, and later she traveled with him to make sure he was dressed and cared for. The details of this biography are hinted at in the picture, but not outlined. Nellie appears proud and calm, wearing a white sweater and a skirt. Her smile is broad and warm. Alternatively, Wirsum's painting shows a completely different identity. Wirsum's interpretation of Monk's emotional rock, stated as "key broad" or "fire lady"[11] in the title, is a woman with yellow and green muscled arms. Her flowing hair is red, punctuated with highlights of white. Her clawlike nails are painted fire-engine red. She juts out her hips; her breasts protrude from her body; one nipple is shown in profile. Around the figure is a subtle but cartoonlike closed pink form. To Wirsum, Monk's foundation is a sexy, fire-laced woman with wild hair and gyrating dance moves. Indeed, what is most interesting about the juxtaposition of both the photograph and the painting is the extent to which Wirsum added his own flair to Nellie's stable identity. Read in the context of the 1960s, Wirsum is visualizing and painting the freedom of the sexual revolution with the music of his time. He mixes racial and social references with music, dance, sexuality, and representation. Despite the divisions in Chicago at that time, Wirsum was able to able to draw and comment freely on his cultural surroundings in his art.

Another work by Hairy Who colleague Gladys Nilsson further underscores the changing face of race relations. Completed in the 1960s, Nilsson's watercolor entitled *Quartets Recording* shows profiles of eight different individuals [p.60]. Typical for Nilsson, all of the faces are quirky but meticulous renderings full of energy and character. But more interesting is how each of their skin tones is a different color. For example, one male figure on the right side wears eyeglasses, but his skin is a light blue color. A woman, shown in the foreground, has brownish skin and red hair, while another has white skin and yellow hair. Taken as a whole, their skin tones are a spectrum of hues. Although Nilsson denies any connection between her work and politics, this early piece seems to foreshadow discussions of diversity and reflect the transformation from race relations taking on just a white vs. black binary.[12] By titling the piece with a verb relating to music, joined with a name for an ensemble of musicians, Nilsson, like Wirsum, also chose the purview of music to think about race and individuals.

Sexuality, within the context of marriage, voyeurism, homosexuality, and transexuality permeate much of the work of the Imagists. Jim Nutt is perhaps the most famous of all the Imagists. Born in 1938 in Massachusetts, Nutt was not a Chicago native, but he ended his undergraduate career at the Art Institute, where he met his future wife, Gladys Nilsson. Although technically not a member of the hippie generation, Nutt's work reveals a striking relationship to sexuality and the body.[13] Chafing against the stubborn attitudes of the day, Nutt's work revels in depictions of the body and its messy functions. He shows the charade of seduction, especially its naughty side. For example,

Jim Nutt
Broad Jumper, 1969
Reverse acrylic on Plexiglas
28 x 26 inches
Russell Bowman Art Advisory, Chicago

Ed Paschke
Hophead, 1970
Oil on canvas in artist's original painted frame
44 ⅞ x 60 inches
The David and Alfred Smart Museum of Art,
The University of Chicago
Gift of Dennis Adrian in honor of Kimerly
Rorschach
Estate of Ed Paschke

Nutt's *Toot 'n Toe* (1969) depicts a very muscular man with black hair [p.55]. His proportions are exaggerated—with enormous shoulders and scrawny thighs. His diseased penis is exposed, and his hands and feet seem like hooves. His nose is a snout. Above his right shoulder is an image of a lounging pinup girl, and above his left shoulder is a cluster of feces. The word "toot" embedded in the title refers to flatulence, but coupled with "toe" it refers to toeing the line. In this case "toeing" functions as a metaphor for wooing. The racy with the bodily is further explored in a work called *Zzzit* (1970), completed just one year later [p.66]. This picture within a picture shows the hairy back of another caricature of a man. Each strand of hair protrudes like a worm from his yellow backside, while his armpit hair is dense and multicolored. Blemishes, like pimples or tumors, puncture his side and waist. In the upper left corner of the work is a cutout image of a woman with brown hair. Nutt combines the playful nature of cartoons with the secretionary and the scatological.

Two years later, Nutt created a two-part construction showing a man and a woman with blue faces [p.68–9]. The woman's face is a pattern of lines, perhaps influenced by the work of Imagist Christina Ramberg or Art Institute of Chicago professor Ray Yoshida. Each object is again a picture within a picture, and the upper edges reveal a very interesting subtext. On the right is a skull-like image next to the image of a woman bent over—her bulbous rear the focus. On the right, two small portraits flank a picture of a woman bent over on her hands and knees. Her body is covered in detailed images of hair, and careful attention has been paid to her buttocks and vaginal area. The title of the work uncovers some of the latent drama, *He Might Be a Dipdick But They Are a Pair*, explaining that the two engage in sexual play, but they act like a normative heterosexual couple. Although Nutt carefully does not reveal his intentions in displaying such sexual imagery, according to Imagist Philip Hanson this was just one way to deal with urges and emotions that were still not easily discussed.[14] A painting on Plexiglas (something Nutt forged during the late 1960s that would be adopted by other Imagists), called *Broad Jumper* (1969) shows a muscular woman, scantily dressed, sucking on a free-floating penis. Fellatio in Illinois was legal, but illegal in the rest of the country. Indeed, it was racy and risky for Nutt to have dared to paint such an image.[15] Finally, Nutt even provides insight into a game of seduction and romance within his own marriage. In a drawing from 1975 titled *Don't Make a Scene*, Nutt shows both himself and Nilsson [p.77]. Each seems crazed and angry, but sexualized and focused on the other. With both anonymous characters and self-portraits, Nutt revels in the

excitement of sexual play within the confines of heterosexual marriage.

People argue whether there really ever was a sexual revolution in the 1960s or if the culture had just begun to talk more openly about sex and fringe culture than before. Much of the work of the Chicago Imagists speaks to and visualizes aspects or characters of those fringe cultures. The paintings of Chicago painter Ed Paschke relished fringe culture and eccentric figures. Paschke's paintings, such as *Ramrod* (1969) and *Hophead* (1970) showcase his interest in mixing several aspects of American culture into colorful Pop paintings. Paschke's *Ramrod* shows a muscular man wearing purple stockings and a garter belt. Where his masculine genitalia would be, there are female genitalia. His hair is slicked back, and his smiling face is flanked by two images of Mighty Mouse. The character's face is covered in a makeshift mask; he wears a cape, and the word used for the title of this painting, "ramrod," is spelled out on either side of the figure in vertical letters. Paschke was born and raised in Chicago to a Polish-American family. In an effort to entertain his children, Paschke's father would often make art with them on the kitchen table.[16] Incorporation of popular culture was often a part of this exercise, and after attending the Art Institute of Chicago and serving in the army, Paschke developed his own artistic style. Contemporary artist Jeff Koons has said this about his former mentor: "[Ed's] paintings are like drugs, but in a good way: they are among the strongest physical images that I've ever seen. They affect you neurologically."[17] Paschke's painting was shocking for several reasons. The mixture of male and female attributes meant that Paschke was challenging traditional gender divisions. His addition of lighthearted cartoon imagery with sexual depiction further pushed the taboo nature of the image—wherein children's imagery was not supposed to be sullied by sexual innuendo. The painting's title, reiterated within the picture plane, also suggests an overt, aggressive sexuality. In an interview with Dennis Adrian, one of the greatest proponents of the Chicago Imagists, Paschke explained his interest this way:

Ed Paschke
Ramrod, 1969
Oil on canvas
44 x 26 inches
Estate of Ed Paschke

> **EP:** The very early work was about a kind of confrontational dissonance, a societal dissonance. I think there was an involvement with certain aspects of gender . . . a playing around with gender identification.
> **DA:** The period you're talking about would be 1968 to 1972?
> **EP:** Yes, works such as *Ramrod* and *Hophead*. The earlier work was sometimes described as being concerned with the underbelly of American society. Then there was the shoe period, the woman series, and the man series . . . I felt I was penetrating the surface, the societal facade, the gamesmanship and the role playing, to get into that subterranean part of the mind that deals with the inner versus the outer self.[18]

According to friends and colleagues of Paschke, he would gain inspiration from visiting bars amid the vibrant nightlife of Chicago. Although happily married to Nancy Cohn Paschke, the artists spent many nights grooving off of the club scene of Chicago. Most certainly what Paschke saw and experienced made it into his paintings.

One also cannot discuss the 1960s without discussing feminism. Because of the fight for equal rights and reproductive rights, there is a strong correlation between the sexual revolution and the women's movement. Consequently, within the work of the women Imagists there are complex treatments of the female body and societal expectations.[19] Christina Ramberg's meticulous and dense compositions relay an interpretation of subjugation and repression that is typical of this discussion. But on closer inspection, one can see a conflicting and revelatory tale of alternative sex practices and both emancipation and constriction. Ramberg's *Tight Hipped* (1974) shows the chiseled features of the male and female body [p.75]. Lines across the abdomen suggest a washboard stomach, and thin hips and muscular thighs suggest the body of a man. At the same time, the straight arms and cupped pubic area suggest the body of a woman that is complicated by the protruding penis-like blue form emanating from the genitalia. Mixing male and female clues, stereotypes, and expectations, Ramberg was interested in conflating stereotypes of men and women. The work *Waiting Lady* (1972) shows just the torso and legs of a woman wearing black lingerie. Because we cannot see her head, she remains general and anonymous to us. Her hair falls down to the ground and her stomach bulges slightly, demonstrating that this pose is neither comfortable nor flattering. The pattern of her underwear is repeated where her armpit hair would be. Like her peer Ed Paschke, Ramberg was not afraid to probe the alternative and the troubling. But her paintings are never just positive or negative. They walk a fine line between seductive and appalling. To my contemporary eyes, Ramberg reminds us that the world is far more complicated than just male and female, alluring and repulsive.

A return to the earth and a DIY aesthetic developed within the rebellion of the 1960s. Although the Imagists, for the most part, were known for meticulous surfaces and a refined technique, their work does demonstrate a sense of ingenuity. For example, Philip Hanson created *Mezzanine* (1969) [p.58]. The domestic scale painting includes a frame made by the artist, painted in a regulated but discreet blue pattern. At the center of the image is a theater curtain partially exposing a pink tile surface. In the background are steps and an image of the moon. Although the moon plays a significant role in the culture of the 1960s—because of Neil Armstrong's trip to the moon—in Hanson's art it takes a backseat to the stage and other details. According to Hanson, he focused on the theater because the world seemed like a stage at that time.[20] With the drama of the demonstrations against the Democratic National Convention and then the ensuing trial of some of the organizers, many in Chicago thought of their city and

Christina Ramberg
Waiting Lady, 1972
Acrylic on Masonite
22 ¾ x 32 ¼ inches
Courtesy of the Renaissance Society

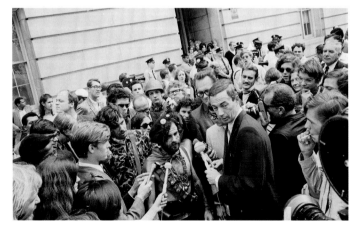

Hulton Archive
Protestors Interviewed Outside 1968 Democratic National Convention, 1968
Getty Images

these times as the arena of a changing order.[21] That drama, for example, began when Abbie Hoffman and Jerry Rubin approached the city for permits for a large-scale "love-in." Denied legal permission, Hoffman and Rubin led what came to be one of the largest protests of the 1960s, bringing scores of people to downtown Chicago to protest America's involvement in the Vietnam War as well as the general culture of the establishment. Moreover, among the many texts Ramberg and Hanson read and adopted during this time, Hanson was reading the *Whole Earth Catalog*. Published in 1968 by Stewart Brand, this journal espoused the political meaning of local eating, sustainable architecture, and the genius of Buckminster Fuller. Hanson's readiness to incorporate structure and meaning into his paintings show this influence.

At the same time, Hanson was eager to address the nature of homemade-ness with the resistance of traditional culture. *Country Club Dance* (1969), another painting from the late 1960s, shows the artist's interest in natural forms with a humorous and troubling depiction of traditional dancing culture. From the title, we can infer the site of Hanson's imagined drama, but the interaction of the female dancers in the painting reveals a dark interpretation of ballroom dancing. For one, the background of the painting is a monolithic black. Each of the dancers wears a typical 1950s-style dress with a structured top and a billowing bottom. The dancer at the center covers her face with a fan, and the others sway to the music with masculine outlines made from brushstrokes of faint white paint. Rather than showing romance or nostalgia, Hanson's interpretation of the previous generation is filled with terror, angst, and shame—all emotions that would have circulated in a late 1960s, counterculture setting.[22]

Another member of the Hairy Who decided to structure his paintings around the theme of the theater. Painter Art Green was born and raised in Indiana, but after studying at the Art Institute of Chicago and being included in exhibitions at the Hyde Park Art Center, he became a member of this loose-knit group. *Regulatory Body* (1969), one of Green's early paintings, shows a brown proscenium pulled back to show a theater stage featuring a giant-sized ice-cream cone interrupted by a mechanized contraption. Blue pershings line the bottom of the painting next to a crate of blueberries, and a melting candy occupies the upper center. By his own account, Green was interested in the ice-cream cone as an icon because it was not only prevalent but it was also symbolic of America.[23] In an interview in 2005 for an exhibition of his work that year, Green said this about the importance of the ice-cream cone as a symbol: "I bought an ice-cream cone one day and noticed that the actual cone couldn't hold a candle to the iconic and idealized image that advertised its ready availability."[24] Advertising, pulp fiction, and the visual world around us influenced Green and crept into his paintings. What's more, his attention, as well as Hanson's, to create stages and theaters within a painting is also a reference to the drama of the protests of that time [p.2].

Years after making *Corps*, Green turned to one of the dominant and mainstream magazines from the day. In 1963,

Philip Hanson
Country Club Dance, 1969
Oil on canvas
29 x 29 inches
Gift of the Raymond K. Yoshida Living Trust
and Kohler Foundation, Inc.
Courtesy of Corbett vs. Dempsey Gallery

Leonard McCombe
Robert S. McNamara, 1962
Time & Life Pictures/Getty Images

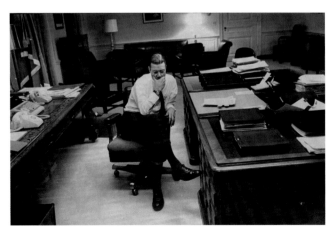

Art Green
Consider the Options, Examine the Facts,
Apply the Logic, 1966
Oil on canvas
89 ¼ x 68 inches
The David and Alfred Smart Museum of Art, The
University of Chicago; Purchase,
Anonymous Gift

Art Green
The Design and the Dilemma, 1966
Lithograph on newsprint in *The Portable Hairy Who!*
(comic book)
11 x 7 inches
The Bill McClain Collection of Chicago
Imagism, Madison Museum of Contemporary Art

Time magazine featured an article about Robert McNamara. Known for his success in the private sector, specifically with the American icon Ford Motor Company, McNamara became the mind behind the Vietnam War for President Lyndon B. Johnson. As the war raged on and Americans became increasingly disenchanted with Americans fighting a war against Communists abroad, McNamara became an unpopular and controversial figure. The spread from *Time* magazine, taken by noted photographer Leonard McCombe, shows a carefully dressed McNamara behind his desk.[25] Pristinely groomed, his tie perfectly knotted, with his shoes polished, McNamara, even in this informal picture, can be the synecdoche for the establishment—for government, order, and deadly decisions. Green made a series of paintings showing this figure, his crossed legs, and his seeming insistence on a semblance of control. In the painting *Consider the Options, Examine the Facts, Apply the Logic* (1966), Green shows McNamara in his office. Two red columns flank the central figure, but cartoonlike fire burns from the top of one of the columns. McNamara's feet rest on a dais, but the supports for the platform look like they are exploding with red and yellow polymorphous shapes. Above his head, there is a thought bubble with "no" spelled out. Years later, and even before he left office, it was clear to some that McNamara did not support the war in the same way that Johnson and others did. In fact, McNamara came to denounce the Vietnam War and war in general in such films as the Errol Morris documentary about McNamara called *The Fog of War: Eleven Lessons from the Life of Robert S. McNamara*. According to Green, he was well aware that McNamara felt conflicted about the war, but to paint him was to deal with both the establishment and doubt at the same time. It was to address the complexities of the world and to address the dissemination of information from the top to the bottom. Green, a quiet and thoughtful man, would never declare his politics overtly, but what we are left with is a humorous rendition of the good, the formal, the bad, the personal, and the political.

Finally, Roger Brown was one of the most prolific and political of the Chicago Imagists. Through his sexuality and his complex treatment of news and media, current events and real estate issues, he made luminous, meticulous creations with cutting-edge statements. According to curator Lisa Stone, Brown culled his inspiration from the world around him:

> Brown became known for responding adroitly to the fabric of twentieth-century life, through works that addressed a range of subjects and issues, including: natural, architectural, urban, and suburban landscapes, the dichotomy of nature and culture, disasters of all types, current and political events, social, religious, and popular culture, autobiographical, personal, and sexual issues, the art world in many guises, cosmology, mortality, history, mythology, transformation, transportation, and the weather.[26]

Brown was born in the South to a very religious and conservative family. He moved to Chicago in the 1960s to attend the Art Institute of Chicago. He met a man, George

Veronda, an architect, who would become his life-long partner, as well as, at times, his muse.

Despite the rage over the war against the Vietnamese Communists, many Americans were known for exploring and advocating for left-leaning groups. One of the groups to emerge during this time with leftist leanings was the Peoples Temple Agricultural Project, led by Jim Jones. Espousing some of the same self-sufficiency ideas as those expressed in the *Whole Earth Catalog*, Jones preached a version of Marxism in an attempt to form a coherent cooperative of individuals and children in a remote village of Guyana. Despite Jones's intentions or the beliefs of his followers, the group was more like a cult in which Jones controlled all of the assets and abused illegal drugs.[27] Eventually, the group took part in a mass suicide that included Jones himself, men, women, and children. Constantly culling information from magazines, newspapers, and the world around him, Brown turned this strange

Roger Brown
Jonestown, 1980
Oil on canvas
72 x 72 inches
Estate of Roger Brown

Roger Brown
Prick and Dribble, 1985
Oil on canvas
24 x 16 inches
Estate of Roger Brown

tragedy into a painting in 1980. The image is divided into two sections. The foreground shows a hilly landscape with tree-covered berms and three modest shelters without walls. Shadowlike figures dot the scenery, as well as a group of men and women waving their hands. A three-part mushroom cloud of white and gray dominates the background. Deceptively beautiful, Brown's painting reveals the harrowing structured life of the cult, as well as their drive to live off the land. The toxic demise of the group, completed by the cyanide Jones had purchased ostensibly to clean gold, is represented by controlled gray tones of the background.

Brown was not all gloom and doom with his paintings. Another work from the 1980s looks back on the 1960s—its icons and landscape at sunset. In Brown's picture of the 1960s, a man sits in his red Volkswagen Beetle. His hair is long and wavy. Against the figurative backdrop painted in warm hues of gray, Brown has painted several growing hemp plants. The suggestion in the painting is this: In the dark of night, with the freedom of transportation, one can experience the fun and insight of hallucinatory drugs. Furthermore, looking back on the 1960s, both the artist and the viewer can recognize the icons of that era: drugs, cars, and overt rebellion.

Having been raised in a religious household in Alabama, Brown was deeply influenced by both religion and Americana. He acquired a tremendous collection of ephemera, furniture, and art by well-known artists and outsider artists. Gifted to the School of the Art Institute of Chicago when he died in 1997, these items as well as two of his houses function as a study collection for students and the house museum of Brown and his work. Despite his affinity for religious sects and even American culture, Brown also explored sexuality in his paintings. One painting from 1985, for example,

shows the head of a penis while it ejaculates. In more general terms, Brown saw sexuality as enticing, dangerous, exciting, and part of everyday life. He often painted urban dwellings, skyscrapers with open windows so viewers could see the drama inside city apartments. Architecture was obviously an interest for Brown.[28] One such painting, *Sudden Avalanche* (1972) shows measured gray buildings with couples fighting, making love, and existing in their abodes. The scene takes place at night, and the sky is black with fading yellow light dividing the foreground from the background. In addition to the drama in the apartments, snow cascades from the sky, enveloping individuals left and right. Heads pop out of the snow, but so do legs and arms. Green curtains are pulled back to show the snow creeping into ground-floor spaces. Brown was a master at creating beautiful, intricately painted compositions with dark, apocalyptic scenes. Although he clearly loved the city and chose to live in it, he saw its dangers and potential for disaster.

During the 1960s, curator and artist Don Baum brought together a group of young American artists. He showed their work in a series of group shows at the Hyde Park Art Center, where the young artists would eventually come to be known as the Hairy Who, the False Image, and the Nonplussed Some, and as a larger group the Chicago Imagists. Lauded by some critics, included in exhibitions in New York, Europe, and Canada, their work is filled with exciting depictions of men, women, body parts, feces, clothing, stages, words, and other details. When looking at specific paintings by Karl Wirsum, Jim Nutt, and Christina Ramberg, among others, one can see reflections of what we associate with the 1960s—renderings of race relations, the sexual revolution, and complicated political transformations.

Roger Brown
The Turbulent Sixties, 1983
Oil on canvas
60 x 96 inches
Estate of Roger Brown

1 *www.en.wikipedia.org/wiki/Largest_cities_in_the_United_States_by_population_by_decade.*

2 Frank James, "During his stay in the city, the civil-rights leader faced a 'hateful' crowd," *Chicago Tribune*, August 5, 1966.

3 William L. O'Neill, *Coming Apart—An Informal History of America in the 1960s* (Chicago: Quadrangle Books, 1971),170.

4 Tom Wicker, "In the Nation: Songmy and the Black Panthers," *New York Times*, December 16, 1969.

5 Author conversation with Karl Wirsum, February 2, 2011. For more about Chicago neighborhoods, see Isabel Wilkerson, *The Warmth of Other Suns: The Epic Story of American's Great Migration* (New York: Random House, 2010).

6 Author conversation with Karl Wirsum, February 2, 2011.

7 Ibid.

8 Jon Pareles, "Screamin' Jay Hawkins, 70, Rock's Wild Man," *New York Times*, February 14, 2000.

9 In our discussion on February 2, 2011, Wirsum stated that he did not intend to use the colors of the Pan-African movement, but he did not deny my interpretation of their meaning.

10 Krin Gabbard, "Jazz: The Loneliest Monk," *Time*, February 28, 1964.

11 For more on the wordplay of the Imagists, especially Karl Wirsum, see Lynne Warren's insightful essay in this volume.

12 Author conversation with Jim Nutt and Gladys Nilsson, December 7, 2010.

13 Ibid.

14 Author discussion with Philip Hanson, February 10, 2011.

15 For more about this, see *www.glapn.org/sodomy-laws/usa/usa.htm*, but it is important to note that nationally, these laws were not repealed until 2003.

16 *www.edpaschke.com/biography/index.php.*

17 Roberta Smith, "Ed Paschke, Painter, 65, Dies; Pop Artist with Dark Vision," *New York Times*, December 1, 2004.

18 Interview with Dennis Adrian in Neal Benezra et al., *Ed Paschke*, exh. cat. (Chicago: Hudson Hills Press and the Art Institute of Chicago, 1990).

19 Author conversation with curator Judith Russi Kirshner, February 11, 2011.

20 Author conversation with Philip Hanson, February 2, 2011.

21 Ibid.

22 For a greater discussion of the term counter-culture and its formation in the 1960s, see Theodore Roszak, *The Making of a Counter Culture: Reflections on the Technocratic Society* (Berkeley, CA: University of California Press, 1968).

23 Author conversation with Art Green, December 8, 2010.

24 Interview completed for Art Green's retrospective in 2005 at the University of Waterloo. Given to the author by the artist.

25 During our interview, Green spoke about learning to use *Time* magazine from Art Institute professor Vera Berdich, who would give the students printing plates of *Time* layouts.

26 Author conversation with curator Lisa Stone, January 16, 2011.

27 For one explanation of this bizarre chapter in American history, see Richard Steele et al., "Life in Jonestown," *Newsweek*, December 4, 1978.

28 Before his death, Brown owned homes in Chicago, Michigan, and California. The Michigan home was designed by his partner, architect George Veronda. Author conversation with curator Lisa Stone, January 28, 2011.

SECOND SEX IN THE SECOND CITY

WOMEN OF CHICAGO IMAGISM

CÉCILE WHITING

In the 1960s an unusual number of women artists, including Sarah Canright, Gladys Nilsson, Christina Ramberg, Suellen Rocca, and Barbara Rossi, participated in exhibitions of Chicago Imagism at the Hyde Park Art Center. None of these women called themselves feminists, nor were they active members in the feminist art community, which developed in Chicago in the early 1970s. Yet all of them produced work that addressed one central concern of second-wave feminism: the prescriptive ideals of female beauty culture. The women of the Chicago Imagist movement adopted a variety of tactics to celebrate and critique the ways in which consumer culture fashioned femininity. Several of the artists explored the seductiveness of female beauty culture, reveling in its power to provoke desire. At other times their work offered explicit parodies of the various models of femininity marketed to women in advertisements. Indeed, both the male and female artists affiliated with Chicago Imagism poked fun at gender ideals. Finally, some of the women artists, rather than simply turning models of femininity on their head or presenting alternative ideals of beauty and the female body grounded in women's history and experience, employed the comic, the grotesque, and the robotic to reconfigure the human altogether.

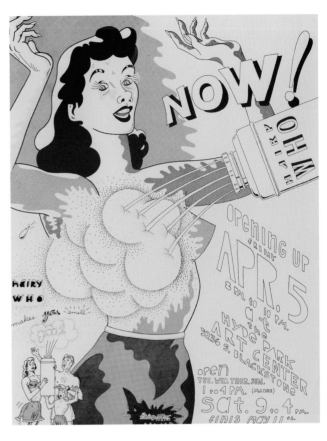

Jim Nutt
Now! Hairy Who Makes You Smell Good
(poster), 1968
Offset lithograph on coated white wove paper
Courtesy of Corbett vs. Dempsey Gallery

Unlike many women artists from the 1950s and 1960s who recall the discriminatory practices they faced in the art world,[1] the women affiliated with Chicago Imagism today speak nostalgically of supportive families, art teachers, and peers. Several enjoyed encouragement from their parents when they decided to enroll at the School of the Art Institute of Chicago (SAIC) despite the financial risks of pursuing a professional career in the arts.[2] Both Suellen Rocca and Sarah Canright singled out their mothers for being particularly nurturing. Canright, whose father died when she was seven years old, attended SAIC because her mother sent her drawings to the school. When Canright was accepted to the BFA program, her mother made a bargain with her, proposing that she enroll in classes for one year and postpone a decision to marry her high school boyfriend; Canright stayed at SAIC and did not marry the fellow. According to Rocca, her mother was a pianist and came from a German Jewish family that had always respected and nurtured the intellect of women. Only Gladys Nilsson states that her working-class parents, concerned about money, were not really supportive of her career choice.

All of these women commented on the encouragement they received from both male and female teachers, especially Vera Berdich, Whitney Halstead, and Ray Yoshida, at SAIC, where all of them received their professional degrees. Because SAIC was not dominated by Greenbergian Modernism or any other ruling "ism," the women did not feel constrained by aesthetic dogma. Instead their teachers exposed them to a range of visual practices including Surrealism, the figurative art tradition in Chicago, and Outsider art, and inspired them to visit the collections not just at the Art Institute

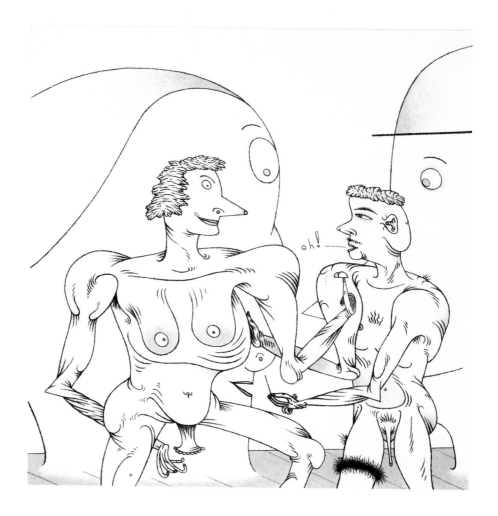

of Chicago but also at the Field Museum. In making art, they all felt free to borrow imagery from a variety of print media including Sears catalogs, comics, and advertisements.

Starting in 1966, Don Baum, exhibitions director at the Hyde Park Art Center, showed their work alongside those of their male peers in group shows with famously catchy names: *Hairy Who*, *Nonplussed Some*, and *False Image*. Barbara Rossi recalls Baum as an extraordinary person who generously exhibited the work of the young recent graduates of SAIC at a time when few other galleries showed contemporary Chicago art. All of these women remember a closely knit professional and social community, which shared artistic ideals and supported one another's work. Canright, for instance, praised her cohort of gifted female students and supportive male colleagues. Theirs was a cooperative enclave that gave the women license to become professional artists.

The retrospective assessment of their lives by these women artists parts ways with the characterization of the dissatisfied and trapped suburban housewife described by Betty Friedan in *The Feminine Mystique*, which was published to much acclaim in 1963. Rather, these women resembled Friedan herself in that they all boasted professional accomplishments and pursued careers as artists, teachers, and curators.[3] Several married, mostly to other artists in the group, and some of these couples had children. These

women enjoyed urban life in Chicago, managed domestic and professional responsibilities, and were prolific painters during the heady and politically volatile 1960s. Today Gladys Nilsson and Barbara Rossi are on the faculty at SAIC; Suellen Rocca is curator of the art collection at Elmhurst College; and Sarah Canright is a member of the art faculty at the University of Texas at Austin. If anything, these women exemplify the postwar ideal formulated in women's magazines that celebrated the individual achievements and careers of women. Although Friedan's book touched a nerve with its focus on stymied lives and its indictment of women's magazines for their blind celebration of motherhood, the magazines themselves contained exposés of homemakers' discontent while also singling out for praise those women who combined motherhood and career.[4] The lives of the women associated with Chicago Imagism corresponded to such stories of accomplished career women rather than tales of the homemaker trapped in suburbia featured in Friedan's book.

On the eve of the feminist revolution of the late 1960s, these women artists began to produce work that explored the ideals of femininity extolled in consumer culture. As historian Joanne Meyerowitz writes, "Commodified sexual representation was a 'woman's issue' well before the contemporary feminist movement."[5] As historian Stephanie Coontz points out, "The Sexual Sell," which was the chapter in *The Feminine Mystique* that generated the most comment from women readers at the time, examined the way in which advertisements manipulated women to purchase products.[6] During the 1960s, the feminist critique of beauty culture grew and received much media coverage, especially when women protested against the Miss America Pageant in 1968, critiqued *Playboy* magazine beginning in 1969, and spoke out in the 1970s against the representation of women in mainstream women's magazines such as *Ladies' Home Journal*. One of the many goals of the feminist movement in the late 1960s and early 1970s was to contest the sexual objectification of women by the fashion and cosmetics industries as much as by pornography. Many feminists rejected what they considered to be an artificial ideal of femininity fabricated by beauty culture meant to please men. The works by women Imagists complicated this critique because they not only parodied beauty culture but also acknowledged the pleasures it gave women.

Many of the works by women artists of Chicago Imagism highlight the contradictions of beauty culture: They point to both the desirability of beauty products and their false promises. A case in point is Christina Ramberg. Beginning in the late 1960s at a time when many young women, repudiating the artifice of beauty culture, grew long straight hair and shed bras and girdles, Ramberg began to paint elaborate hairdos and female lingerie. While a student at SAIC, where she obtained her BA in 1968 and MFA in 1973, she started producing small-scale paintings of hair. She reported that "working in the school store, I bought 6 x 6 inch squares of Masonite. They were only ten cents a piece, so I bought a whole bunch of them, and started to make these paintings of the backs of women's heads."[7] Ramberg's paintings emphasize the variety, artifice, and sensual appeal of complex hairdos while also poking fun at them.

None of Ramberg's pictures of hair imitate precise hairstyles, and in fact the hair's stylization is so imaginative and dramatic that it leaves the realm of the hair salon

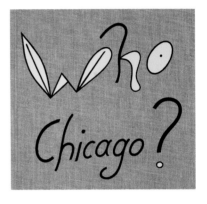

Jim Nutt
Who Chicago? 1980
Limited edition exhibition catalog hard bound in silkscreen on fabric
9 ¼ x 9 ½ x 1 ½ inches
The Bill McClain Collection of Chicago Imagism, Madison Museum of Contemporary Art

behind. And yet the painted pleats, knots, and braids cannot help but evoke the elaborate hair designs of the immediate past: The beehive, bouffant, poodle, and French pleat hairstyles of the 1950s and even the flips of the early 1960s all required curlers, teasing, and hair spray to get volume and curls. Ramberg's paintings exaggerate the stylization of hair, exploring its artifice while denying its ability to define a pleasing feminine appearance. *Head*, a color lithograph of 1969–1970, displays a thick mass of black hair covering the back of the head, neck, and shoulders [p.63]. Blue zigzag lines resembling a cartoon version of an electrical current demarcate the crests of folded black hair. Defined by a geometric pattern composed of dazzling blue hatch marks on black, the hair looks more like an abstraction in the shape of a bottle top than a human head. *Untitled* (ca. 1975) completely detaches four irregularly shaped patches of braided hair from the semblance of a head [p.78]. The painting arrays the hair as if it were a collection of bonbons contained in accordion wrappers, each tinted a different pastel hue. Neither painting—indeed none of Ramberg's images of hair—pictures a face transformed by hair's stylization.

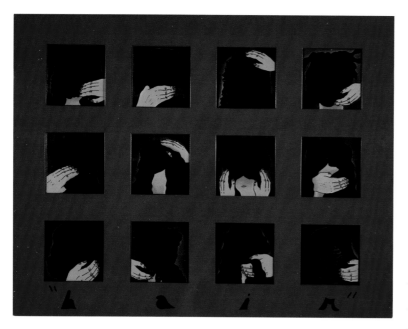

Christina Ramberg
Hair, 1968
Acrylic on Masonite
18 x 24 inches, each
Courtesy of the Renaissance Society

This is not to say that the female body does not appear in these works; it does, but in the form of a hand rather than a face. *Hair* of 1968, a relatively small acrylic on Masonite, catalogs the way in which hair can be imaginatively manipulated into all sorts of complex styles with curls, meshes, parts, and even extensions. Each of the twelve individual panels, arrayed into three rows of four squares each, depicts the same hand, its nails carefully polished, as it manipulates, pats, primps, lifts, and parts the hair. At times, its position suggests that the hand belongs to the woman whose hair we see; for instance, in the upper left corner a woman appears to be reaching behind her head to push some hair away from her neck. At other times, the angle of the hand implies the presence of a second person, perhaps a hairdresser, who massages the hair. One panel even contains two hands belonging to another woman who presumably stands behind the head and parts the hair in the middle, exposing some neck. In all cases, the hair's stylization appeals to the touch of a distinctly female hand. A similar work, *Cabbage Head* (1968) not only highlights the physical contact between two women, it also implicates the viewer in the conflation of looks and touch. In *Cabbage Head* a hand belonging to a second person holds the yellow hair in place, gently pressing down on its smooth straight surface. Humorously, on the other side of the head, the hair has been curled

Christina Ramberg
Cabbage Head, 1968
Acrylic, wood, and glass
9 ½ x 10 ½ inches
Courtesy of the Renaissance Society

into very tight, horizontal pleats resembling cabbage leaves. Because the painting is contained within the frame of a vanity mirror, it can be swiveled on its stand to display a mirror on the other side: The mirror then reflects the viewer's face, and thus, by implication, the painting represents the back of the viewer's head. The format of the vanity mirror invites the viewer to imagine her own hair being touched and tamed by the manicured hand of another woman. That feminine hairstyle is an artifice seems obvious enough in Ramberg's highly stylized hair paintings; that hair requires touch to achieve its varied and sometimes ridiculous appearance returns the artifice of femininity to the realm of labor while highlighting the sensuality of such handiwork.

In 1971, Ramberg shifted her focus from hair to the female torso clad in elaborate, intricately designed lingerie, dating from the 1950s. Art historian Judith Kirshner points out that Ramberg produced these at a moment in the early 1970s when women were discarding girdles, garters, bras, and hair spray.[8] Although the face continues to be absent in Ramberg's pictures of lingerie, a hint of neck or of hair curling down the back presumes the presence of a head just as some upper thigh emerging from panties and girdles suggests legs. The point of view nevertheless focuses attention on the lingerie and the torso from a very proximate position; the paintings that include hands go one step further in making manifest the physical nearness of viewer and viewed.

Ramberg's paintings cast the lingerie into the past. Even though the artist produced some drawings loosely based on current lingerie catalogs, her sober colors suggest the passage of time, as if the lingerie dated from an earlier era rather than coming from glossy magazine advertisements of the present. Indeed, both the titles and style of the lingerie itself recall undergarments from the 1950s. Critic Carol Becker speculated that the paintings may have been based on memories of Ramberg as a girl watching her mother getting dressed: "They are painted so lovingly, so tenderly, so innocently, that I begin to suspect that the implied voyeur of these strong and complex paintings might not be an adult at all, but rather a young girl, perhaps sitting on the edge of the bed, watching her mother dress, focused in close on the breasts, the torso, the hips, thighs, and pelvis."[9] Becker's insight was confirmed later in an interview between Ramberg and Kerstin Nelje:

> My father was in the military and I can remember sitting in my mother's
> room watching her getting dressed for public appearances. I got to
> put her hankie, lipstick, and compact mirror in one of those tiny beautiful
> little purses. I watched her getting dressed, and she would wear these—
> I guess that they are called "Merry Widow"—and I can remember
> being stunned by how it transformed her body, how it pushed up her
> breasts and slendered down her waist. Then she put on these fancy
> strapless dresses and went to parties. I think the paintings have a lot to
> do with this, with watching and realizing that a lot of these undergarments
> totally transform a woman's body . . . Watching my mother getting dressed
> I used to think that this is what men want women to look like, she's
> transforming herself into the kind of body men want. I thought it was
> fascinating . . . in some ways, I thought it was awful.[10]

Ramberg's assessment of the way in which lingerie and dress transformed her mother's body into an image of desirable femininity for her husband and other men may reflect an adult retrospective assessment rather than a daughter's insight from the late 1950s and early 1960s. Even so, the artist clearly recalls the aesthetic appeal of all of the objects from lipstick to corset involved in the process of her mother's transformation. She also keenly remembers her sense of privilege in being part of the intimate ritual of helping her mother get ready for the evening.

Based on a combination of memory and actual advertisements, Ramberg's paintings depict lingerie as both constraining and seductive. "Containing, restraining, re-forming, hurting, compressing, binding, transforming a lumpy shape into a clean smooth line," Ramberg wrote in her journal in reference to corsets.[11] Ramberg's choice of verbs point to the sadistic function of the corset as it cinches the waists, pushes up the breasts, and forces a woman's body into an ideal shape with its wires, clasps, and zippers. Many critics have highlighted the sadomasochistic aspect of the corseted body in Ramberg's paintings. About one of her paintings, critic Dennis Adrian comments, "the brassiere, dress shields, corset, panties, shiny boots (the tops are visible) and stockings suggest the stereotypes of these girlie magazine images having a whiff of S and M and fetishism."[12] Many of the corsets do hint at bondage, or at the very least focus attention on the way in which undergarments force the torso into precisely rounded and columnar forms.

A number of the paintings also evoke the homoerotic allure of the female through the inclusion of the hand of a second woman, which, approaching the corseted body has a more obvious erotic charge than the hairdresser's hand on hair. In *Probed Cinch* of 1971, a hand with red manicured nails probes beneath the cinched waist of a girdle. Likewise in *Shady Lacy* of 1971, the position and exaggerated size of the hand implies the presence of a second woman. At the very least, these hands invite viewers to imagine feeling what they see: the pressure of manicured nails, glossy hair, and lacy undergarments on the body. In *Shady Lacy*, moreover, a strand of hair is tucked under the lacy seam of the panties, implying some sort of autoeroticism in which the figure feels the sensual touch of shiny, glossy black hair and delicate floral black lace on her skin.

Ramberg's torsos neither simply wait to be caressed nor present themselves only as victims of corsets. Often they contain inexplicable and disturbing details that puncture any fantasy of ideal femininity. For instance, in *Probed Cinch*, strange white petals, or perhaps tongues, emerge from the top seam of the black girdle cinching the waist. What are those odd feathered shapes, and what is their relation to the fabric that covers the uppermost portion of the thighs? Or consider *Black Widow* of 1971, which evokes both a style of corset and a deadly spider. The so-called Merry Widow corset dates to 1952 when it was released and marketed to coincide with the premiere of the film *The Merry Widow* starring Lana Turner. The strapless bra and boned corset forcing the breasts, waist, and hips into an hourglass shape was designed to match the cinched waist of the "New Look" introduced by Christian Dior.[13] Not only does Ramberg's title reference Lana Turner's performance as a widow in the film, it obviously names the

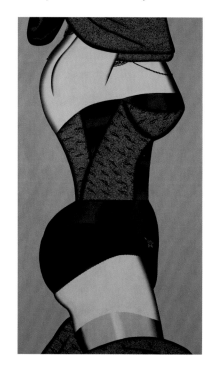

Christina Ramberg
Black Widow, 1971
Acrylic on Masonite
31 x 18 ½ inches
Courtesy of the Renaissance Society

black widow spider that earned its macabre epithet because females of the species eat the males after mating. The title alone hints at danger and death. In Ramberg's painting, the strapless bra, with its cups edged in black satin to match the seam of the black panties, contains a busty body. The fabric gathered at the calf (perhaps a skirt) adds heft to the legs as well as introducing ambiguity to the scene: Is this woman dressing or undressing? What is that fabric anyway? The corset makes this body recognizable as a female but the fabric renders the body's contour somewhat strange and endows it with a threatening bulk and odd cloth appendages.

Ramberg's imagery evokes advertisements in women's magazines that enticed women into buying products to improve their appearance and sexual allure by emphasizing the eroticism of manicured nails, lacy undergarments, and fancy hairdos. The exaggerated artifice of both the hair and lingerie in Ramberg's paintings draw attention to femininity as a theatrical performance in which curves are exaggerated, bodies cinched, and hair stylized. At the same time that Ramberg's paintings examine and make visible the accoutrements of female beauty culture, they also highlight their sensual appeal to the eye and hand and point to the close physical exchanges that occur between women in fashioning femininity. In the early 1960s, one woman in particular made public her enjoyment in cultivating femininity and in exploring her sexuality. In *Sex and the Single Girl* of 1962, Helen Gurley Brown encouraged women to take pleasure in performing femininity and in using their sexual allure to pursue paid employment and independent lifestyles. As historian Jennifer Scanlon has recently observed, "In *Sex and the Single Girl*, sexy and sexually satisfied women are those who support themselves, enjoy men and male company but do not depend on it for survival, and enjoy sex, sexual desire, and, to some degree, being objectified sexually."[14] But by the late 1960s, the moralizing campaigns mounted by women against pornography in the mid-twentieth century had joined forces with the feminist critique of the sexual objectification of women.[15] Ramberg, perhaps responding to such critiques, certainly tempered the wholesale celebration of female sexuality as articulated by Brown. After all, these are headless torsos, anonymous and schematic bodies with no identity beyond their lingerie, and the contorted hairdos are sometimes just silly. At least in the case of the paintings of lingerie, the power and pleasure of femininity goes hand in hand with a recognition of the painful bondage of undergarments. Ramberg's paintings contain an ambivalent and complicated attitude toward female beauty culture.

Ambivalence is evident as well in the watercolors by Gladys Nilsson in which the vulgarity of the female body is the source of both its power and humor. In Nilsson's work from the 1960s, women literally make a spectacle of themselves by appearing as performers in public. In her pen-and-ink drawing entitled *Hoofers* of 1963, for instance, the women have short, scantily clad torsos with large protruding breasts and thick legs. They do not resemble middle-class suburban housewives, and as part of the entertainment world, they display their sexual allure onstage. They shuffle about and kick up their heels, dancing onstage before masked men playing musical instruments. These voluptuous dames, who evoke the sirens of the 1930s, command the stage with their physical presence. In Nilsson's watercolor *Looking* of 1963, they dominate as well by

Gladys Nilsson
Hoofers, 1963
Pen and ink on paper
11 x 8 ½ inches
Courtesy of Jean Albano Gallery

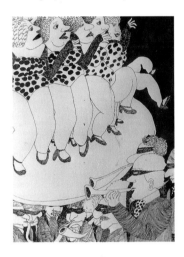

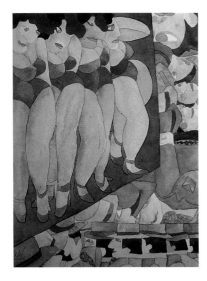

their gazes; rather than presenting themselves simply as spectacles to be looked at, they pointedly stare down at the men, who, all clad in identical blue suits and fedoras, appear smashed together in the space below the green stage. Nevertheless, Nilsson pokes gentle fun at her female performers by crowding their thick bodies together. Bumping up against one another, they fail to present a coordinated chorus line, much less alluring poses.

Suellen Rocca manifested an equivocal interest in the accoutrements of 1950s femininity when she represented motifs such as purses and rings. Reflecting on how being a woman has impacted her work, Suellen Rocca has stated:

> I emerged as an artist in the late 1960s. My paintings of that period were filled with multiple mini-iconic images appropriated from popular culture. Many of these images reflected or related to cultural stereotypes of women. I was inspired by the sepia-toned Sears catalog pages which displayed a multitude of bras and girdles and the back pages of "cheap" magazines which advertised ornately designed hair extensions or wigs. While male "Hairy Who" members Jim Nutt and Karl Wirsum were fascinated by the images in wrestling and body-building magazines, I was transfixed by the rows of diamond engagement rings I saw in the jewelers' catalogs at my father-in-law's office.[16]

Fascinated with products marketed to women in store catalogs, Rocca transformed goods into pictographs and presented them either in neat rows, in chaotic abundance, or in association with women, home, and children. In all cases, however, the juxtapositions of objects consistently rejected the display tactics and promises of consumer culture.

Having perused catalogs whose layouts organized goods of one type (whether a bra or a diamond ring) in order to emphasize their differences in style, size, and color, Rocca reduced products to simple graphic symbols and placed them in wild juxtapositions. Both the color etching and drypoint on paper titled *Rings* (ca. 1966) and the oil *Catalogue Painting* (ca. 1965) classify symbols into relatively neat columns and rows. Yet the surrealistic mixture of objects perplexes rather than tempts: *Rings* includes Santas, children dancing, hats, palm trees, faucets, and the eponymous rings, while *Catalogue Painting* places rings next to columns of underpants, jackets, and abstract squiggles. More often than not, irrationality takes the form of a fear of leaving empty spaces (horror vacui) rather than illogical juxtapositions. Pictographs swirl about in *Untitled* (1966–67), making colorful chaos of a game board (the words "start here" and "stop here" appear on the canvas). In *Sleepy-Head with Handbag* and *Dream Girl*, both of 1968, cartoonish symbols of house, purses, dancing legs, extended arms, and palm trees explode across female bodies. *Night Light for Little Girl* (1969), an oil painting framed with an actual ruffle along the edge, features a lamp whose base resembles a lamb painted in pastel colors while the blue lampshade pictures a blond girl whose hairstyle and dress featuring a Mary Jane collar comes straight out of a children's book of the 1950s. On

closer inspection, the blue clouds to the right contain feet while faucets in the form of penises drip water from the sky. When the naïve-looking and colorful pictographs are specifically linked to dreams and fantasies of female fulfillment in marriage and home-making, the pictures seem particularly childlike. Rocca represents the accoutrements of femininity as touchingly innocent, yet arrayed to exemplify irrationality and chaos.

Much of the work done by women of Chicago Imagism revealed the desirability, power, and attractiveness of femininity as constructed by beauty culture, while simultaneously highlighting its false promises often through gentle parody, exaggeration, and playfulness. Although such images may express ambivalence toward the prescriptive ideals of female beauty culture, these women also contributed work to the various exhibitions mounted at the Hyde Park Art Center that more explicitly criticized consumer culture for promoting stereotypes of femininity and masculinity. Male and female artists collaborated on the posters for the exhibits of the *Hairy Who* (three exhibitions), *False Image* (two exhibitions), and *Nonplussed Some* (two exhibitions) as well as the comic book catalogs accompanying the *Hairy Who* exhibitions. For instance, the six artists associated with the Hairy Who (James Falconer, Art Green, Gladys Nilsson, Jim Nutt, Suellen Rocca, Karl Wirsum) worked together and individually to design the comic book catalogs, signing some of the pages, but leaving most unsigned. Both the posters and catalogs combined outrageous humor, bad taste, and grotesque imagery calculated to offend.

The posters and comic book catalogs for the second and third *Hairy Who* exhibitions at the Hyde Park Art Center parodied female beauty culture. On the poster for the third show (April 5–May 11, 1968) designed by Jim Nutt, a woman sprays her upper torso with an aerosol can labeled "Hairy Who," covering one of her breasts with mounds of foam. Below her, in the lower left corner, a storybook family consisting of husband, wife, and girl hold up a monumental spray can as if it were a religious totem. In the cloud above the can appears the word "good," while the promotional text promises: "Hairy Who makes you smell!" Humor abounds as consumer products meant to sanitize have the opposite effect. Inside the catalog for the second *Hairy Who* exhibit (February 24–March 24, 1967) an unsigned page labeled "Be a Sweat Heart" shows a young woman with carefully groomed, shoulder-length hair spraying herself with "purse spray"; worms that resemble drops of sweat cover her face. The text at the bottom of the page names an imaginary sponsor: "by Persperation W." In these images, women who spray themselves with beauty products often meet

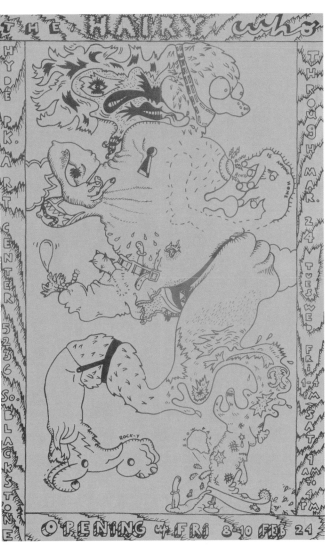

Poster for the Hairy Who exhibition,
Hyde Park Art Center, Chicago
Don Baum Poster Collection, Museum of
Contemporary Art, Chicago, Archive of Art

Cécile Whiting

Suellen Rocca
Rings, ca. 1966
Etching and drypoint in aquamarine
blue on white wove paper
15 ¼ x 23 3/5 inches
Restricted gift of Mr. and Mrs. Gustave
Rath, The Art Institute of Chicago

with catastrophic results. On the cover of the catalog for the third show a young woman, blinded by bandages crisscrossed over her eyes, sprays herself with perfume while slipping in her high heels in a pool of water. The wordplay and the facetious transformations of the female body in these images consistently poke fun at products promising to improve feminine appearance.

Two images signed by Suellen Rocca and included in the third *Hairy Who* comic book catalog likewise parody the fantasies of femininity cultivated by advertising. In *Now the Nightmare Begins*, Rocca juxtaposes some of her signature pictographs—dancing legs, palm trees, rings—with a so-called dream girl, who stands tall on a palm tree. Lining the dream girl's torso are the words: "grace, charm, beauty, trim, slim." The words name ideal traits of femininity that demand that women discipline their bodies and behavior. Yet, according to Rocca's scenario, by conforming to such prescriptive virtues, the dream girl enters into a nightmare. On another page in the same catalog Rocca presents a nighttime scene titled *Sleepy-y Head* in which we read the words "Keep Turning," "As You Sleep," "If You Want," "True Body," and "Balance" printed next to the outlines of four female bodies, each of which is lying in a different position. The commands of beauty culture control the woman at sleep, and present an unappealing future for the girl in bed pictured at the bottom of the page. In both images, Rocca pairs the dreams and fantasies of childhood with the realities of womanhood, which appear to be controlled by the prescriptive demands of consumer culture.

Nor did ideals of masculinity escape the parodic wit of the Hairy Who artists. The cover of the comic book catalog produced for the first *Hairy Who* exhibition (February 25–April 9, 1966) depicts a man displaying his bulging biceps. The man's pose and the surrounding words—"Buy It," "Approved," "Prestoe," "E-Z"—borrow from advertisements featuring Charles Atlas and Mike Marvel in the early 1960s. Promising big brawny bodies in a few easy steps, body builders promoted their exercise regimes in superhero comic books targeting young male readers. Art Green recalls looking at body building magazines: "They had all this arcane terminology referring to the body in pursuit of some ideal within a hermetically sealed environment . . . I was fascinated by their illustrations of people who had grotesquely distorted their natural proclivities in the service of an ideal, and who had become warped and twisted and strange and yet admired within their circle."[17]

Inside the first Hairy Who comic book catalog, Nilsson developed the theme of the cover by devoting several pages to a female body builder, the Aquarell Woman, who boasts a muscular body and elephantine nose. Nilsson also aimed her satiric wit against male body builders in a work she completed the following year: *Super Dik* of 1967 contains in its title an obvious sexual reference. In Nilsson's rendition, Dik, who resembles a penis more than a man, wears a Superman outfit that reads "Super Natomy" while smaller male and female figures crowd around to admire him. With evident humor, the artists of the Hairy Who made fun of the exaggerated ideals of both masculinity and femininity by creating a carnivalesque world populated by freak characters.

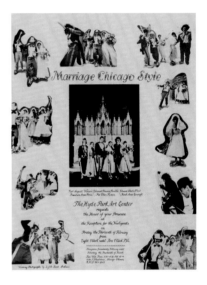

Marriage Chicago Style (poster), 1970
Courtesy of Corbett vs. Dempsey Gallery

In an era when young people challenged not just gender stereotypes but also the institution of marriage, the poster for the *Marriage Chicago Style* exhibition from February 1970 announced the unification of the artists associated with the Hairy Who and Nonplussed Some in a zany marriage of convenience. Standing within St. James Church at 2900 Wabash Avenue, the artists pair up at the altar and are identified as "Karl August Wirsum and Barbara Anne Rossi," "Edward Francis Paschke and Sue Ellen Rocca," and "Edward Charles Flood and Sarah Anne Canright" (who were actually married). The women wear prom dresses and first communion veils while the men sport tuxedos. But with ice skates on their feet and with brushes of a house painter wielded as hockey sticks in their hands they hardly adopt the accouterments and demeanor appropriate for a church ritual. Surrounding the photograph of the brides and grooms are snapshots of the newlyweds dancing jigs, waving brushes, and grinning happily. Their boisterous antics wreak havoc with the traditional marriage ceremony performed in the sacred site of the church.

More broadly, the artists who exhibited under the name False Image parodied the image as a misleading fabrication rather than an authentic identity. The poster for the second *False Image* exhibit features a mass of knotted, twisted, braided black hair by Christina Ramberg: A mirror held up in the center of the hair, perhaps covering a face, does not offer a reflection, but—in a twist worthy of René Magritte—projects the words "False Image." Targeting the "image," these artists joined advertisers, social scientists, psychologists, and historians who, after the Second World War, devoted

many pages of writing to analyzing and debating the role of images, personalities, brand names, and trademarks in selling products. By the late 1950s, self-consciousness about the power of a product's image extended beyond the realm of goods and services, triggering discussions about how best to package people such as presidential candidates. Critical evaluations, some of them sensationalist, about the consequences of producing images to sell goods or people also began to appear. One of the most searing critiques of the role of the image in American culture from this period came from the pen of a historian at the University of Chicago, Daniel Boorstin. In his book, *The Image*, published first in 1962 and reissued in paperback in 1964, Boortsin lamented the shift in American culture from the cult of the hero to that of the celebrity. He attributed many of the shifts to media and advertising. By the late 1960s, images, including the image of masculinity and femininity as fabricated by consumer culture, came under attack as well—and not just by feminists. Challenges to ideals of femininity and masculinity became so widespread that when art critic Harold Rosenberg penned the article "Masculinity" in the late 1960s in *Vogue*, he concluded, "On the neon-lighted lonesome prairie, masculinity is a matter of certain traditional costume details: the cowboy hat, jeans, and guitar. It has become clear that the traditional traits of the man's man (and the ladies' man) can be put on, too. One *plays* manliness."[18] All of the Chicago Imagists highlight the performance of masculinity and femininity and parody the gender stereotypes presented in advertising. That they did so fully aware of sociological criticisms of the image is evident in the nomenclature "False Image," with its pointed critique of those who groom themselves literally and metaphorically in the mirror.

Other art movements in the 1960s, most notably Pop art, blatantly critiqued the image and highlighted the links between commodity and gender; for instance, Mel Ramos famously draped pinups around commodities in outrageous send-ups of advertising culture. But the Chicago Imagists took a different approach: With their punning, their cartoonish and explicitly vulgar figures, and their frequent address to tactility, they elicited a visceral response to the commodification of gender stereotypes. The poster for the second *Hairy Who* show, for instance, features a huge, distorted creature, part human and part animal, with a hybrid male/female head. As the beast runs and leaps across the bright-yellow ground, one of its feet, resembling a claw at the end of a cactus, steps on a nail as if to make literal the physical pain Chicago Imagism hoped to elicit in its viewers.

Both the male and female Imagists relied on the subcultural language of the comics, often recalling the hilarity and grotesqueries of *Mad* magazine, to parody gender stereotypes in a manner meant to prompt a visceral reaction. The grotesque figure in the poster for the second show of the Hairy Who conjure Basil Wolverton's monsters published in *Mad*, the most famous of which appeared in a send-up of *Life* magazine.[19] In May of 1954, *Mad* adopted the format, colors, and typeface of *Life* covers to feature a creature by Wolverton photographed against a city skyline: a smiling female dog, skin covered with huge bunions, displays two rows of crooked teeth, as she smiles with tongue hanging from her mouth. The headline reads: "Beautiful Girl of the Month." Even the wordplay of the Imagist comic book catalogs owes a debt to *Mad*, which began

Basil Wolverton
Mad magazine cover, 1954
Estate of the artist

to parody the advertising industry in March 1955 with product labels such as "Belch-Not Strained Babies," "Heidz Retchup," and "Stikky Choke Style Peanut Butter."[20] Belching, choking, retching, *Mad* magazine advertisements like Wolverton's gorgons offended protocols of propriety and good taste. *Mad* offered a potent precedent to the artists of the Hairy Who, who experimented with puns and imagery meant to be as outrageous, humorous, and offensive as possible.

And they succeeded: Critics responded viscerally to Chicago Imagism. In December 1969 in a review of artists who borrowed from the comics published in *Art 'n' Artists*, Joan Siegfried commented with thinly veiled horror on the monstrous bodies of Chicago Imagism:

> Figures are monstrously mutated, waving limbs like amputated stumps.
> They are beset by tongues and intestines, saliva, mucous, and excrement.
> Around them float various objects, which may be hats, panties, half-eaten sandwiches, aerosol sprays, as well as words, either sounds, like
> "titter," or "ha ha," or funny phrases, such as "itches off yur waste."
> It is a vision of man reduced to his bodily functions, the kind of man
> American advertising struggles mightily to overcome with all its highly
> touted preparations for personal hygiene.[21]

Reviews of the *Hairy Who, Nonplussed Some*, and *False Image* exhibitions in Chicago newspapers repeatedly express feelings of disgust, revulsion, and nausea at the sight of the obscenity of the body stripped of its hygienic cover.[22] The critics aligned the effort by Chicago Imagists to provoke extreme emotional reactions with the youth movement of the day. For instance, critic Franz Schulze commented, "The predominant mood among these Chicagoans is the predominant mood of the younger generation nationally: a bold, freewheeling, impersonally cheerful kind of cool which deems no experience off limits, apparently because it holds no values sacred except freedom." To the extent that Chicago Imagists shocked and offended viewers on a gut level with their attacks on sacred cows, they were seen as part of a broader revolt in the 1960s against societal conventions and strictures.

If much of the imagery by Chicago women Imagists featured or parodied the gender stereotypes created by consumer culture, other works by these women reconfigured the human altogether. In such paintings it is often difficult to tell the difference between male and female, clothing and skin, animal and human, the interior of the body and its outside. Rather than simply reversing existing gender stereotypes, these paintings imagined a third body type not linked at all to the idealized models of masculinity and femininity marketed in advertisements.

Starting in the mid-1970s, Ramberg painted torsos with an ambiguous sexual identity. With a title that itself suggests irresolution, *Hereditary Uncertainty* of 1977 presents a torso wearing fragments of clothing—shirt, skirt, shorts—belonging to both men and women. *Tight Hipped* of 1974 exposes a male chest and sternum, while the narrow waist and slender arms and legs could be female [p.75]. A short black skirt dec-

orated with knotted hair fits around the figure's waist and extends the glossy black hair wrapped around the sternum, confusing the inside and outside of the body. At the same time a small round shape outlined in black hangs from below the hem, in between its legs. The picture confuses the signs by which we typically identify males and females. Other works are likewise sexually charged but do not affirm sexual difference. The torso in *Untitled #15* of 1982 has rounded female hips accented in deep red, but two vaguely sexual shapes—one a black beak pointing down and the other a triangle with horizontal brown stripes pointing up—overlap where the torso meets the hips [p.93]. Because of their placement at the pelvis, the triangular shapes evoke female and male sex organs, but they could also simply be decorative accessories applied to the surface of the red dress. In contrast to the paintings of lingerie from the early 1970s, these works eliminate female breasts, recognizable underclothing, and caressing hands. Torsos instead foreground sexual ambiguity.

Often Ramberg's ambiguous bodies appear to be breaking apart. The sexless manikins in *Hermetic Indecision* and *Schizophrenic Discovery*, both of 1977, wear a combination of male and female clothing and do not display identifiable physical markers of sexual identity. Cloth wound around the chest, forearm, and waist of the torso in *Hermetic Indecision* and around the knees of *Hereditary Uncertainty* evoke gauze bandages used to cover a wound. In both works, the bodies fly apart: In *Hermetic Indecision* half of the body consists of horizontal strips of hair breaking away from the other half of the torso, while in *Hereditary Uncertainty* the limbs on the right side of the torso are disarticulated from the rest of the torso. Given that these broken, wounded, wrapped bodies appear in the late 1970s following the end of the Vietnam War, they cannot help but evoke dismembered veterans returning from combat. Critics have also connected these works to medical illustrations. Whatever their source or reference, these sexless manikins whose bodies have lost their coherence confuse the binary of masculinity and femininity.

Around 1970, Nilsson began to conflate the human with either vegetables or animals. In the watercolor *Veggie Great* of 1970, vegetables, which resemble the television character Gumby more than they do carrots and asparagus, fill the space [p.65]. Elaborate hairdos, breasts, and colorful dresses cast many of the figures as female. Their tentacles reaching around one another and their toothy grins make these anthropomorphized vegetables look vaguely frightening and certainly monstrous. In *Svelt Bearsisters*, also from 1970, three large bears assume human sex attributes and clothing. However, the brown bear in the center, despite its breasts, wears shirt and shorts and its heft looks more masculine than feminine, while the green bear has a body lacking any identifiable sex markers at all. Surrounding them are smaller figures, whose bodies, snouts, and ears vaguely evoke animals; some of these have female breasts and skirts but most look like imaginary creatures with spindly legs and arms. In an interview in which Nilsson ruminated on the source of her pictures, she emphasized both the natural world of humans, plants, and animals and also the imaginary world of werewolves and vampires:

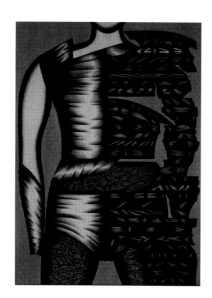

Christina Ramberg
Hermetic Indecision, 1977
Acrylic on Masonite
49 x 37 inches
Courtesy of the Renaissance Society

My "figures" just evolved over time from what I was interested in at the
time. Some sort of animal/human, bird/human, plant life/human
involvement. I really don't know where or what sources they/it sprang
from, but the idea of changing, or nowadays, morphing, has always
intrigued me. This runs rampant in the history of art and it is a given that
any one of the many images I have/had seen over the years does/did
indeed creep/crept into my personal iconography. Hmm, I would suppose
that a few urban/peasant stories fed into the mix, the werewolf,
vampires. Those were all films I loved growing up, and were reinforced
by the '6os soap opera "Dark Shadows," which I watched and really
loved! I do what I see.[23]

As creatures that change from human to monster during the night, the werewolf and
vampire thematize the strange and often threatening hybrids in Nilsson's pictures of
the early 1970s.

Barbara Rossi's series of heads and shoulders painted with acrylics on Plexi-
glas from the late 1960s and early 1970s also confuse male and female as well as inside
and outside of the body. Little beads of pink, yellow, blue, and green paint frame ab-
stracted body parts in *Eye Deal* of 1974: A hand at the end of a long rubbery arm, an eye,
and a tongue can be detected among other organic shapes, some of which resemble
intestines [p.74]. A jeweler's loupe appears at the left edge of the painting through
which an eye might peer at the pearl held between the fingers of the hand at lower left.
Or is the loupe a mirror that might reflect an "ideal" (implied by the title *Eye Deal*)
image? In any case it is impossible to tell if the inchoate body depicted by Rossi arrested
in motion belongs to a male or female or even depicts a head or body, or both.

Despite their obvious preoccupation with beauty culture and gender stereo-
types, the women of the Chicago Imagist movement never identified with the next gen-
eration of women who formed the feminist art movement in Chicago. The most famous
feminist to emerge from SAIC was Shulamith Firestone, who earned a BFA in painting
from the school in 1967. Recently filmmaker Elisabeth Subrin discovered the thirty-
minute documentary film *Shulie* about Firestone, produced when she was a student at
SAIC. Subrin reshot the original film, frame for frame, in 1997, and in one scene Fire-
stone, played by Kim Soss, is being taken to task by a jury of five male artists. The scene
exposes the sexism Firestone perceived at SAIC: Not only are there no female judges,
but the interaction between male teachers and female student also exemplifies the au-
thoritarianism of the classroom that many feminist educators would challenge in the
years to come. The film gives a very different view of life for the women students at
SAIC than do the memories of the Chicago Imagists.

The trajectory of Firestone's career also points to the gulf between the per-
spective of the Imagists and younger feminists of that era. Ultimately, Firestone did
not pursue a profession as an artist but instead became a writer and feminist activist,
first in Chicago and then in New York. She co-organized the Westside Group, which

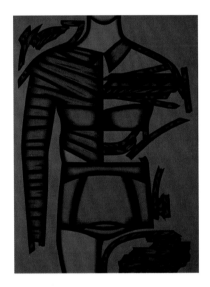

Christina Ramberg
Schizophrenic Discovery, 1977
Acrylic on Masonite
49 x 37 inches
Collection of Ball State University Museum of Art

preceded the Chicago Women's Liberation Union, and in October 1967 she moved to New York City and cofounded New York Radical Women; in 1969 she cofounded both Redstockings and New York Radical Feminists. Firestone's controversial book *The Dialectic of Sex: The Case for Feminist Revolution*, published in 1970, offered a radical critique of sex roles and the family, arguing that women should be freed from their biological role of bearing children and that babies born in artificial wombs should be raised collectively. Obviously Firestone's book went much further than parodies of gender stereotypes, and called for a basic restructuring of family and sex roles.

After Firestone left Chicago, a number of female artists, many of whom also received their degrees from SAIC, began to organize in the spring of 1971 and to develop connections with feminists in New York and Los Angeles. Ellen Lanyon, an older painter who became involved in the feminist movement in both Chicago and New York, established a chapter of WEB (West East Bag) in Chicago in 1972, which had been founded a year earlier by critic Lucy Lippard in New York and artists Judy Chicago and Miriam Schapiro in Los Angeles to establish a registry of female artists. The Chicago chapter of WEB brought Lucy Lippard and Judy Chicago to speak in Chicago. Two women cooperative art galleries ARC (Artists Residents of Chicago) and Artemisia were formed in 1973.[24] Other artists established the Women's Graphics Collective to produce posters addressing women's issues. Most of these young feminists defined themselves in opposition to Imagist art and encouraged the exploration of other modes of art making.

In the end, the involvement of the women Imagists in the feminist art movement was only peripheral.[25] Neither Nilsson nor Rocca were even in Chicago at the time. Rocca lived in the East Bay near San Francisco for nine years (between 1972 and 1981), and Nilsson moved with her husband, Jim Nutt, to Sacramento in 1970, where Nutt had been hired to teach at the campus of California State University there. They stayed in California seven years before returning to Chicago. Canright and Rossi, who remained in town, did have some involvement with Chicago feminism in the 1970s. Canright hosted curator Marcia Tucker, who spoke to a group of women gathered in Canright's studio. Canright commented that Tucker lifted the scales off their eyes.[26] She began to notice that some of the male Imagists were selling more and getting more attention from the galleries than the women. Canright recalls discussing this concern with Ramberg, who had noticed the same thing. In short, Canright and Ramberg became sensitized through Tucker to the sexism operating in the art world of Chicago.

Rossi inspired at least one young feminist artist with her teaching and her work in textiles. When *Ms.* magazine published an article entitled "What Is Female Imagery," it interviewed women artists in Chicago, Los Angeles, and New York. Chicago painter and sculptor Joy Poe emphasized the impact a course taught by Rossi had on her development as an artist: "I was in Barbara Rossi's Cloth Construction class, after struggling along for years, painting, and really not liking it . . . Finally I had a female instructor who encouraged me. I started working exclusively with cloth and loved it."[27] Unlike Firestone's humiliating experience with the male jurors at SAIC, Poe received positive support from Rossi. Rossi's choice to teach a course on cloth construction

reflected her own experimentation with textiles and other materials. For instance, she embedded hair, feathers, and satin in her reverse Plexiglas paintings. Around this time, she also sewed and quilted; a work such as the quilt *Comforter* from 1970 contains a vaguely female figure printed on each panel. Critic Dennis Adrian remarks:

> Rossi made at least eleven full-size quilts by sewing together twenty or
> more separate impressions of intaglio prints and then filling, backing,
> and quilting them following the traditional techniques of this kind
> of work. Most of these splendid quilts are further embellished with such
> things as beading, feather edgings, sequins, satin fringes or buttons.[28]

Rossi was not alone among the Chicago Imagists in borrowing materials closely associated with the realm of craft and femininity when they made their art. Rocca, for instance, incorporated fabric along the edge of her frame, and she also painted actual lampshades. In this regard, the women Imagists resembled a number of second-wave feminist artists, including Judy Chicago, Miriam Schapiro, and Faith Ringgold, who turned to crafts such as embroidery and quilting that traditionally had been associated with domestic labor and subordinated to the arts of painting and sculpture. These artists questioned a value system that prioritized large-scale, abstract, geometric oil paintings over personalized and decorative design, and brought attention to the patience, care, and aesthetic skill required by the domestic crafts. While the Chicago Imagists may not have used the word "feminist" to describe their works, they also adopted practices of craft, which they considered creative artistic labor, and incorporated actual stuff—fabrics, hair, feathers—associated with femininity into their art. These works validated female craft culture and implicitly poked fun at the high seriousness of Modernism rather than at the fantasies of female beauty culture. With their use of textiles, they challenged the purity of Modernism at a time when painting as a practice was under fire from many fronts.

Where many feminists revived crafts traditionally associated with women and denigrated by Modernism, Canright took a different approach and produced abstractions with pastel colors. Canright has explained that she took a trip to Europe in 1968 to see the Venice Biennale and spent four months abroad. Her trip proved a turning point in her career as it caused her to decide that she needed to make art from the perspective of woman. *Shadow* of 1969 was among the first paintings she completed after her trip to Europe. Painted in colors associated with Easter eggs, *Shadow* depicts a cloudlike shape evoking angel wings or flowers [p.61]. Generally, her abstractions from this period, with titles such as *Illusion*, *Whisper*, and *Shadow*, juxtapose organic and geometric shapes painted in pale colors. Many of these works contain shapes that can be read as plants, braided hair, clouds, and curtains. The visual associations of the shapes with femininity and their "pretty" colors insist on a gendered reading of abstraction. Art historian Helen Molesworth astutely sheds light on the gendering of modernist painting in a recent essay about three New York women artists:

[Howardena] Pindell has recounted her artistic training (in the Josef Albers school of color theory) at Boston University: "Al Held was there and he made fun of the women. He got angry if a woman used certain colors in her work. A guy could use white mixed with red, which is pink, but if a woman used it he would go into a tirade." Pindell continued to use pink, of course, as did [Joan] Snyder and [Mary] Heilmann, sometimes to such an extent that their work feels like a bit of a dare—a cocky demand that the viewer look past, or better yet through, the sickly pinks and washy brush strokes of Snyder, or the off-kilter compositions and decidedly domestic references of Heilmann, or the glitter and talcum powder and self-destroying drawings of Pindell to ascertain just what exactly in the end makes a "good" painting.[29]

Canright was not reacting against prescriptive teachers, yet she too adopted colors in her abstractions typically disdained owing to their association with femininity to transform the practices of modernist painting. Given that Canright referred to Frank Stella as an artist who was making a big splash in Europe when she went abroad in 1968,[30] her subsequent paintings need to be considered as a gendered response to the protractor series with their sharply defined bands of bold, bright colors.

Just like Simone de Beauvoir's book *The Second Sex*, which was translated into English in 1953, the art by the women artists of Chicago Imagism pondered the meaning of "femininity" and "woman" in an era when many began to question the assumption that gender differences were innate and universal. Even though the women of the Chicago Imagist movement did not identify themselves as feminists, or participate in feminist circles in Chicago, their art manifests a complex critique not just of female beauty culture but also of modernist painting.

[1] Several excellent essays published recently that address gender discrimination in the art world of the 1950s and 1960s include: Helen Molesworth, "Painting with Ambivalence," in *Wack! Art and the Feminist Revolution*, ed. Cornelia Butler (Cambridge, MA: MIT Press with Museum of Contemporary Art Los Angeles, 2007), 428–39; and Sid Sachs, "Beyond the Surface: Women and Pop Art 1958–1968," in *Seductive Subversion: Women Pop Artists 1958–1968*, eds. Sid Sachs and Kallipi Minioudaki (New York: Abbeville Press Publishers with University of the Arts, Philadelphia, 2010), 18–89.

[2] I conducted phone interviews with Sarah Canright (September 10, 2010), Suellen Rocca (July 30, 2010), and Barbara Rossi (October 4, 2010), and had an e-mail exchange with Gladys Nillson (October 1, 2010). Unfortunately, Christina Ramberg passed away in 1995.

[3] Friedan worked as a freelance writer when living in the suburbs and raising her children, and she had a background as a labor organizer. See Daniel Horowitz, *Betty Friedan and the Making of "The Feminine Mystique": The American Left, the Cold War, and Modern Feminism* (Amherst: University of Massachusetts Press, 1998).

[4] See Joanne Meyerowitz, "Beyond *The Feminine Mystique*: A Reassessment of Postwar Mass Culture, 1946–1958," in *Not June Cleaver: Women and Gender in Postwar America, 1945–1960*, ed. Joanne Meyerowitz (Philadelphia: Temple University Press, 1994), 229–62; Eva Moskowitz, "'It's Good to Blow Your Top': Women's Magazines and a Discourse of Discontent, 1945–1965," *Journal of Women's History* 8 (Fall 1996): 66–98.

[5] Joanne Meyerowitz, "Women, Cheesecake, and Borderline Material: Responses to Girlie Pictures in the Mid-Twentieth-Century U.S.," *Journal of Women's History* 8 (Fall 1996): 9.

6 Stephanie Coontz, *A Strange Stirring: "The Feminine Mystique" and American Women at the Dawn of the 1960s* (New York: Perseus Books Group, 2011), location 834 on Kindle reader.

7 Interview with Christina Ramberg on March 6, 1990, by Kerstin Nelje, quoted in Kerstin Nelje, "Christina Ramberg and Luce Irigaray: A Feminist Analysis of Ramberg's Female Figures," (MA thesis, School of the Art Institute of Chicago, 1990).

8 Judith Russi Kirshner, "Formal Tease: The Drawings of Christina Ramberg," in *Christina Ramberg Drawings*, exh. cat. (Chicago: Gallery 400, University of Illinois at Chicago, 2000), 20.

9 Carol Becker, "Christina Ramberg in Retrospect," in *Christina Ramberg: A Retrospective 1968–1988*, exh. cat. (Chicago: The Renaissance Society at the University of Chicago, 1988), 19.

10 Interview with Christina Ramberg on March 6, 1990 in Nelje, "Christina Ramberg and Luce Irigaray," 3.

11 Kirshner, *Christina Ramberg Drawings*, 11.

12 Dennis Adrian, "Christina Ramberg," in *Christina Ramberg: A Retrospective 1968–1988*, 4.

13 Amanda Brown, "The Return of the Corset: The Merry Widow," www.loti.com/fifties_fashion/The_Merry_Widow.htm.

14 Jennifer Scanlon, *Bad Girls Go Everywhere: The Life of Helen Gurley Brown*, (New York: Oxford University Press, 2009), 108. According to Scanlon, the focus was on heterosexual women only at the insistence of her publisher. Scanlon offers a penetrating comparison of Friedan and Brown in her book on pages 98–110.

15 For an excellent summary of the debates among women about the sexual objectification of women at midcentury, see Meyerowitz, "Women, Cheesecake, and Borderline Material," 9–35.

16 Scott H. Snyder, *Women and Chicago Imagism*, exh. cat. (Rockford, IL: Rockford Art Museum, 1996), 8.

17 Dan Nadel, "Hairy Who's History of the Hairy Who," *Ganzfeld* 3 (2003): 134.

18 Harold Rosenberg, "Masculinity," *Vogue*, November 25, 1967, 106.

19 Art Green states, "When I was a kid, I really liked *Mad* and the drawings of Basil Wolverton." Karl Wirsum also comments that he was interested in the early *Mad* as well as the EC Comics *Frontline Combat, Shock Suspense Stories*, and *Tales from the Crypt*. See Nadel, "Hairy Who's History of the Hairy Who," 137 and 139.

20 Maria Reidelbach, *Completely Mad: A History of the Comic Book and Magazine* (Boston: Little, Brown and Company, 1991), 50.

21 Joan Siegried, "The Spirit of Comics," *Art 'n' Artists* (December 1969): 21.

22 See David Katzive, "Crème de la Phlegm—Hairy Who II," *Hyde Park Herald*, March 8, 1967; Franz Schulze, "An Exuberant Era Takes Off In Chicago Art," *Chicago Daily News*, March 11, 1967; Norman Mark, "Just Call Us the Sweat Set," collected clippings in the Hyde Park Art Center Papers, box 1, Archives of American Art, Smithsonian Institution.

23 Gladys Nilsson in Nadel, "Hairy Who's History of the Hairy Who," 128.

24 For information about the feminist art scene in Chicago, I am indebted to Matthew Rohn, "Feminism and Chicago Art Today," in *Chicago: The City and Its Artists 1945–1978*, exh. cat. ed. Diane Kirkpatrick (Ann Arbor: University of Michigan Museum of Art, 1978), 48–51; see also Linn Hardenburgh and Susan Duchon, "In Retrospect—The Midwest Women Artists' Conference," *Art Journal* 35 (Summer 1976): 386.

25 Nilsson is the most adamant about insisting that she never experienced any gender bias. She states that the only concern was/is that the art is good not male or female. Gladys Nilsson, e-mail message to author, October 1, 2010. Helen Molesworth, analyzing why women artists of the 1960s routinely rejected an identification based on gender or with feminism, calls on Peggy Phelan's work. Phelan argues that the feminist awakening was based as much on the trauma of identification with the subaltern position as on liberation. Molesworth goes on to quote critic Lucy Lippard, who wrote of her own awakening to feminism: "I was decidedly not accustomed to identifying with female underdogs . . . I made it as a person, not as a woman, I kept saying." Helen Molesworth, "Painting with Ambivalence," 431–32.

26 Author interview with Sarah Canright, September 10, 2010.

27 "What Is Female Imagery?" *Ms.*, May 1975, 63.

28 Dennis Adrian, "Barbara Rossi," in *Barbara Rossi Selected Works: 1967–1990*, exh. cat. (Chicago: The Renaissance Society at the University of Chicago, 1990), 10.

29 Helen Molesworth, "Painting with Ambivalence," 434.

30 Author interview with Sarah Canright, September 10, 2010.

JEST DIGESTION

[TRULY AWFUL] PUNS, [GENITALIA] JOKES, AND [CAUSTIC] WIT IN CHICAGO IMAGISM

LYNNE WARREN

First of all, before anyone gets upset, the title of this essay is supposed to be funny. Yes, humor is a funny thing, but there is one thing about the topic that is certain: What is funny to some isn't necessarily funny to others. There's no accounting for humor one might say. To further complicate things, there are those who seem to be humorless.

But even for those of us who laugh at the drop of a hat or seek out brutally dark wit in literature or film, when it comes to contemporary art, humor is hardly the first thing that comes to the fore. There are individual artists and even a few art movements where humor is an important consideration. Yet it can be difficult to summon how one should approach humor in these works of art, as there is little art world context to support such an approach. A search of "humor and art" on the Internet, for example, yields a mystifying episode of PBS's *Art:21* series titled "Humor." It is introduced by comedian Margaret Cho who visits an embarrassingly bad shtick on dancer/media artist Charles Atlas. Then, the hardworking performance artist Eleanor Antin, the scatological draftsman Raymond Pettibon, the abstract painter Elizabeth Murray, and neo-Audubonian illustrator Walton Ford are set forth as examples of the use of "irony, goofiness, satire, and sarcasm" in contemporary art. A complete viewing of the segments yields none of these things. Very much reflecting the nature of their art, Antin is sincere, Pettibon dour, Murray insecure, and Ford pedagogical. And even taking into consideration Pettibon's comic book–inspired drawings and Murray's Max Fleischeresque shapes (which while shown are never mentioned as such), nothing explains why these four artists were grouped together in an episode called "Humor."

This interesting nugget embedded in a review of the 2010 *Whitney Biennial* clarifies things a bit: Peter Schjeldahl wrote, "Charles Ray is a gadfly conscience of a culture given to the myth that artists are free to do whatever they like."[1] Whether Schjeldahl meant this to be a positive or negative comment about art world favorite Ray is considerably more difficult to figure than the truth of the observation. Even a somewhat casual observer of twentieth-century art can't help but notice that artists are really not free to do whatever they want, and when they do "do whatever they want," they are often marginalized or ignored. A recent (and riveting) exhibition at the Arts Club of Chicago demonstrated how George Grosz, highly celebrated as a "provocative modern artist" for his Dadaist innovations and for pen-and-ink drawings done during the Weimar Republic, was considered more or less washed up after he left Germany in 1933.[2]

Chicago's own H. C. Westermann offers another more recent example. When Westermann's work appeared in the 1959 Museum of Modern Art exhibition *New Images of Man*, he was described by critic John Canaday as a clown who mistakenly shows up at a snitzy dinner party.[3] To this day, Westermann is described as an eccentric "out of the mainstream" figure who, in the minds of many, apparently did not fully understand the depths and intricacies of contemporary art making. In her review of a 2001 exhibition of Westermann's work that I curated at the Museum of Contemporary Art, Chicago, Katy Siegel writes:

People often complain, and they're probably right, that there are two kinds of art: the kind the art world likes and the kind everyone else likes. To appreciate the former, you have to know something about art history; the latter holds an immediate, broad appeal that doesn't depend on specialized knowledge. Although he has his fans in the art world, H. C. Westermann sits primarily in the latter category.[4]

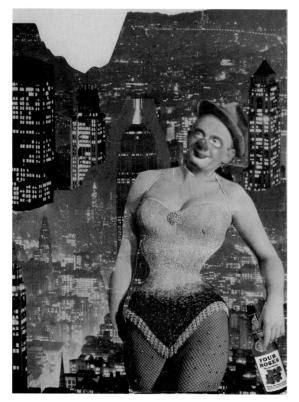

It is especially interesting to note that both Grosz and Westermann relied heavily on humor in their work,[5] but the bigger problem was that neither artist paid attention to the tacitly accepted parameters of the art world that are set at various times and places. In the same review of Westermann Siegel writes, "His work was peculiar, and peculiarly, American, even in the '50s and '60s, a time when most American artists were focused on European modernism," as if Westermann had made some sort of error. Apparently Grosz made the mistake of leaving behind his style—which savagely skewered politicians, the bureaucracy, and the military—to explore more personal work; his late collages, especially *Myself and New York* (1957) have haunting resonances with Ed Paschke's work.

There are many other examples of artists lauded then discarded, or discovered too late, or valued only by other artists, or known and appreciated only in a certain region. And for those artists grouped under the rubric Chicago Imagists, there is a double whammy. The Chicago Imagists, many of whom are represented in the McClain collection, have been—certainly up to now—best known in Chicago and the upper Midwest. And yes, their art features content not generally supported in twentieth-century art, especially wit and humor. Double whammy indeed. But the experience of Imagist art through the lens of humor is an aspect—especially as we move well into the twenty-first century and the movement looks toward its fiftieth birthday—that needs to be more fully explored.

It just has to be accepted that the classical aspects of comedy—humor, wit, jokiness, satire, farce, and so on—are not common features of visual art either historically or today. Sometimes it is allowed in the back door, so to speak, when those who are primarily cartoonists become popular as fine artists: Saul Steinberg and Robert Crumb for example. Sometimes the bravura of artists with their chosen media and larger-than-life personae make them impossible to ignore, such as Robert Arneson or Peter Saul. There are the gentle humorists, the chiders, so to speak, such as Claes

Oldenburg with his small, common things made monumental. There are the provocateurs such as René Magritte (dour variety) or Yves Klein (exuberant variety). (Interesting that these artists who use humor are all men!) And despite what we've heard from the producers of Art:21, there are contemporary figures who do consistently use humor and other aspects of comedy in their work, notably the Russian duo Komar and Melamid, and more recent figures including Mike Kelley, Christian Jankowski, and David Shrigley.[6] But rarely has an entire movement shown so many of the aspects of comedy as what has come to be called Chicago Imagism.

It has not gone unnoticed, of course, that Chicago Imagism often comic element. Comics proved to be very influential among the artists who later came to be grouped under this rubric—Roger Brown, Art Green, Jim Nutt, Gladys Nilsson, Ed Paschke, Christina Ramberg, Suellen Rocca, Karl Wirsum, among others—whether daily newspaper comic strips or comic books. Yet as even a casual observer of the comics knows, not all "funnies" are funny. Indeed, the range of styles in the medium is as broad as that in any of the literary arts, from serious drama to evanescent looniness. This said, along with formal influences from comics—outlined figures, expanses of unmodulated color, hierarchal compositions, narrative action—the Chicago Imagists also feature a great deal of comedy.

This tendency has not gone unnoticed either. Over the years critics have described Jim Nutt's work as "a surrealistically comic vision of human psychosexual life."[7] Karl Wirsum is "addicted to puns of all sorts, especially outrageously corny ones."[8] Ed Flood displays "cheeky pictorial humor."[9] "With mordant humor, [Christina] Ramberg forced alternative meanings from aesthetic reversals and telling juxtapositions of bandages and veils," Judith Russi Kirshner writes.[10] Franz Schulze describes Gladys Nilsson as "coolly tongue-in-cheek, fey and fastidious," contrasting her to the "dead-serious icons" or "delicately hushed hallucinations" created by earlier Chicago artists.[11]

A tendency toward the comic has also been noted in evaluations of the larger group. In his initial introduction of the younger generation in his classic book *Fantastic Images*, Schulze characterizes the Hairy Who group as demonstrating "horseplay" and notes they "spoof the city's [Chicago's] crassness."[12] Russell Bowman, a leading Imagist scholar, wrote in 1980 that a major "characteristic which seems to link most Chicago Imagist work is a literary one: an involvement with language, narrative, and signs . . . [P]uns, malapropisms and misspellings have become an Imagist mainstay . . . they embrace paradox, irony and humor, again, not as a statement but as a method."[13]

In tackling the topic of humor in Imagist art, it is important to remember that despite the grim seriousness of the times in which the Imagists emerged—the Cold War tensions, student protests, carnage in Vietnam, civil rights movement, assassinations of John F. Kennedy and Martin Luther King—or perhaps as a reaction to these world-changing events, there was frivolity in the air. Humor was goofy, lighthearted, irreverent.[14] This was the time of the passing of the well-crafted joke and traditional straight man and goof-up foil (Bob Hope, Abbott and Costello) and the rise of parody and absurd humor (Bob and Ray) and the ascendance of wordplay and stream of con-

H. C. Westermann
He Whore, 1957
Plywood, vermillion, oak, maple, walnut,
fir, birch, mirror, paint, chromium-plated brass,
cork, rope, and U.S. dimes
23 ½ x 11 ½ x 20 inches
Collection Museum of Contemporary Art, Chicago,
gift of the Susan and Lewis Manilow Collection
of Chicago Artists
Art © Lester Beall, Jr. Trust/Licensed by VAGA,
New York, NY

sciousness in humor (Firesign Theater, Monty Python).[15] Those lovable lads from Liverpool were on full wacky display in 1964's *A Hard Day's Night*. The animated feature *Yellow Submarine*, with its gentle but surreal looniness, was a huge hit in 1968.

People were reading the satiric black humor of Kurt Vonnegut, the fantastic insanity of Joseph Heller, the comic novels of Kingsley Amis.[16] As much as is often made of the Chicago Imagist artists being "apart from the mainstream," again, this is more art world myopia than an accurate observation. They were certainly "apart from the mainstream" if one defines the mainstream as the art world as viewed from New York. And in the 1960s when they emerged as mature artists, unfortunately this was all too true. But if one takes the more sensible (and currently more acceptable) viewpoint of observing art making in a larger cultural context, the Chicago Imagists were completely of the mainstream of their time. The influences on their work, including their sense of humor, were in harmony with those of the rising generation of the day, the so-called hippie generation: those who listened to psychedelic rock, got muddy at Woodstock, and dug jazz, Lenny Bruce, and *Mad* magazine.[17] Many of the Imagist artists, notably Jim Nutt and Gladys Nilsson, cite movies as inspirational. The artists who came to be known as the Chicago Imagists, not to be overly dramatic, were youth culture in action.

The Chicago Imagists certainly had their detractors. Besides those who did not appreciate their sense of humor, there were those who thought the work frivolous, badly conceived, uninterestingly executed, or downright puerile. This did not phase the artists. The very name Hairy Who was at the expense of a stentorian-toned radio critic popular in the early 1960s in Chicago. Jim Nutt painted Zzzit in 1970 partly to further aggravate Franz Schulze, who had denounced Nutt's work as unbearably immature [p.66]. A frequent target of Roger Brown's was Alan Artner, the longtime *Chicago Tribune* art critic who largely dismissed the Imagists as decorative or too obsessed with craftsmanship. Brown created one of his most acerbic images with the painting *Alan Artner, Ironic Contortionist of Irony* (1993) in which the critic is shown with his head up his ass. The humor in this image—as disturbing as it is—of mimicking an old circus sideshow banner, might understandably have been lost on Artner.[18] Joanna Frueh, a former Chicagoan, published a trenchant article in 1978 on the interrelationships among youth culture and the biting humor of Wirsum, citing *Split Beaver Broad* (1971), a large articulated figure, as an example of the complexities of these relationships. "On one level, the woman is ridiculous—an outlandish joke demeaned by her own sexuality. The situation is at once funny, pathetic, and provocative." Frueh goes on to say that "since the late 1960s imagism has become an art of provocation, and though it may make us laugh, the chuckles don't last long, for an art of provocation is ultimately irritating and not amusing."[19] Frueh's viewpoint on Imagist humor as decadent and ultimately destructive to cultural values is, however, definitely in the minority.

Having had the opportunity to observe audiences viewing the work of the Chicago Imagists in two recent MCA exhibitions, it is clear that while the mainstream art of 1960s New York—Minimalism and Pop art—is respected and even sought out by a younger demographic, it is the glow of official sanctification that seems to be the

appeal.[20] With the Imagists' work, younger audiences seem to be apprehending it directly, for it speaks to their own experience. They know this language, especially the wacky, raunchy humor. Pop art, as has been pointed out, simultaneously utilizes popular cultural imagery and stands apart from it, representing the material with irony or a critical distance. This was art by artists—Andy Warhol, Roy Lichtenstein, Robert Rauschenberg—who fully knew that what they were putting forth was the accepted, even lauded art of the day. Because the Imagists dealt with popular culture directly and integrated it fully into their visual language, they speak directly to contemporary audiences who have been raised on the notion of popular culture as "the culture"—TV, cartoons, music, movies, pulp fiction, graphic novels, stand-up comedy (as opposed to

religion, mythology, historical and classical art references, poetry, literature, etc.)—and are not puzzled by its appearance in art. In this sense, the Chicago Imagists are a lot more "mainstream" than their New York peers ever were.

It is important, however, to note that the humor in Imagist art certainly does not stem solely from popular culture. The French artist Jean Dubuffet, admired both for his work and his interest and support of untrained artists (l'Art Brut), was the subject of a large retrospective at the Art Institute of Chicago in 1962. Jim Nutt specifically cites this exhibition as important, but the appreciation of folk and outsider art as well as vernacular forms and humor as demonstrated by

Jean Dubuffet
Flies in the Face, 1948
Gouache on cream wove paper
18 x 22 ¼ inches
Gift of Mr. and Mrs. Joseph R. Shapiro,
The Art Institute of Chicago
© 2008 Artists Rights Society (ARS),
New York / ADAGP, Paris

Dubuffet with such works as *Flies in the Face* (1948) was inspirational to the larger Chicago community.[21] Many of the Chicago Imagists refer to Giorgio de Chirico, specifically the iconic *The Philosopher's Conquest* (1913–14) with its sexual visual puns in the form of a cannon and cannon balls and two artichokes.[22] Surrealism in general—with its bizarre and unexpected visual language, its focus on the expression of the subconscious mind, and its emphasis on narrative content—is another important art historical influence.

As with any aspect one examines in the work of the Chicago Imagists, there is a wide range and degree of humor to be found. Karl Wirsum's work seems to be the most jokey, playful, and animated by puns, irony, visual gags, and general high spirits. While Jim Nutt's works of the Hairy Who period also frequently feature puns as titles, this tendency in Wirsum has continued to the present. And they are unsurpassed in sheer bravado. There is *Genuine Genie Wine* (1969), a papier-mâché genie coming out of

a bottle, and the multiple he made for the Museum of Contemporary Art, Chicago, consisting of two articulated cutouts, *Hare Toddy* (a rabbit) and *Kong Tamari* (a gorilla), namely: "Here today, gone tomorrow." In the present exhibition, Wirsum is featured with *Strangers on a Terrain* (2004), which depicts a man and a mammal of some sort in a desertlike landscape. It is doubtful the reference to the well-known Alfred Hitchcock film is anything more than wordplay given the highly disparate subjects of the two artworks. *Stork Reality* (1985) [p.97] is a particularly successful "truly awful pun," featuring a very round and insistent infant.

While Nutt's punning days may be behind him, the rich wordplay of his Hairy Who years extends beyond the titles of the works. Nutt was particularly fond of rebuses, those picture-and-word puzzles. In his masterful *Zzzit* (1970), a rebus across the bottom of the work says, "Lips that make the eyes go blooey!" This inscription refers not to the main figure of a man's body running out of the picture plane, but to the small image of a woman in the upper left corner as reflected in a mirror. Nutt also contributed the cover of the *Hairy Who (cat-a-log)* (1968), a comic book that accompanied the 1969 exhibition at the Corcoran Gallery of Art, Dupont Center, Washington, D.C., illustrating the title "cat-a-log" as a rebus.

Nutt's sense of humor is particularly on display in the two-part work *He Might Be a Dipdick But They Are a Pair* (1972), and it somehow manages to be mordant and whimsical all at the same time [p.68–9]. The corruption of the term diptych—a traditional art historical term that describes a two-part work—allows for particularly loaded piece of sexual slang. The piece consists of two freestanding acrylic on paper paintings, one, placed to the viewer's left, shows a male figure, and the other, on the right, shows a female. The reverse side of the female half of the diptych is inscribed with the words "It doesn't bother her" and below this inscription, "stoud [sic] up by Jim Nutt," a double entendre referring both to the fact that the piece stands by means of a little bracket constructed by the artist and to the treatment the man has perpetrated on the woman. On the back of the male half of the work is written "Somethings not quite right!" and "braced for the occassion by Jim Nutt," another double entendre referring both to artwork's physical nature and its narrative. Behind the image of the man is a large landscape formation, a mesa, perhaps, supporting the vaguely Navaho patterning of the man's clothing. The piece itself is cut in the shape of this formation. Above the image of the man is a long narrow box, reminiscent of a cartoon strip, featuring three images with accompanying captions. There is a sort of strange dog/skeleton image, below which is written "his presense." A tattooed man's back is in the center with the caption "his back." Finally on the right is a sort of bizarre mash-up of harpy and putti, a woman with an odd hairdo and sharp fierce wings with the caption "his dream."

The woman is blank faced—her features consist entirely of fabric-like patterning that is reminiscent of Ray Yoshida's forms as seen in works such as *Unreasonable Lineage* (1975). The shaped backdrop to the anonymous face, in stark contrast to the voluptuous forms of the backdrop for the man's portrait, is spiky, filled with tension. The woman's accompanying familiars, so to speak, are "her boyfriend" (a sad-faced man), "herself" (nude and in a provocative but submissive sexual position), and "her

friend" (a straightforward, concerned-looking woman). The narrative associations are rife with raunchy humor, biting commentary on sexual mores, and high-spirited visual invention.

Another work in the current exhibition, *Toot 'n Toe* (1969), is an example of Nutt's humor at its raunchiest: The "toot" of the title refers to the large naked man's passing of gas, which propels him upward in a swarm of images of "killer women." Here Nutt presents "image play" as opposed to wordplay, for his women are not only extraordinarily attractive—the vernacular meaning of "killer women"—but perhaps literal killers, for one is presented along with a very large knife [p.55].

Gladys Nilsson's work, well represented in the McClain collection, is certainly not "laugh out loud" material, but throughout her career she has plied in playful, sometimes downright goofy imagery. Her color (luscious and translucent watercolor) and graphic technique (long loping lines and layers of imagery) is entirely pleasant, despite any strange goings-on that might reveal themselves at closer inspection. *Beautify* (1994) is pure vintage Nilsson: Two female figures face each other, or perhaps it is the same image reflected in the mirror. At any rate, one scowls and the other smiles. The message is clear: Beauty is in the spirit and the character of a person, not the physical appearance. *Smart Dressing* (1989) is high-spirited: A dashing and rather self-satisfied couple show off their sartorial splendor; sallow onlookers cast what seem to be envious eyes. A smaller couple—the use of hierarchical scale of figures is a common feature of Nilsson's work—looks up from the smart dressers' knees. The woman is delighted; her companion seems disgruntled. All in all, the work is a loaded comedic passage in which Nilsson, with consummate skill, renders facial expressions, body language, and articles of clothing in a farcical masquerade of male and female preening and the envy evoked by such. Nilsson has cited the often-farcical screwball comedies of Preston Sturges as influential on both the action and hierarchical nature of figures in such works.[23]

Ern (1999) aims its wit at the artist herself (standing in for all artists)[p.100]. The female figure looks up with trepidation and perhaps a little disgust at a large vase of flowers. If one looks carefully at the work, one can see a tiny vase of flowers set up on a bright runner of cloth; this is probably the "real" still life while the outsized vase is how it looms in the artist's imagining of how to tackle the artistic task. A small male figure lounges leisurely at the picture's bottom. And again, the sexual narrative cannot be denied. The flowers are stand-ins for human genitalia. The ripe flowers of the still life spill out pollen; spermlike forms swarm among the blooms.

While Suellen Rocca's titles or subject matter are not really comedic, the fact that she "framed" the work *Night Light for Little Girl* (1969) with a diaphanous frill of fabric certainly shows a spirited sense of humor. The dizzy sense of girlhood and female adolescence she conveys with her chalky, not quite pastel colors and body fragments, untethered palm trees (a motif common to many of the Imagists), handbags, shoes, and other everyday accoutrements and clothing items achieve a buoyant sense of youthful tomfoolery, foreshadowing the more serious entanglements life inevitably has to offer [p.62].

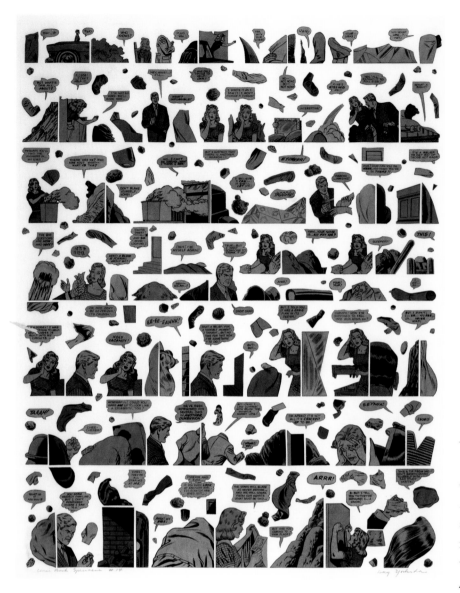

Ray Yoshida
Comic Book Specimen #14, 1969
Collage on paper
24 x 19 inches
The Bill McClain Collection of Chicago Imagism,
Madison Museum of Contemporary Art

Christina Ramberg in many ways seems the more austere of the Imagists. Even though her mostly monochromatic palette lightened up in the 1980s and early 1990s before her premature death in 1995, the unrelenting quality of her line and forceful geometric compositions inevitably read as rigorous. Her untitled 1975 work in the Mc-Clain Collection may at first glance even seem to be an abstract painting, yet it is part of a series of hairdo works, including Christina Ramberg's *Glamour Guide* (1973), which shows various hair styles in profile. In *Untitled* (ca. 1975), the hair seems to be made up of braided hairpieces, but presented like chocolates in their little fluted paper cups they look suspiciously like Fannie Mae Pixies [p.78]. The tongue is not only in the cheek; one can also feel the mouth salivate. Bound by their bras, corsets, garter belts, and hosiery, Ramberg's women come unsettlingly close to being sadomasochistic representations, but the visual inventiveness (not to mention the feminist message) more than rescues the work from mere prurience. In *Vertical Amnesia* (1981), Ramberg merges what seems to be a male body with structures that hark to her earlier series of chair backs [p.84]. Her untitled series of 1981, two of which are featured in the present exhibition, are considerably more whimsical, combining dress silhouettes with flattened medallion-like forms.

Art Green's hard-edge, geometric style reflects that of Ramberg, but Green favors brilliant clear color and more realistically represented objects. He also delves into trompe l'oeil, that original visual arts comedy trope. The claustrophobic interior of *Regulatory Body* (1969) is revealed by the peeling away of the image in the lower right to be but a backdrop that hangs in front of a moonlit sky [p.2]. The title, which can translate as "body control" or "regulatory body" as well as refer to mechanical parts or even body lotions or emollients, gives only a clue to what is a surrealistic work filled with ridiculous images including an ice-cream cone bound with meshing gears and chain link fencing and a Baby Ruth bar, cracked open to look like a giant maw. Parted theatrical curtains reveal a room trimmed with traditional architectural molding, which

apparently is a stage set, as further back beams and struts appear. The obvious sexual references of the candy bar mouth ready to devour the bound and distended ice-cream cone genitalia make the image even more outrageous.

Ray Yoshida, who was an important teacher for Nutt, Nilsson, Brown, and others, directly uses comic book imagery in the collage works *Comic Book Specimen #2* (1968) and *Comic Book Specimen #14* and *Untitled* (both 1969). Laid out in lines across the picture plane (much like Brown organized his compositions), the works form bizarre, engaging, surreal narratives.

Roger Brown may at first view seem the least humorous of the Imagists, yet it does not take a great deal of study to see that many of his works feature the blackest of humor, often in the form of witty, bitingly caustic commentaries on American culture. The early work *Tourist Trap* (1974) is typical. Formations reminiscent of those found in Arches National Park provide the backdrop for an oversized swimming pool where tourists do their laps, oblivious to the magnificent natural splendor the human construction has despoiled. In the Madison collection, *Welcome to Siberia, the Nuclear Freeze, the Flat Earth Society, No Nukes, and the Dark Ages (When the Earth was Flat and the Evening Sun was Red From Looking Down Into Hell)* (1983) is a prime example of black humor [p.95]. This large canvas lays out, in Brown's characteristic schematic way, a numbing array of intercontinental nuclear missiles and nuclear power plants to demonstrate the folly of the superpower America. The two large disks that are the focus of the composition are not dissimilar to the Looney Tunes logo, an orange disk of concentric circles from which the titles or characters pop out. In Brown's discourse, one disk features sixteenth-century galleons, one of which falls off the edge of the expanse of earth that hovers before the angry red of the title's evening sun. The other disk shows cooling towers, their steam rising high in an otherwise bucolic landscape. The message is clear: The ignorance that allowed our ancestors to believe the earth was flat still plagues us. When are we ever going to learn? Only by being hyperbolic and almost terminally cynical, both characteristics of black humor, can the artist's message cut through the blather of aesthetic politeness of the art world herd.

Ed Paschke's work does not really seem to fall under the rubric of comedy, pointing out that the grouping "Imagism" is indeed an elastic one that fits some better than others.[24] Paschke's formal methods as well as his subject matter set him rather firmly apart, not only from the Hairy Who artists (Nutt, Nilsson, Rocca, Green, Wirsum) featured in Madison's collection, but also from others associated with Imagism as well, such as Sarah Canright, Ed Flood, Barbara Rossi, Phil Hanson, and Ray Yoshida. His works of the 1970s, while showing outlandish stylization, as can be seen in the lithograph *Tudor* (1976), cannot really be said to contain any elements of humor, and his subsequent work—often described as being influenced by the way images appear on television screens—seem likewise to resist analysis in the comedic sphere [p.79].

Yes, comedy, to corrupt the saying a bit, is in the eye of the beholder. Chicago Imagism may not appeal to every taste, but for those with a thirst for the comedic in their visual art, it is a reliable place to visit.

Postscript

Titles of works in the Madison Museum of Contemporary Art collection

[Truly Awful] Puns
- *Dish Jockey*, Gladys Nilsson
- *Tight Hipped*, Christina Ramberg
- *Eye Deal*, Barbara Rossi
- *Stork Reality*, Karl Wirsum

[Genitalia] Jokes
- *Problematical Tripdickery*, Gladys Nilsson (an etching done as a triptych)
- *He Might Be a Dipdick But They Are a Pair*, Jim Nutt (a painting done as a diptych)

[Caustic] Wit
- *Welcome to Siberia, the Nuclear Freeze, the Flat Earth Society, No Nukes, and the Dark Ages (When the Earth was Flat and the Evening Sun was Red From Looking Down Into Hell)*, Roger Brown
- *Really?* Ray Yoshida

[1] Peter Schjeldahl, "The Art World: No Offense, the Whitney Biennial," *New Yorker*, March 8, 2010, 80.

[2] *George Grosz in America: 1933–1958*, May 12–July 23 2010. The press release accompanying the exhibition acknowledges that "Grosz is known for the work he produced in the 1910s and 1920s at the beginning of his career while living in Germany . . . He left Germany in 1933, only weeks before the Nazis declared him an enemy of the state . . . In America he continued to produce work that railed against greed and brutality, but created from his new vantage point the art did not carry the same impact. His portfolios of watercolors, prints and drawings were not successful, and many assigned to the American output a lesser status."

[3] John Canaday, "Art: New Images of Man," *New York Times*, September 30, 1959. The exact quote is "a guest who arrived in a clown suit, forty years late for a costume party, to find a formal dinner in progress."

[4] Katy Siegel, *Artforum* 40, no. 2 (October 2001): 151. Siegel goes on to note that "he lived in the city for only a few years after attending the Art Institute but unmistakably bears the Chicago imprint: expressiveness, surrealism, funky materials, a love for visual and verbal puns (traits shared by Jim Nutt, Karl Wirsum, and others)."

[5] Leading Imagist expert Russell Bowman postulated in a 1985 article that Westermann is the spiritual godfather of much of the Imagist sense of humor. Bowman points out his works were often visual puns (such as *The Big Change* of 1963, which is a laminated plywood construction of a knot) or combined image and text, the texts often vernacular and playful, featuring the willful misspellings that characterize many of the inscriptions and titles of the Imagists. While Westermann's influence on the Imagists in general regarding wordplay has been perhaps overstated, he definitely influenced Nutt in this regard. Russell Bowman, "Word and Images: A Persistent Paradox," *Art Journal* 45, no. 4 (Winter 1985): 339.

[6] There are increasing numbers of artists, especially those who use video, who do focus on humor in their work, but generally in an ironic, conceptual fashion, or they use humor in a piece or two without really making it central in their artwork. A 2005 exhibition circulated by ICI called *Situation Comedy: Humor in Contemporary Art* noted this tendency and presented sixty artists including Christian Jankowski and David Shrigley and others such as John Waters and Richard Prince. Presenting institutions and reviewers alike cited it as a rare opportunity to laugh while viewing art.

[7] Ken Johnson, *Art in America* 80, no. 2 (February 1992): 85.

[8] Dennis Adrian, *Karl Wirsum: A Retrospective Exhibition*, exh. cat. (Urbana, IL: Krannert Art Museum, University of Illinois at Urbana-Champaign, 1991), 20.

[9] Robert Storr, "Tropical Isles for a Cold Climate," in *Ed Flood: Constructions, Boxes & Works on Paper*, exh. cat. (Chicago: Corbett vs. Dempsey Gallery, 2010), 9.

[10] Judith Russi Kirshner, "Formal Tease: The Drawings of Christina Ramberg," in *Christina Ramberg Drawings*, exh. cat. (Chicago: Gallery 400, University of Illinois at Chicago, 2000), 11–27.

[11] Franz Schulze, *Fantastic Images* (Chicago: Follett Publishing Company, 1972), 7.

[12] Ibid., 161.

[13] Russell Bowman, "Chicago Imagism: The Movement and the Style," in *Who Chicago? An Exhibition of Contemporary Imagists*, exh. cat. (Sunderland, UK: Ceolfrith Gallery, Sunderland Arts Centre, 1980), 27, 28.

[14] Joan C. Siegfried, in her essay in the exhibition catalog *The Spirit of the Comics*, writes that the Hairy Who's use of such motifs as hair calls up multiple "serious issues" but they use a "fantastic comic book" to address them, which leads to discussion of black humor and a Bruce Jay Friedman quote that points out that "a new Jack Rubyesque chord of absurdity has been struck in the land . . . a new mutative style of behavior [is] afoot, one that can only be dealt with by a new, one-foot-in-the-asylum style . . . there is an awful lot of questioning these days, some of it despairing . . . some of it young, vigorous, outrageous— throwing you laughs to get you to lower your guard." Joan C. Siegfried, "Art from Comics," in *The Spirit of the Comics*, exh. cat. (Philadelphia: Institute of Contemporary Art, University of Pennsylvania, 1969), unpag.

[15] Firesign Theater, the legendary audio comedy group, first emerged in 1966. There were proto–Monty Python appearances on British TV as early as 1964. *Monty Python's Flying Circus* first aired in Britain in 1969 and the United States in late 1974, the year the show ended its UK run.

[16] Gladys Nilsson cites Kingsley's combination ghost story, moral fable, and black comedy *The Green Man* (1969) as the inspiration for her painting of the same name.

[17] It is important to clear up recent misperceptions that Nutt and others of the Chicago Imagists were influenced by *Mad* magazine, in particular Basil Wolverton, as is claimed in a poorly re-searched book by Glenn Bray, *The Original Art of Basil Wolverton: From the Collection of Glenn Bray*. Nutt denies ever reading *Mad* as a youth, and claims as a young artist he was not familiar with Wolverton's work. It is frankly much more interesting to think of Wolverton and Nutt as both arising out of the same popular cultural soil of the late 1950s and early 1960s. Author interview with Jim Nutt, March 13, 2010.

[18] Brown also memorably lampooned Jeff Koons in the painting *57th Street (After Sunset Blvd.)* (1988), which conflated the story of the movie *Sunset Boulevard*—in which a young stud uses an aging movie star to get ahead—with Koons's emergence as an art star. The painting is laid out in a series of comic strip boxes.

[19] Joanna Frueh, "Chicago's Emotional Realists," *Artforum* 17, no. 1 (September 1978): 42.

[20] *Everything's Here: Jeff Koons and His Experience of Chicago*, 2008, and *Seeing Is a Kind of Thinking: A Jim Nutt Companion*, 2011. An Andy Warhol show that appeared at MCA in 2006 generated one of the highest attendances ever, and the demographic skewed heavily toward the under thirty-fives.

[21] Franz Schulze, "Art in Chicago: The Two Traditions," in *Art in Chicago: 1945–1995* (London and Chicago: Thames and Hudson and Museum of Contemporary Art, 1996), 50.

[22] See "A gallery of some of Roger Brown's favorite art objects at the Art Institute of Chicago and elsewhere," in *Roger Brown* (New York and Washington, D.C.: George Braziller, Inc. and the Hirshhorn Museum and Sculpture Garden, 1987), 102–3.

[23] David Russick in *Gladys Nilsson*, exh. cat. (Chicago: Jean Albano Gallery, 2000), 2.

[24] In person Paschke was apparently quite a card. Karl Wirsum describes being with Paschke as "like working on a comedy routine." *Chicago Gallery News*, www.chicagogallerynews.com/pdfs/ArtistJan11.pdf.

PLATES CHECKLIST

Art Green
Regulatory Body, 1969
Oil on canvas
75 ¼ x 57 ¼ inches
The Bill McClain Collection of Chicago
Imagism, Madison Museum of
Contemporary Art

Karl Wirsum
Moon Dog First Quarter, ca. 1966–1967
Oil on linen
38 ½ x 25 ½ inches
Gift of the Raymond K. Yoshida Living
Trust and Kohler Foundation, Inc.
Collection of Madison Museum of
Contemporary Art

Karl Wirsum
Untitled (Head of Bearded Man), 1966
Mixed media on paper
13 ¾ x 10 ½ inches
The Bill McClain Collection of Chicago
Imagism, Madison Museum of
Contemporary Art

Suellen Rocca
Game, ca. 1966–1967
Oil on canvas
27 ¾ x 30 ⅞ inches
The Bill McClain Collection of Chicago
Imagism, Madison Museum of
Contemporary Art

Jim Nutt
Rosie Comon, 1967-68
Acrylic on Plexiglas with artist painted frame
37 ¾ x 27 inches
The Bill McClain Collection of Chicago
Imagism, Madison Museum of
Contemporary Art

Jim Nutt
Toot 'n Toe, 1969
Acrylic on Plexiglas with artist painted frame
62 ⅜ x 38 ¼ inches
Gift of Howard and Judith Tullman
Collection of Madison Museum of
Contemporary Art

Jim Nutt
Oh Dat Sally, 1967
Etching on paper
19 ¼ x 14 ⅞ inches
Gift of the Raymond K. Yoshida Living Trust
and Kohler Foundation, Inc.
Collection of Madison Museum of
Contemporary Art

Karl Wirsum
Fire Lady or Monk's Key Broad, 1969
Acrylic on canvas
48 x 35 ¾ inches
The Bill McClain Collection of Chicago
Imagism, Madison Museum of
Contemporary Art

James Falconer
Hateha from *Da Hairy Who*, 1967–1968
Color silkscreen on paper
14 x 11 inches
Gift of the Raymond K. Yoshida Living
Trust and Kohler Foundation, Inc.
Collection of Madison Museum of
Contemporary Art

Philip Hanson
Mezzanine, 1969
Oil on canvas with artist painted frame
21 ⅝ x 19 ½ inches
The Bill McClain Collection of Chicago
Imagism, Madison Museum of
Contemporary Art

Suellen Rocca
Foot Smells, ca. 1966
Oil on canvas with artist painted frame
19 ⅝ x 15 ½ inches
Gift of the Raymond K. Yoshida Living
Trust and Kohler Foundation, Inc.
Collection of Madison Museum of
Contemporary Art

Gladys Nilsson
Landed Bad-Girls with Horns, 1969
Watercolor on paper
11 ⅛ x 14 ¾ inches
Museum purchase, through the
Brittingham Foundation Fund
Collection of Madison Museum of
Contemporary Art

Sarah Canright
Shadow, 1969
Oil on canvas
33 ⅜ x 27 ¼ inches
The Bill McClain Collection of Chicago
Imagism, Madison Museum of
Contemporary Art

Suellen Rocca
Night Light for Little Girl, 1969
Oil on canvas with ruffle
30 x 22 inches
The Bill McClain Collection of Chicago
Imagism, Madison Museum of
Contemporary Art

Christina Ramberg
Head from the portfolio Screen Prints 1970,
1969–1970
Screenprint on paper
14 ¾ x 15 inches
The Bill McClain Collection of Chicago
Imagism, Madison Museum of
Contemporary Art

Gladys Nilsson
Quartets Recording, 1965
Watercolor on paper
12 x 13 ½ inches
The Bill McClain Collection of Chicago
Imagism, Madison Museum of
Contemporary Art

Gladys Nilsson
Veggie Great, 1970
Watercolor on paper
30 ¼ x 21 ⅞ inches
The Bill McClain Collection of Chicago
Imagism, Madison Museum of
Contemporary Art

Jim Nutt
Zzzit, 1970
Acrylic on metal
21 ⅜ x 19 ⅛ inches
The Bill McClain Collection of Chicago
Imagism, Madison Museum of
Contemporary Art

Roger Brown
Untitled (Circus), ca. 1970–1971
Oil on canvas
60 x 48 inches
Gift of the Raymond K. Yoshida Living
Trust and Kohler Foundation, Inc.
Collection of Madison Museum of
Contemporary Art

Jim Nutt
He Might Be a Dipdick But They Are a Pair, 1972
Acrylic on watercolor paper
16 ½ x 13 ½ x 6 inches, each
The Bill McClain Collection of Chicago
Imagism, Madison Museum of
Contemporary Art

Roger Brown
Sudden Avalanche, 1972
Oil on canvas
72 ⅛ x 47 ⅞ inches
The Bill McClain Collection of Chicago
Imagism, Madison Museum of
Contemporary Art

Karl Wirsum
Mity Mite Quilted Twin, 1972
Polychrome on wood with quilted fabric
36 x 18 x 7 inches
The Bill McClain Collection of Chicago
Imagism, Madison Museum of
Contemporary Art

Roger Brown
Mountain Sites, 1973
Oil on canvas
54 x 70 inches
Purchase, through a contribution from
the Wisconsin State Journal
Collection of Madison Museum of
Contemporary Art

Ed Flood
Aluminum Floater #2, 1974
Acrylic on Plexiglas with aluminum frame
31 ⅞ x 24 ⅝ x 2 inches
The Bill McClain Collection of Chicago
Imagism, Madison Museum of
Contemporary Art

Barbara Rossi
Eye Deal, 1974
Acrylic on Plexiglas
39 x 29 ⅛ inches
The Bill McClain Collection of Chicago
Imagism, Madison Museum of
Contemporary Art

Christina Ramberg
Tight Hipped, 1974
Acrylic on Masonite
47 ½ x 35 ½ inches
The Bill McClain Collection of Chicago
Imagism, Madison Museum of
Contemporary Art

Roger Brown
Untitled (Bus), 1975
Enamel on iron
8 ⅜ x 5 ¼ x 5 inches
The Bill McClain Collection of Chicago
Imagism, Madison Museum of
Contemporary Art

Jim Nutt
Don't Make a Scene, 1975
Graphite on paper
11 ¼ x 9 ¼ inches
The Bill McClain Collection of Chicago
Imagism, Madison Museum of
Contemporary Art

Christina Ramberg
Untitled, c. 1975
Acrylic on Masonite
6 x 6 inches
The Bill McClain Collection of Chicago
Imagism, Madison Museum of
Contemporary Art

Ed Paschke
Tudor, 1976
Lithograph on paper
34 ¾ x 28 inches
Museum Purchase Fund
Collection of Madison Museum of
Contemporary Art

Roger Brown
Skyscraper with Pyramid, 1977
Acrylic on wood
71 ½ x 37 ½ x 37 ½ inches
The Bill McClain Collection of Chicago
Imagism, Madison Museum of
Contemporary Art

Art Green
Dead Reckoning, 1980
Oil on canvas/panel
84 ¼ x 47 ¾ inches
Museum purchase, through funds from
Mr. and Mrs. Frederic Renfert
Collection of Madison Museum of
Contemporary Art

Philip Hanson
Untitled (Woman Disrobing), 1979
Oil on board with artist painted frame
27 ¾ x 21 inches
The Bill McClain Collection of Chicago
Imagism, Madison Museum of
Contemporary Art

Karl Wirsum
Measle Mouse Quarantined from His Fans, 1980
Acrylic on wood
24 ⅛ x 15 x 4 inches
The Bill McClain Collection of Chicago
Imagism, Madison Museum of
Contemporary Art

Christina Ramberg
Vertical Amnesia, 198
Acrylic on Masonite
47 ⅝ x 35 ½ inches
Purchase, through funds from George
and Sally Johnson and the Rudolph
and Louise Langer Fund
Collection of Madison Museum of
Contemporary Art

Christina Ramberg
Untitled #13, 1981
Acrylic on Masonite
14 ¾ x 11 inches
Gift of Howard and Judith Tullman
Collection of Madison Museum of
Contemporary Art

Roger Brown
Giotto in Chicago, 1981
Color lithograph and photolithograph
on paper
22 ½ x 30 inches
Gift of the Raymond K. Yoshida Living
Trust and Kohler Foundation, Inc.
Collection of Madison Museum of
Contemporary Art

Ed Paschke
La Chanteuse, 1981
Oil on linen
25 ⅞ x 48 inches
Purchase, through the Rudolph
and Louise Langer Fund
Collection of Madison Museum of
Contemporary Art

Ed Paschke
Pachuco, 1982
Oil on canvas
41 ¾ x 80 inches
The Bill McClain Collection of Chicago
Imagism, Madison Museum of
Contemporary Art

Ed Paschke
Prothesian, 1982
Oil on canvas
42 x 80 inches
The Bill McClain Collection of Chicago
Imagism, Madison Museum of
Contemporary Art

Christina Ramberg
Untitled #15, 1982
Acrylic on Masonite
14 ⅝ x 11 ⅞ inches
Gift of Howard and Judith Tullman
Collection of Madison Museum of
Contemporary Art

Roger Brown
Welcome to Siberia, The Nuclear Freeze,
The Flat Earth Society, No Nukes and The
Dark Ages (When The Earth Was Flat
And The Evening Sun Was Red From Looking
Down Into Hell), 1983
Oil on canvas
48 x 72 ⅛ inches
The Bill McClain Collection of Chicago
Imagism, Madison Museum of
Contemporary Art

Roger Brown
Family Tree Mourning Print, 1983
Woodcut on paper
11 x 14 inches
Anonymous gift
Collection of Madison Museum of
Contemporary Art

Gladys Nilsson
Problematical Tripdickery, 1984
Color etching on paper
22 x 30 inches
The Bill McClain Collection of Chicago
Imagism, Madison Museum of
Contemporary Art

Karl Wirsum
Stork Reality, 1985
Acrylic on canvas
31 ⅞ x 22 ⅞ inches
The Bill McClain Collection of Chicago
Imagism, Madison Museum of
Contemporary Art

Jim Nutt
Wee Jim's Black Eye, 1986
Acrylic on Masonite with painted
wood frame
26 ⅛ x 21 inches
The Bill McClain Collection of Chicago
Imagism, Madison Museum of
Contemporary Art

Jim Nutt
Cheek, 1990-91
Acrylic on linen with wood frame
26 ¼ x 26 ¼ inches
The Bill McClain Collection of Chicago
Imagism, Madison Museum of
Contemporary Art

Gladys Nilsson
Ern, 1999
Watercolor and gouache on paper
40 ½ x 25 ¾ inches
The Bill McClain Collection of Chicago
Imagism, Madison Museum of
Contemporary Art

Jim Nutt
Untitled, 2002
Graphite on paper
15 x 14 inches
The Bill McClain Collection of Chicago
Imagism, Madison Museum of
Contemporary Art

Jim Nutt
Untitled, 2008
Graphite on paper
16 x 15 inches
The Bill McClain Collection of Chicago
Imagism, Madison Museum of
Contemporary Art

Karl Wirsum
Brown Derby Bouncer, 1983
Acrylic on wood
45 x 31 x 7 ¾ inches
The Bill McClain Collection of Chicago
Imagism, Madison Museum of
Contemporary Art

Roger Brown

b.1941, Hamilton, AL; d.1997
Roger Brown exhibited alongside Eleanor Dube, Philip Hanson, and Christina Ramberg in the False Image group shows at the Hyde Park Art Center in 1968 and 1969. In his earlier works, Brown depicts urban and suburban landscapes occupied by silhouetted figures and illuminated by eerie pools of light. His later paintings became increasingly politicized, exploring the impact of natural disasters on civilization, violent news events, and social controversies. Simplification of forms and repeated motifs suggest instant readability and signal Brown's rejection of the modernist principle of art for art's sake. And, though pictorially accessible, Brown's paintings succeed in communicating the complexity of contemporary life.

Sarah Canright

b.1941, Chicago, IL. Lives in Austin, TX.
An abstract painter associated with Chicago Imagism, Sarah Canright first showed at the Hyde Park Art Center in 1968 with Ed Paschke, Richard Wetzel, and her husband, Ed Flood, all of whom adopted the group moniker the Nonplussed Some. Organic swells of pastel color ripple out from the center of her paintings and float against soft, geometric backdrops of interlocking or braided patterns. Canright's unapologetic use of pale, subtle colors and delicate, ethereal shapes encourage a feminist treatment of modernist abstraction.

James Falconer

b.1943, Chicago, IL. Lives in IL.
Eager for more substantial exposure, James Falconer and Jim Nutt devised the idea of assembling small groups of artists who, based on the aesthetic compatibility of their art, would exhibit their work together. This idea ultimately culminated in the infamous Hairy Who group—which also included Gladys Nilsson, Suellen Rocca, Art Green, and Karl Wirsum—and *Hairy Who* exhibitions at the Hyde Part Art Center. Falconer, like his Hairy Who cohort, was drawn to complex forms, intense color, and frenetic compositions.

Edward Flood

b.1944, Chicago, IL; d.1985
Presenting his work at the Hyde Park Art Center's Nonplussed Some group exhibitions, Ed Flood, along with his Imagist contemporaries, took advantage of the expressive power offered by comic book illustrations and mass-produced advertisements. Flood's skillfully crafted box constructions combine multiple Plexiglas panels—each painted with flat, graphic images—into a single, unified structure, thereby playfully challenging viewers' perception of depth and space.

Art Green

b.1941, Frankfort, IN. Lives in Ontario, Canada.
Like the other members of Hairy Who, Art Green studied at the School of the Art Institute of Chicago. Originally enrolled in an industrial design program, he soon redirected his efforts to painting and drawing, finding artistic inspiration in the architecturally rich and consumer-driven world around him. His compositions, densely layered with geometric structures held together by ropes, cables, and wires, present illusions of three-dimensionality.

Philip Hanson

b.1943, Chicago, IL. Lives in Chicago, IL.
Philip Hanson first came to prominence in 1969 as one of the False Image artists. Working within the characteristic Imagist style of decorative abundance, Hanson's early paintings—visual investigations of architectural spaces, blossoming flowers, and billowing garments—tend toward the surreal and the romantic. Sensual and dreamlike, his series of canvases from the midseventies feature women who, facing away from the viewer, are enveloped in ambiguous surroundings and dressed in delicately flowing blouses.

Gladys Nilsson

b.1940, Chicago, IL. Lives in Wilmette, IL.
Exhibiting alongside her husband, Jim Nutt, and the other four artists in the Hyde Park Art Center's seminal *Hairy Who* exhibitions, Nilsson quickly gained critical recognition as one of American's premier watercolorists. Nilsson fills her compositions

with lively characters whose elongated, elastic bodies activate the work's intricate and enigmatic narratives. Often combining traditional, art historical references with the vernacular, her paintings address very human, often autobiographical concerns with humor and irony.

Jim Nutt
b.1938, Pittsfield, MA. Lives in Wilmette, IL.
During the Hairy Who years (1966–69), Nutt primarily exhibited his playful, punning reverse-Plexiglas paintings of sexually charged characters occupying the same flat space as scatological detritus. Experimenting with narrative-based vignettes in the 1970s, Nutt began to fill his compositions with bizarre and often naked figures engaged in staged dramas of deviance. Far from adolescent inanity, these early works suggest the artist's absorption and integration of myriad artistic sources, including Surrealism, Expressionism, Northern European painting, and popular culture. Since the late 1980s, Nutt's work has focused on portraits of imaginary women. Reflecting his exacting precision and continued formal interest in the nature of line and color, the works in the ongoing portrait series feature female busts set against dense, monochrome backgrounds and accentuated by distorted, angular noses and sculptural, stylized hairdos.

Ed Paschke
b.1939, Chicago, IL; d.2004
Appropriating images from media and popular culture, Ed Paschke joined fellow Imagists in the *Nonplussed Some* exhibitions at the Hyde Park Art Center. Paschke's glowing portraits reference celebrity icons and anonymous underworld archetypes— from Marilyn Monroe, Elvis Presley, and Claudette Colbert to pimps, prostitutes, and deviant fetishists. Although representational in style, his art relies heavily on surrealist juxtapositions and the expressionistic use of sickly color and jarring compositions to elicit emotional response. Capturing the spirit of our increasingly technological world, Paschke's later portraits are highly abstracted, their surfaces blurred by fluorescent bands of color, the visual static of electronic distortion.

Christina Ramberg
b.1946, Fort Campbell, KY; d.1995
Along with the other False Image artists, Christina Ramberg exhibited at the Hyde Part Art Center, thereby solidifying her connection to Chicago Imagism and her status in the art world. Her tight, controlled paintings depict portions of the human body, from leather-bound and corseted female torsos to more androgynous bodies suggestive of an intersexed physicality. In later compositions, bodily forms morph into abstracted human-object hybrids. Women's hourglass figures are rendered with vessel-like solidity, and loose outlines of bodies offer a structural frame upon which amalgamations of clothing, rope and wire, wooden scraps, and other inanimate objects stand in for arms, legs, musculature, and genitalia.

Suellen Rocca
b.1943, Chicago, IL. Lives in Romeoville, IL.
Exhibiting alongside other members of the Hairy Who in the 1960s, Suellen Rocca shared her colleagues' artistic interest in bold color, personal iconography, and surrealist combinations of objects entangled within a single, flat space. Drawing inspiration from serial product displays in advertising magazines and jewelry catalogs, Rocca developed her own visual vocabulary, crowding her canvases with simplified graphics of images related to women and girls: handbags, diamond rings, wigs, and hats.

Barbara Rossi
b.1940, Chicago, IL. Lives in Berwyn, IL.
Rossi's association with Chicago Imagism began with her inclusion in the Hyde Park Art Center exhibitions *Marriage Chicago Style* in 1970 and *Chicago Antigua* the following year. Like other Imagists during this period, she experimented with reverse painting on Plexiglas, creating vibrant works with saturated colors and strong, curvilinear lines. Featuring complex amalgamations of amorphous shapes weaving and twisting around each other, these paintings, which contain subtle suggestions of eyes, noses, lips, and misplaced body parts, are reminiscent of human heads.

Karl Wirsum

b.1939, Chicago, IL. Lives in Chicago, IL.
Exhibiting his work in Chicago since the
early 1960s, Wirsum first received critical
attention during the initial 1966 *Hairy Who*
exhibition. Through a process of free
association, he creates paintings, drawings,
and sculptures layered with meaning and
narrative—their cryptic content only
heightened by his frequent incorporation of
visual and verbal puns. Carefully construct-
ing figurative images whose smooth, flat
surfaces evince no indication of the artist's
hand, Wirsum still succeeds in infusing
his work with emotion and raw, animated
energy by employing bright color, dynamic
line, and the graphic boldness of comic
book art.

Ray Yoshida

b.1930, Kapaa, HI; d.2009
An influential teacher at the School of the
Art Institute, Ray Yoshida played an
instrumental role in encouraging his
students—including those who would be-
come known collectively as the Chicago
Imagists—to break away from tradition and
engage more openly with the world around
them. Though he was not represented
in the infamous Imagist shows at the Hyde
Park Art Center, the inclusion of his work in
larger survey exhibitions starting in 1969
at the Chicago Museum of Contemporary
Art not only demonstrated the fluid,
back-and-forth exchange existing between
Yoshida and his students, but also effectively
placed him firmly within the Imagist camp.
During the late sixties Yoshida became
known for his comic book specimen col-
lages. Developing a lexicon of images from
clippings excised from their original comic
context, he rearranged these fragments
into orderly grids on large sheets of paper,
thereby creating compositions that
simultaneously allude to and conceal a
larger narrative whole.

SELECTED BIBLIOGRAPHY

Entries appear in chronological order

Hairy Who, *The Portable Hairy Who!*, exh. cat. (Chicago: Hyde Park Art Center), 1966.

Hairy Who, *The Hairy Who Sideshow*, exh. cat. (Chicago: Hyde Park Art Center), 1967.

Hairy Who, *Hairy Who*, exh. cat. (Chicago: Hyde Park Art Center), 1968.

Hairy Who, *Hairy Who (cat-a-log)*, exh. cat. (Washington D.C.: Corcoran Gallery of Art), 1969.

Stephen S. Prokopoff and Joan C. Siegfried, *The Spirit of the Comics*, exh. cat. (Philadelphia: Institute of Contemporary Art, University of Pennsylvania), 1969.

Franz Schulze, *Fantastic Images: Chicago Art since 1945* (Chicago: Follett Publishing Company), 1972.

Patricia Stewart and Franz Schulze, *Chicago Imagist Art*, exh. cat. (Chicago: Museum of Contemporary Art), 1972.

Dennis Adrian, *What They're Up To in Chicago*, exh. cat. (Ottawa, Canada: National Gallery of Canada), 1973.

Don Baum et al., *Made in Chicago*, exh. cat. (Washington D.C.: Smithsonian Institution Press), 1974.

Don Baum, *Made in Chicago: Some Resources*, exh. cat. (Chicago: Museum of Contemporary Art), 1975.

Koffler Foundation Collection: A Traveling Exhibition of Paintings and Sculpture by Chicago Artists, exh. cat. (Chicago: Illinois Arts Council), 1976.

Wilma Beaty Cox, *West Coast '76: The Chicago Connection*, exh. cat. (Sacramento, CA: E.B. Crocker Art Gallery), 1976.

Goldene Shaw, ed. *History of the Hyde Park Art Center, 1939–1976* (Chicago: Hyde Park Art Center), 1976.

Diane Kirkpatrick et al., *Chicago: The City and Its Artists, 1945–1978*, exh. cat. (Ann Arbor, MI: University of Michigan Museum of Art), 1978.

Chicago Currents: The Koffler Foundation Collection of the National Collection of Fine Arts, exh. cat. (Washington D.C.: Smithsonian Institution Press), 1979.

Katharine Lee Keefe, *Some Recent Art from Chicago*, exh. cat. (Chapel Hill, NC: Ackland Art Museum, University of North Carolina), 1980.

Tony Knipe et al., *Who Chicago? An Exhibition of Contemporary Imagists*, exh. cat. (Sunderland, UK: Ceolfrith Gallery, Sunderland Arts Centre), 1980.

Dennis Adrian et al., *Selections from the Dennis Adrian Collection*, exh. cat. (Chicago: Museum of Contemporary Art), 1982.

Dennis Adrian and Richard A. Born, *The Chicago Imagist Print: Ten Artists' Works, 1958–1987, A Catalogue Raisonné*, exh. cat. (Chicago: David and Alfred Smart Gallery, University of Chicago), 1987.

Brady Roberts and Dennis Adrian, *Chicago Imagism: A 25 Year Survey*, exh. cat. (Davenport, IA: Davenport Museum of Art), 1994.

Lynne Warren et al., *Art in Chicago, 1945–1995*, exh. cat. (Chicago: Museum of Contemporary Art), 1996.

Linda Dorman Gainer et al., *Jumpin' Backflash: Original Imagist Artwork, 1966–1969*, exh. cat. (Munster, IN: Northern Indiana Arts Association), 1999.

Cynthia Roznoy, *Chicago Loop: Imagist Art, 1949–1979*, exh. cat. (New York: Whitney Museum of American Art), 2000.

KARL WIRSUM *Brown Derby Bouncer* 1983

Chicago Imagists is a publication of the
Madison Museum of Contemporary Art
(MMoCA), created in conjunction with
the exhibition *Chicago Imagists at the Madison
Museum of Contemporary Art.*

The exhibition and the publication were
made possible by generous funding from:
National Endowment for the Arts
The DeAtley Family Foundation
Ellen Rosner and Paul Reckwerdt
Perkins Coie LLP
Daniel and Natalie Erdman
J.H. Findorff & Son Inc.
MillerCoors
McGladrey
The Terry Family Foundation
Madison Arts Commission, with additional
 funds from the Wisconsin Arts Board
Dane County Cultural Affairs Commission
A grant from the Wisconsin Arts Board
 with funds from the State of Wisconsin
 and the National Endowment for the Arts
MMoCA Volunteers

ART WORKS.
arts.gov

Library of Congress
Cataloging-in-Publication Data

Chicago imagists / [with essays by
Lynne Warren . . . et al.].
 p. cm.
 Published in conjunction with an exhibition
 held at the Madison Museum of Contemporary
 Art, 11 September 2011–8 January 2012.
 Includes bibliographical references and index.
 ISBN 978-0-913883-36-5
 1. Chicago Imagists (Group of artists)—
 Exhibitions.
 2. Art, American—Illinois—Chicago—
 20th century—Exhibitions.
 3. Figurative art, American—Illinois—
 Chicago—20th century—Exhibitions.
 I. Warren, Lynne. II. Madison Museum of
 Contemporary Art (Madison, Wis.)
 N6512.5.C49C49 2011
 759.173′1109046—dc23 2011019468

Edition 2,000

In stated dimensions, height precedes
width precedes depth.

Editor and Project Coordinator
Jane Simon

Manuscript Editor
Paula Cooper, Madison, Wisconsin

Catalogue Design
Lorraine Ferguson, New York, New York

Printer
Oceanic Graphic Press, China

Photography

Photography © The Art Institute of Chicago:
15, 37, 45, 104, 124, 139

William H. Bengston: 108, 118, 120, 128

Courtesy of the Roger Brown Study Collection,
the School of the Art Institute of Chicago
and the Brown family. Photo: William H. Bengtson.
© SAIC: 95, 111, 112

Mark Bullard: 121

Photograph © 2011 courtesy of The David
and Alfred Smart Museum of Art, The University
of Chicago: 106, 110

Nathan Keay, © Museum of Contemporary Art,
Chicago: 16, 17, 137

Photo © Museum of Contemporary Art, Chicago:
17, 28, 123

Digital Image © The Museum of Modern Art/
Licensed by SCALA / Art Resource, NY: 38, 41